AMERICA THE PICTURESQUE

AMERICA
THE
PICTURESQUE
IN
NINETEENTH CENTURY
ENGRAVING

Albert F. Moritz

New Trend
New York · Toronto · Munich

Published by
New Trend Publishers
31 Portland Street
Toronto, Ontario M5V 2V9

A New Trend Book
New York, Toronto, Munich

Distributed in the United States by
Dodd, Mead & Company
79 Madison Avenue
New York, N.Y. 10016

Library of Congress Catalog Card Number: 83-061957

Canadian Cataloguing in Publication Data

Main entry under title:
America the picturesque

Bibliography: p.
ISBN 0-88639-002-8

1. Engraving — 19th century — United States.
2. Engraving, American. 3. Illustration of books —
19th century — United States. 4. Magazine illustration —
19th century — United States. 5. United States in art —
History — 19th century. I. Moritz, A. F.

NE507.A43 1983 769.973 C83-098854-8

Printed and bound in Canada

Contents

The White Mountains, From the Conway Meadows, by Harry Fenn,
Picturesque America, 1872

List of Plates

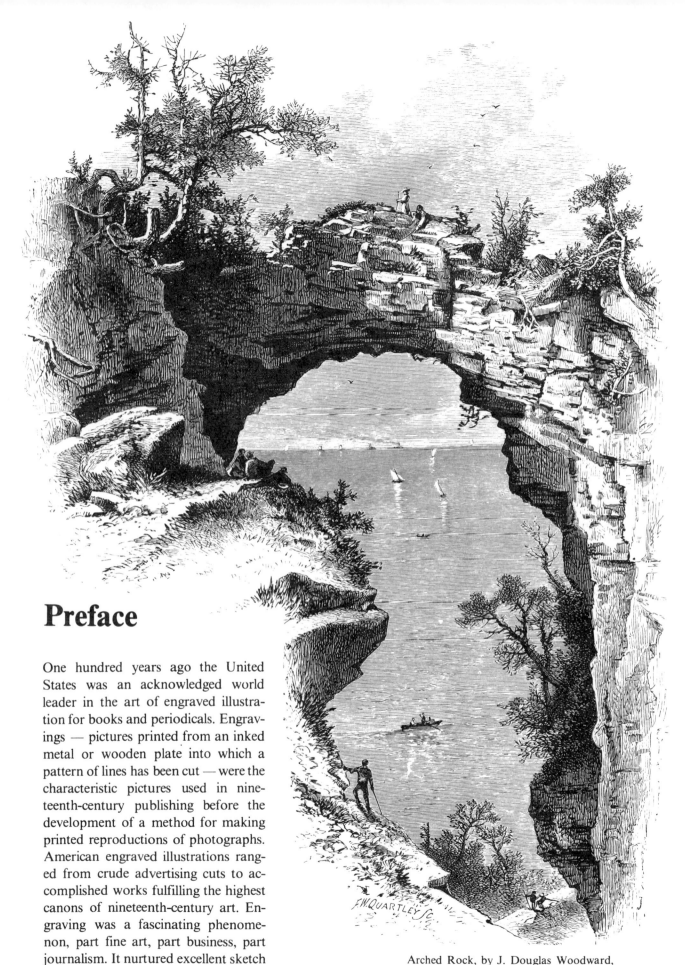

Preface

One hundred years ago the United States was an acknowledged world leader in the art of engraved illustration for books and periodicals. Engravings — pictures printed from an inked metal or wooden plate into which a pattern of lines has been cut — were the characteristic pictures used in nineteenth-century publishing before the development of a method for making printed reproductions of photographs. American engraved illustrations ranged from crude advertising cuts to accomplished works fulfilling the highest canons of nineteenth-century art. Engraving was a fascinating phenomenon, part fine art, part business, part journalism. It nurtured excellent sketch artists and painters who criss-crossed

Arched Rock, by J. Douglas Woodward,
Picturesque America, 1872

9

the country interpreting news events and natural wonders, engravers who developed extraordinary skill in translating artists' originals into prints, and a whole publishing industry of newspapers, magazines and books.

Engraved illustration in the eighteenth and nineteenth centuries was a popular art which attracted serious artists and frequently produced works of high quality. In this it resembles photography and the film, modern forms of visual expression which provide a wide range of images at the service of popular culture. *America the Picturesque* recalls the era dominated by engraved illustration with some of its best productions, particularly those depicting the American landscape. The nineteenth century was a great period of landscape painting, and American art achieved its first maturity in the landscape movements now generally designated as the early and later phases of the Hudson River School. It was in the context of the Hudson River School's artistic and popular success that, from the 1830s onward, serious artists began to interpret the topography of every part of the United States. Landscape painters were closely connected with the production of engravings. The thriving graphic arts industry was the primary source of income for many artists at a time when it was extremely difficult to make a living by painting alone. The finest nineteenth-century American painters often worked as sketch artists, or 'designers' as they were called, for engraved periodicals, gift books, travel books and annuals. Most published graphic material depicted news events, everyday scenes, cities, buildings and the like; it was hastily produced and often crude, even when it originated in the sketches of such artists as Winslow Homer. At the same time, however, the artists, engravers and publishers produced a large number of artistic set pieces, especially for expensive travel and gift books, but for magazines as well. For these special productions, American landscape was the most important subject.

The interpretation of the United States in engraved landscape art depended on artistic and publishing events in other parts of the world. Technical developments in printing, paper-making and engraving that permitted large popular editions originated in Europe, and especially England, as did the phenomenon of the popular illustrated press. It was also the European taste for illustrated accounts of exploration and settlement in the New World that produced many of the best and most widely circulated early views of what is now the United States. This

View of the Kern River, by Albert Bierstadt,
Art in America, 1872

tradition of engraved topographical art, which stretches back to the age of discovery, reached its height in travel books written by both adventurers and professional travelers in the period from the late eighteenth through the mid-nineteenth centuries. American artists inherited from Europe not only an interest in their country's landscape but also a special theory as to its proper appreciation and presentation in art. During the late eighteenth and nineteenth centuries, European and American landscape art was dominated by the aesthetic theory of the 'picturesque,' a far-reaching set of attitudes about the special charm of the 'wilderness' element of nature and its depiction. American artists modified rather than rejected this European-born tradition to arrive at a realistic, accurate and feeling account of their New World landscape.

This impulse of artists toward American ways of seeing and expressing distinctively American subject matter was realized largely in the genre of landscape during the mid-nineteenth century. The

medium of engraved illustration brought the new artists to a public increasingly aware of its American identity. An expressive difference developed between European and American manners of depicting the United States within the general idiom of picturesque illustration. In *America the Picturesque*, this difference is displayed by considering in detail the two most impressive books devoted to engraved landscape depiction of the nineteenth-century United States. The first is *American Scenery* (1840), with 115 steel-engraved plates after pictures by the English artist William Henry Bartlett and two after the American Thomas Doughty. The height of artistry in American landscape illustration was reached in *Picturesque America*, published in New York in 1872 and illustrated with wood and steel engravings after paintings and drawings by many of the finest artists of the day. Together, the books give an excellent view of the achievements of nineteenth-century engraved illustration, the variety and development of picturesque landscape art, and the originality in landscape interpretation achieved by American artist-illustrators.

Early Illustration of the United States

The first pictures of America that Europe saw were engraved scenes and portraits decorating explorers' maps and accounts of their voyages. Although many of the explorers were not distinguished sketch artists, their drawings were eagerly taken up as the basis of book illustrations prepared either as woodcuts or metal engravings by craftsmen in Europe.

By the great age of discovery, the sixteenth century, illustration was already a venerable part of European publishing. In fact, the very first books ever printed on a press, thirty years before Gutenberg's invention of moveable type, were primarily pictorial. These are the 'xylographica,' volumes of pages printed from carved blocks of wood on which both pictures and lettering were cut by hand. Early in the fifteenth century individual prints from carved woodblocks were made in Europe, and soon afterwards the xylographica began to appear.

About one-third of the books printed before 1500 were illustrated, all by woodcut. In the woodcut, areas of a wood block are cut away to leave bold raised lines. These are then inked and printed, creating the image. This is a 'relief' process: as with the

letters in letterpress printing of type, it is the raised portion of the block that contacts the paper and leaves a print. The medium enjoyed wide popularity in both prints and books, and was brought to a high state of perfection by Albrecht Dürer (1471-1528). Late in the sixteenth century, woodcuts were superseded by metal engraving which had long been practiced as an art of decoration for implements and jewelry. Prints taken from engraved metal plates were capable of much finer detail and a much greater range of effects than were woodcuts.

To produce a metal engraving, the engraver uses a tool called a 'burin' or 'graver' to incise very fine lines into the metal plate. Ink is then rubbed into the grooves and the surface of the plate is wiped clean. The plate is printed on a high pressure press which forces the paper into the grooves to pick up the ink, reproducing the engraver's lines. This type of printing, 'intaglio,' is quite different from relief printing and requires a separate press. Thus, despite the aesthetic advantages of metal engraving, it presented difficulties for illustration. Illustrations could not be printed with the rest of a book; they had to be placed on separate pages that were later inserted in the text before binding. In addition, the metals that were at first used, copper and cast metal, could not stand up to the press well enough to make more than a few hundred acceptable prints; after that a new plate had to be engraved. Steel was better in this respect. Steel engraving was introduced in the late eighteenth century, and by the nineteenth century editions of 30,000 prints were possible. However, steel's extreme hardness — which allowed it to take very fine impressions and made steel engraving the most respected form of the art — meant long, expensive hours of craftsmanship for each engraving produced. Entrepreneurial publishers made steel-engraved books sell during the nineteenth century, but in general the difficulties of metal engraving resulted in a decrease in the proportion of illustrated books between the woodcut era and the early nineteenth century when a new medium, wood engraving, provided an economical and speedy means of printing illustrations in huge editions. Wood engraving will be described below in connection with the rise of American illustration.

A few of the earliest views of the present United States were printed from woodcuts, but most were copper, and later steel, engravings. The fullest early pictorial accounts of territories now part of the United States were made by Jacques Le Moyne de Morgues in Florida in 1564 and by John White in Virginia and North Carolina from 1585 to 1587. The

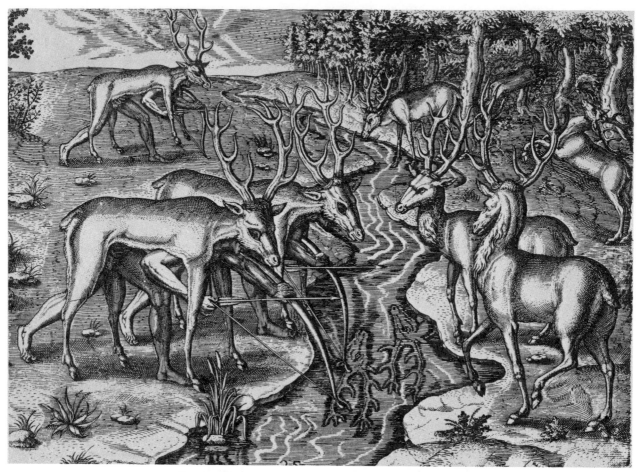

Hunting Deer, by Theodor de Bry after Jacques Le Moyne,
America, Vol, II, 1591

work of both men became widely known in Europe in the form of engraved illustrations. Le Moyne accompanied the Huguenot captain René Goulaine de Laudonnière on his 1564 expedition to found a French Protestant colony called Fort Caroline at the mouth of the River May. The colony was destroyed by the Spanish in 1565, who settled on the site, renamed it San Matheo, and inhabited it until forced out by the British in the early eighteenth century. Le Moyne published an account of the Huguenot experiment, the Fort Caroline region and the native inhabitants, and in addition he made forty-two brilliantly colored gouache paintings. Unfortunately, only one of the originals survives. Others are known only from copies, chiefly engraved copies published by the Frankfurt engraver and publisher Theodor de Bry. From 1590 through 1618, de Bry produced a monumental ten-volume *America*, which consisted of illustrated republications of various explorers' narratives translated into Latin. The second volume of *America*, published in 1591, was Le Moyne's narrative with engravings after many of his paintings.

The first volume of *America*, issued in 1590, was a translation of Thomas Harriot's 1588 book, *Briefe and true report of the new found land of Virginia*. De Bry's version was illustrated with engravings after the drawings and watercolors of John White. A skilled artist, White presented in his pictures a fresh and accurate picture of the Algonquian Indians who inhabited the area near the first Virginia colony, at what is Roanoke, North Carolina. White was one of the original members of the expedition sent in 1584-85 to colonize Virginia under the aegis of Sir Walter Raleigh, who had named the "new found land" in honor of Elizabeth, the virgin queen. In fact, White was governor of the Roanoke Island settlement in 1587, and was among those who returned to it in 1590 to find that it had been wiped out.

Both White's and Le Moyne's original pictures (in the latter case we must judge by a single surviving example) tend to idealize the natives, who represent the artists' major interest. Landscape is a perfunctory background. Le Moyne is more frank

than White in that he presents some of the cruel practices, such as cannibalism, that Europeans found among the Indians of the eastern seaboard. White avoids these aspects of Indian life, but on the other hand his drawings seem more spontaneous and accurate, less dependent upon European prototypes that do not match the peoples he is depicting. In engraving both artists, de Bry exaggerated the idealizing and classicizing tendencies, sometimes greatly, with the result that the Indians come to resemble Greco-Roman statues of heroic nudes. His engravings shared and greatly helped to strengthen the European tendency to see America and its natives in terms of existing philosophical and aesthetic ideas.

Among the most charming of early engravings of America are the primitive illustrations in John Smith's *Generall Historie of Virginia, New England, and the Summer Isles*, published in London in 1624. Smith is, of course, the famous Captain John Smith, leader of the Jamestown, Virginia colony founded in 1607. In the book he recounts his adventures, which have entered into American mythology: how he was captured by the Algonquians and condemned to execution by Chief Powhatan, how the Princess Pocahontas interceded for him out of love and saved his life. One large illustration in the *Generall Historie* tells this story, and other of Smith's exploits, in panels arranged around a map of Virginia's coast south from Port Henry (in present-day North Carolina). The engravings, by Englishman Robert

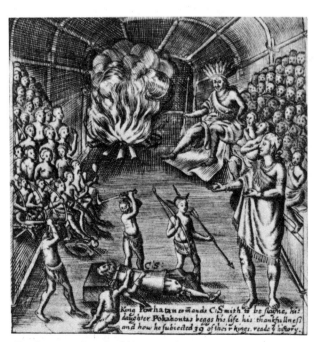

Powhatan orders Smith's execution, by Robert Vaughan, *The Generall Historie of Virginia*, 1624

Vaughan, have a naive appeal and convey significant information.

Idealizing distortions dominated the visual depiction of the present United States in engraved books for the next 200 years. Although many of the pictures produced by amateur sketch artists have informational value and primitive artistic interest, none had the influence of de Bry's widely circulated, sophisticated, impressive engravings. These continued to be reprinted and imitated for nearly two centuries, and contributed to a widespread notion of the Indians as a prelapsarian race, naked and unashamed, physically similar to the ancient Greeks. A very few artists — notably Albert Eckhout, who during the 1640s painted meticulously accurate, life-sized canvasses of Brazilian natives and their natural surroundings — might have corrected such a view if they had been widely known. North America did not attract or produce an Eckhout until the 1830s and 1840s, when frontier and Indian life was painted by such men as George Catlin, Alfred Jacob Miller, Karl Bodmer, Seth Eastman and Paul Kane. The last two are the most important for engraved illustration. In 1859 in London appeared the Canadian Kane's *The Wanderings of an Artist*, with color lithographed plates and wood-engraved text illustrations from his 1846-48 journey from Toronto to Fort Vancouver and back, some of it through United States territory. It was from the work of Eastman, then a captain in the United States Army, that the steel engravings were made for Henry Schoolcraft's six-volume *Historical and statistical information respecting the history, condition and prospects of the Indian tribes of the United States* (1851-57), commissioned by the Department of Indian Affairs and financed by Congress.

Between the earliest settlements and the emergence of a self-consciously American art, depiction of the present United States continued to focus on the native people and prodigies such as the buffalo or the beaver, and to be widely circulated in the books of 'voyages' (travels or explorations) that were popular during the period. The French and Spanish, as much as the British, were active in exploration, so that many early illustrations depict the extreme north, south or west limits of the country. Father Louis Hennepin, the Recollet friar who accompanied La Salle on his Great Lakes explorations, which included the European discovery of Niagara Falls, wrote three illustrated accounts of his voyages: *Description de la Louisiane* (Paris, 1683), *Nouvelle decouverte d'un tres grand pays* (Utrecht, 1697) and

Building the *Griffon*, by Fr. Louis Hennepin,
Nouveau voyage, 1704

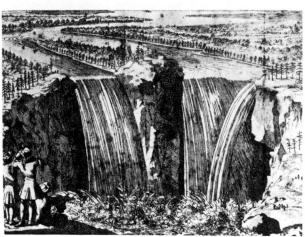

First printed view of Niagara, by Hennepin,
Nouvelle decouverte, 1697

Nouveau voyage d'un pais plus grand que l'Europe (The Hague, 1704). Pictures from Hennepin's books — such as the buffalo, the building of La Salle's *Griffon* (the first sailing ship on the Great Lakes), and Hennepin's own departure from Michilimackinac by birchbark canoe — are among the first to show artistic attention to North American landscape. The views are clearly influenced by the late Renaissance background landscapes which, by the mid-seventeenth century, had evolved into a major element in painting and one that often formed the chief interest of a picture. Some of Hennepin's drawings give great prominence to landscape, which dwarfs the human actors placed in the foreground. This shows the influence of the growing appreciation for scenes of nature's power and for pictures of human beings struggling in the midst of rugged wilderness. Such attitudes, which gradually coalesced to form the sublime and picturesque landscape aesthetic of the eighteenth and nineteenth centuries, intrude on the basically informational aims of Hennepin's drawings, which still manage to convey a generally accurate visual impression of the Pre-Cambrian Shield territory.

The mixture of topographical accuracy with idealizing tendencies characterizes all of the most significant engraved illustrations of North American landscape throughout the seventeenth and eighteenth centuries. Artists who saw the new world at first hand saw it through European pre-conceptions; and the distortion of American realities was often exaggerated by the fact that sketches — or even written descriptions — made on the spot in America were re-drawn and engraved by artists in Europe.

The Englishman Thomas Pownall, governor of Massachusetts in the mid-eighteenth century, took several sketching tours through Britain's northern North American colonies, and showed a keen interest in landscape, sometimes making it the sole subject of a picture, as in his study of the Great Cahoes Falls on the Mohawk River in Pennsylvania. His sketches were made into paintings in England by the artist Paul Sandby, and were published as engraved prints in 1761, fifteen years before Pownall published *A topographical description ... of North America* (London, 1776).

Other eighteenth-century engraved illustrations of American landscape include several pictures of what is now California which appear in George Shelvocke's *A voyage around the world* (London, 1726). Like many pictures of Florida and eastern Indians imitated from de Bry's engravings after Le Moyne, the pictures in Shelvocke's book focus on native peoples and seem to have been drawn in Europe from the descriptions in the text or from sketches. The natural backgrounds bear no relation to the places where the pictures were ostensibly made: for instance, there are snowclad Alps-like mountains in the background of a picture of the Indians of lower California. The Frenchman Le Page du Pratz includes engraved pictures of life among the Natchez Indians in his *Historie de la Louisiane* (1758). For informational value on Indian life and practices, these rival White's pictures, the engravings after Le Moyne and other early illustrations based on pictures drawn in what is now Canada by Samuel de Champlain — and their attention to landscape is equally perfunctory.

Among the English, Jonathan Carver was an important example of the official or semi-official explorers who published accounts, often illustrated, of their travels. Major Robert Rogers employed Carver to explore west from the British post at Michilimackinac (today's Mackinac). In 1766-67 Carver went down the Fox River, portaged to the Wisconsin River, followed it to the Mississippi and ascended the Mississippi. His *Travels through the interior parts of North-America* was published in London in 1778. The authenticity of Carver's narrative, map and sketches has been questioned, but both pictures and descriptions have, for the most part, the accuracy and vividness of first-hand observation. Carver's interest in landscape is indicated by a fine picture of the Falls of St. Anthony, first discovered by Hennepin in 1680-81. Of the falls Carver wrote:

> The country around them is extremely beautiful. It is not an uninterrupted plain where the eye finds no relief, but composed of many gentle ascents, which in the summer are covered with the finest verdure, and interspersed with little groves, that give a pleasing variety to the prospect. On the whole, when the Falls are included, which may be seen at a distance of four miles, a more pleasing and picturesque view cannot, I believe, be found throughout the universe.

Carver's picture and description of the falls are characteristic of an emerging concept of American landscape based upon the theories of the picturesque. Carver uses the term itself, which was not thoroughly discussed and defined until the 1780s and 1790s, and his imagery contains many elements that were later included under the picturesque: untouched wilderness, variety of scenery, great distances, the drama of nature's power (represented by the falls in this case), and the absence or relative insignificance of man. The pictures of Pownall, Carver and other eighteenth-century travelers in America display a full awareness of the currents of taste that were then forming the picturesque aesthetic in Europe. These British artist-travelers were in fact participating in the growth of picturesque art and in its early adaptation to American scenery. They begin a tradition which culminates in the nineteenth century in *American Scenery* with illustrations by William Henry Bartlett, the best of the British picturesque interpreters of the United States.

Two books published soon after the Revolution and illustrated with fine engravings show how European aesthetic standards, coupled with the taste for travel books about far away places, continued to

Falls of St. Anthony, by Jonathan Carver,
Travels through . . . North America, 1778

put a picturesque America before large audiences. Isaac Weld toured the country in 1795-97 and published his *Travels through the states of North America* in 1799. Weld's accounts and illustrations draw attention to the aesthetic qualities of American landscape. His picture of the natural bridge in Virginia is one of the earliest views of a site that became a favorite of artists, world-renowned for its awe-inspiring grandeur; Jefferson called it "the most sublime of nature's works" in his *Notes on the State of Virginia*. Weld's picture is in the true sublime and picturesque tradition of landscape art. It looks through the opening of the natural bridge, which overshadows two human foreground figures as well as the huge tree they stand beneath. On top of the bridge is what seems an entire forest, and through its towering arch can be seen a vista of wooded mountainside, with a looming rock formation in the central background. Through this scene winds the lonely road the travelers are following in the solitude.

A French counterpart of Weld's book is *Voyage dans Amerique septentrionale (A Journey in North America)* by General Victor Collot, governor of the French colony of Guadeloupe and a man who had fought for the United States in the Revolution. Collot made his extensive tour in 1795-96, journeying down the Ohio and Mississippi to New Orleans, at the request of France's minister to the United States. The resulting book, illustrated with engravings after the author's drawings, was not published until 1826. Despite its semi-official origin, Collot's work, like Weld's, falls into the category of illustrated travel literature published specifically for the curious general public. Of course, earlier volumes of 'voyages,' such as those of Le Moyne or Carver, had been aimed at a public, but they had always partaken largely of the character of scientific, geographic or governmental documents. Further, their appeal to

15

the public had not been primarily as entertainment or art. Rather, they had been intended to raise popular enthusiasm for colonization, or to encourage support of new trading and exploration ventures. Merchants and explorers knew that illustrated accounts of their discoveries were even more appealing than plain prose narratives, and were more likely to help produce a groundswell of popular approval. Toward the end of the eighteenth century, travel literature began to detach itself from the business of exploration and become a literary genre in its own right, practiced by professional travel writers and artists, who produced sumptuous volumes illustrated with engravings after drawings and watercolors. Weld and Collot are products of this trend, and their illustrations, while accurate, reflect the artistic taste of the times for picturesque landscape. One of Collot's best shows a frontier home, a log cabin, with a pot boiling before the door, in the midst of a clearing filled with the stumps of felled trees. In the background is a dense forest, with rather sinister-looking pines overshadowing the house, and in the door stands the dreamlike, isolated figure of the pioneer wife, an image of loneliness that has long held its place in the imagination of America. Collot's picture is meant to convey fact, but in choice and treatment of subject it is not far from Salvatore Rosa, with his images of toil-worn humanity in the midst of desolate wildernesses.

Before the nineteenth century, the finest artist to illustrate either a travel book or an exploration narrative concerning parts of the present United States was John Webber, the artist attached to Captain James Cook's epic third voyage of discovery in the Pacific Ocean. Engravings after Webber's paintings and drawings, including many made in what are now the states of Hawaii and Alaska, illustrate *A Voyage to*

the Pacific Ocean in the years 1776, 1777, 1778, 1779 and 1780 (London, 1784), volumes one and two written by Cook himself, the third volume by Captain James King. Cook's voyages, especially the third, are among the greatest adventures and explorations ever undertaken; Webber's superb, evocative illustrations were in their day what the broadcast and printed reproductions of photographs from Saturn and Jupiter are in ours.

Unlike a remote-controlled photograph, however, a drawing or painting by a human observer is bound to show a significant degree of interpretation. Webber was an excellent artist and his pictures combine faithfulness to reality with imaginative control. Sometimes one or the other ingredient predominates, but in Webber's best work the combination of the two allows him to convey not just a discovery, a new reality, but the mental and emotional state of the men who experienced it. In so doing, he gives us a glimpse into the European mind in the midst of the heroic age of exploration.

Webber sketched Hawaii twice, once during Cook's first landing there, the European discovery of the archipelago Cook called the Sandwich Islands, and once on the fateful return visit during which Cook was killed by natives. In between, the expedition sailed north to the present Canadian and Alas-

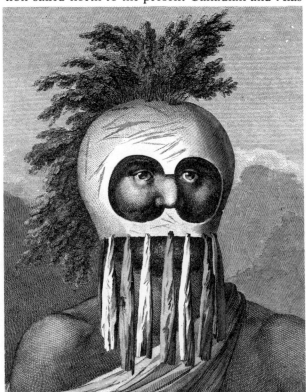

A Man of the Sandwich Islands, in a Mask,
by John Webber, *A Voyage to the Pacific Ocean,* 1784

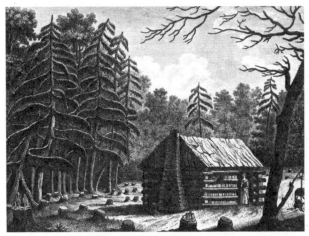

Frontier cabin, by Victor Collot,
Voyage dans l'Amerique Septentrionale, 1826

16

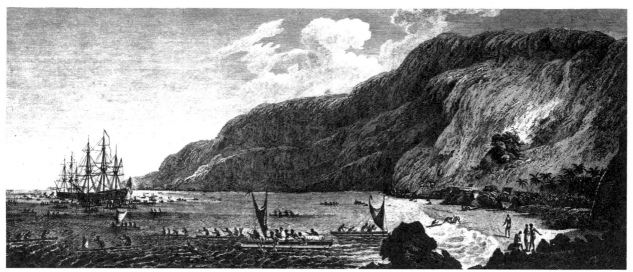

A View of Karakakooa, in Owyhee, by Webber,
A Voyage to the Pacific Ocean, 1784

kan coasts, also touching on Siberia, the Aleutians and other islands south of the Bering Strait. His drawings in Alaska and Hawaii are equal in quality to the famous ones he made in Van Dieman's Land (Tasmania) and in the South Pacific Islands. The Hawaiian and Alaskan pictures range from informative but always expressive views of natives, animals and landscape features to a few extravagantly fanciful scenes, which later observers and scientists have been unable to relate to anything known of Hawaii since Cook's time. Webber's drawings of the physical characteristics of Hawaiian and Alaskan natives show less of the classicizing tendency found in his pictures of Tahitians, who seemed to Cook's party to be inhabitants of an earthly paradise. Constant elements in all pictures, however, are a vivid presentation of the colorful aspects of native appearance and custom, and an eager responsiveness to sublime and picturesque elements of the new landscape. Repeatedly Webber presents Cook's ships surrounded by native craft in harbors overhung by immense, receding vistas of mountain. Whether these are the storm-shrouded icy peaks behind Prince William Sound (in present Alaska) or the tropically wooded slopes of the harbor of Huaheine (Tahiti), the composition and emotion of the pictures emphasize the sublime and inhuman vastness of the environment, the precariousness of man's existence in the grip of the wilderness. Even the most idyllic scenes introduce the motif of looming nature which holds man in its all-powerful grip even when it allows him to be happy. Webber, in harmony with the artistic temper of his day, found a pleasurable emotion and a note of profound truth in the rugged immensity of unaltered

nature and the contrasting smallness of man. The native peoples he observed seemed to him to exist in picturesque subjugation to the will of the elements and the brooding power of their environment. Thus he contributed to the picturesque interpretation of America, which reached its fullest development by a European artist sixty years later on the other side of the continent in the work of Bartlett.

William Henry Bartlett and American Scenery

William Henry Bartlett (1809-54) was one of the most talented and popular European artists to visit the United States. His career was almost totally devoted to illustration, and his widely circulated work on the United States was the best product of the picturesque interpretation of America by European artists. The book, *American Scenery* (1840), was the joint product of Bartlett and Nathaniel Parker Willis (1806-67), an American journalist and poet today remembered chiefly as an editor who published Poe, Thackeray and other major authors. *American Scenery; or, Land, Lake, and River: Illustrations of Transatlantic Nature* was issued in London by George Virtue, the publisher who brought out a steady stream of books illustrated and sometimes written by Bartlett from 1832 until 1856. All were picturesque travel books, usually in several volumes, with full-

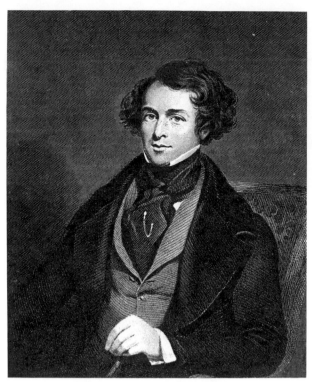

Portrait of William Henry Bartlett,
American Scenery, 1840

page steel-engraved plates inserted in the letterpress. They were customarily issued in periodical numbers, each containing a few engravings — four was common. Readers had the choice of subscribing or buying bound volumes when the periodical publication was complete. Subscribers could remove individual prints and frame them; engravings were often tinted with watercolors before framing, and providing this service supported a class of commercial 'artists' throughout the nineteenth century. Some subscribers would collect the periodical numbers and have them hand-bound. *American Scenery* was published in this manner, and released by Virtue in New York as well as in London.

Bartlett was by far the more important of the artist-writer team, although the combination was successful enough that Virtue published two further Willis and Bartlett collaborations, *Canadian Scenery Illustrated* (1842) and *The Scenery and Antiquities of Ireland* (1842). Willis's contribution to *American Scenery* is described under Bartlett's name on the title page this way: "The Literary Department by N. P. Willis, Esq." Born in Portland, Maine, of Puritan stock and educated at Yale, Willis was a dandy, bon vivant and minor literary figure whose greatest importance is as a magazine editor. While working as a traveling correspondent for George Pope Morris's New York *Mirror*, he became a darling of English high society and a friend of many of the leading European and American cultural figures of the day. Aside from his imitative romantic poetry and his two plays (probably his best work), most of his books are of a piece with his voluminous, chatty magazine journalism. Willis accompanied Bartlett on the artist's 1836 travels through the United States and wrote historical or descriptive items about each scene Bartlett pictured, often quoting or paraphrasing other writers without providing clear attribution. Thus, the text of the book is haphazard, ranging from intriguing glimpses of history or legend from unknown sources, to banal vignettes such as Willis's story of how some distinguished lady friends of his fell into a lake during a boating party. He manages to include chapters and illustrations on his own home and that of his employer, General George Pope Morris; in the latter he enthusiastically quotes examples of Morris's poetry, including "The Oak" with its famous first line, "Woodman, spare that tree!" The organization of the book, which may well have been beyond Willis's control, is also confused. The opening chapters are written around pictures of Niagara Falls, West Point, Trenton Falls and Mount Holyoke. The fifth chapter then moves back to the Niagara frontier for the outlet of the Niagara River; the sixth returns to the Hudson; the seventh is at Niagara again for the rapids above the Falls, and so on. The order of the chapters in the finished book must, therefore, have been determined by the order in which the original periodical numbers could be issued. This causes the book to return to the same or virtually the same scene, such as the District of Columbia or Niagara or Harper's Ferry, at two and sometimes three widely separated places in the text.

Despite the text's occasional value, Bartlett's pictures are the great interest of *American Scenery*. Bartlett was one of the most widely known English artists of his day, due to his paintings and drawings engraved for the picturesque travel books which were so much in vogue between 1820 and 1860. As a picturesque interpreter of landscape, he was the equal or near-equal of such contemporary landscape specialists as Samuel Prout. Although he was not primarily a painter, his work in his chosen medium is worthy of comparison with similar work by major artists, such as the designs which Constable did in the 1820s for a series of steel-engraved prints of Wales. Bartlett completed his apprenticeship in 1829 and immediately entered upon his career as a landscape

illustrator by contracting to provide pictures for a book on Switzerland by the prominent author William Beattie. Ultimately Bartlett illustrated six books by Beattie, three by Willis, and at least seventeen by other writers. He himself became a travel author, writing and illustrating twelve books bearing such names as *The Nile Boat; or Glimpses of the Land of Egypt* and *Footsteps of Our Lord and His Apostles in Syria, Greece and Italy*. He traveled extensively and pictured the landscape and monuments of the Holy Land and Near East, Italy and Sicily, Switzerland and the Alps, the Danube, Holland, Belgium, the Rhine, Greece, Scotland, Wales and Ireland. In

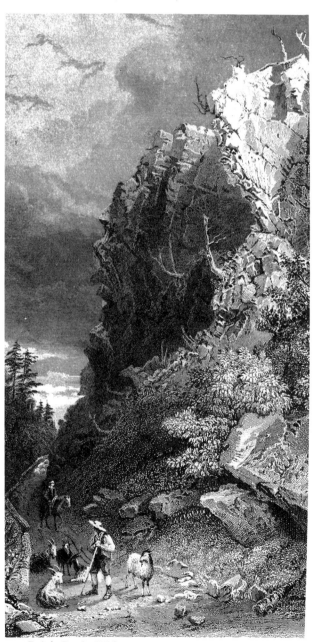

Pulpit Rock, White Mountains (detail), by Bartlett, *American Scenery*, 1840

England he illustrated separate volumes on cathedrals, castles and abbeys, cities, coastal towns and resorts, the history and topography of the County of Essex, and other specialized subjects. His work in North America included, besides *American Scenery* and *Canadian Scenery Illustrated*, a book entitled *The Pilgrim Fathers* and a multi-volume *History of the United States of North America*, completed after Bartlett's death by another author. In all, Bartlett made four extended visits to the United States between 1836 and 1852; all the engravings in *American Scenery* come from the first of these.

Bartlett was a thoroughly picturesque artist. His career was almost exactly coextensive with the greatest vogue of picturesque travel books from the late Romantic to the mid-Victorian periods. Like all landscape artists of the era, including the English masters John Constable and J. M. W. Turner, Bartlett was brought up in an artistic atmosphere charged with theories of the sublime, the beautiful and the picturesque. In addition, he was accustomed to think of the public taste for landscape art as a given feature of the artist-audience relationship, and thus to view the designing of engraved landscapes for mass circulation as an important artistic endeavor.

Today the words picturesque, sublime and beautiful are still used to describe landscape, and they retain much of the force that was given to them by the extended aesthetic debates of the eighteenth and nineteenth centuries. These debates were of intense interest to the growing middle classes. In fact, picturesque taste was one of the dominant characteristics of the first true mass audience, and thus of the first 'popular culture' of the industrial era. All newly created leisure classes aspire to some ideal of refinement and attempt to develop artistic styles and tastes which are partly their own and partly an adaptation of accepted standards. Landscape art in the picturesque and sublime manner became an important cultural stepping stone for the literate groups that were the product of industrialization, mass education and new technologies that allowed the printing of books in tens of thousands of copies. The vogue of landscape art is in many ways parallel to the popular lionization of nineteenth-century poets such as Byron, Browning and Longfellow. In both art and literature, a widespread aspiration to high culture produced a huge audience — or apparent audience — for serious novels and poems, art journals and books. It is a phenomenon that never existed before or since, and that continues to reverberate through modern society: the situation of the serious artist who

is divorced from a mass public and has only a small specialized audience is perhaps seen as a problem chiefly because of the Victorian comparison, which stands at the origin point of our period.

Bartlett, like most early nineteenth-century artists, took the picturesque landscape genre very seriously. There was a common desire among artists, as among writers, to appeal to and help form the taste of the new masses. Although the belief that true art is difficult and speaks only to a few always remained alive, most of the great Romantic and Victorian artists also experimented, at least at times, with the concept that art could be made to speak to a vast general public. Within any branch of art, such as landscape painting, this situation created a spectrum of quality, from work of the highest intention and achievement to that which was commercial and merely exploited the atmosphere of aesthetic reverence. At the top of the spectrum would be the work of Constable for engraved prints or of Turner for prints and illustrations; a Bartlett nearer the center could still be a highly skilled artist who would realize he was catering to a popular taste but would simultaneously believe he was contributing to the aesthetic and even the moral betterment of his audience.

'Picturesque' is a term which, in the late eighteenth century, was used to indicate a quality of roughness and wildness both in landscape and in painting or literature depicting landscape. People had long discussed emotions of awe inspired by wild nature before such experiences came to be systematically analyzed, defined, labeled and applied to aesthetics. The origin of quasi-religious emotion before natural scenery is often traced back to Petrarch, and hints of it can be found in many Renaissance writers. At the dawn of the 'age of reason' in England, Joseph Addison (1672-1719) wrote essays on the "Pleasures of the Imagination," in which he spoke of the pleasure the mind derives from being filled with "the prospects of an open champaign country, a vast uncultivated desert, of huge heaps of mountains, high rocks and precipices, or a wide expanse of water." The Earl of Shaftesbury was perhaps the first English writer to concern himself almost entirely with the emotions aroused by scenery and to impute to them a religious and moral significance:

> O glorious Nature! supremely fair, and sovereignly good! All-loving and All-lovely, All-divine! ... Wise substitute of Providence! impower'd Crea-

tress! Or Thou impowering Deity, supreme Creator! Thee I invoke, and Thee alone adore. To Thee this Solitude, this place, these Rural Meditations are sacred; while thus inspired with Harmony of Thought, tho unconfin'd by Words, and in loose Numbers, I sing of Nature's Order in created Beings, and celebrate the Beautys which resolve in thee, the Source and Principle of all Beauty and Perfection.

This passage, written in 1727, gives a fair sample of the gathering complex of attitudes that shaped the European depiction of American landscape for 200 years.

Before the picturesque was explicitly defined, that service was performed for two related terms, 'sublime' and 'beautiful,' by Edmund Burke (1729-97), in his 1757 book *A Philosophical Enquiry into the Origin of our Ideas of the Sublime and the Beautiful*. Burke thought of sublime emotion as similar to terror and called it "the strongest emotion which the mind is capable of feeling." It is closely associated with pain and danger, and is felt in the presence of grandeur, vastness, great height or depth, precipitousness, and power. Sublime feeling arises from what Burke calls 'Astonishment,' which he describes as "that state of the soul, in which all its motions are suspended, with some degree of horror." Beauty was opposed to sublimity and was associated with feelings of pleasure, security, well-being, freshness and youth. In art and nature, the marks of the beautiful were smoothness and regularity, small and proportional forms, gently curving and completed

Entrance to the Hudson Highlands, Near Newburgh, by Bartlett, *American Scenery*, 1840

lines. Beauty was a mark of the idealizing mind of man and was found much more frequently in cultivated nature than in wild nature. Since the mid-seventeenth century, English landscape architecture had exemplified the ideas that Burke grouped in his definition of the beautiful. The famous architect Lancelot 'Capability' Brown had designed entire estates dominated by the beauty of gracefully curving paths, streams and lakeshores, and by carefully shaped and managed wooded areas and lawns. However, as the eighteenth century progressed, elements that later were termed 'picturesque' began to appear in English landscaping. These include careful design to create a less formal, more 'natural,' appearance, and the erection of imitation ruins, sometimes actually inhabited by hired picturesque hermits.

Most scenery is, of course, neither sublime nor beautiful; it occupies a middle ground. It is not wholly a matter of gigantic mountains and fearful precipices; on the other hand, it is not a manmade formal garden or the paradise of Genesis. Natural scenes, as well as scenes of human beings or artifacts in their natural settings, seldom create impressions that fulfill the criteria of the beautiful and the sublime as laid down by Burke and other eighteenth-century theorists. In time the term 'picturesque' took over the middle — and by far the largest — area in the landscape aesthetic of the period. It was used to cover not only natural scenery itself, but also the growing taste for the depiction of ruins in landscape, and of rustic or primitive individuals dwarfed by the rugged grandeur of their environment. The picturesque qualities of immensity, roughness and wildness in scenery or its portrayal in art were associated with elevated emotions that involved a sense of man's dependency before time and nature. Nature, rearranged and idealized by the artist to express its inner poetic truth, could be portrayed in and for itself as an expression of the bounty, or the fearfulness, of existence; or it could be combined with man and man's works to express either the benevolence of the universe, or man's smallness in the face of its immensity and power.

The picturesque movement in artistic theory and practice was particularly strong in England, but it was derived from continental sources. Through English reverence for their work, the French artists Claude Lorrain (1600-82) and Nicholas Poussin (1594-1665) became the great exemplars of the picturesque in painting and landscape architecture. The characteristically 'natural' English landscaping style that flourished until the mid-nineteenth century owed much to their painting. Claude was particularly influential, with his idealized landscapes with deep backgrounds where sea, sky and earth merge, and his scenes of imaginary ancient buildings and mythological figures in landscape settings. The Italian painter Salvatore Rosa (1615-73) was important for his use of picturesque persons — such as gypsies, woodmen, robbers or beggars — in dramatic and often threatening scenes dominated by mountains, wild skies, forests or desolate tracts of land. Lorrain is the creator of the tiny, dreamlike foreground figures that give both scale and poetic feeling to so many picturesque landscapes. Rosa, on the other hand, is the antecedent of works in which stoic humanity is more prominent.

William Henry Bartlett was trained in an artistic milieu which regarded landscape as perhaps the highest genre of art and which thought of landscape wholly in terms of picturesque theory. Further, this picturesque art was in Bartlett's time intimately related to travel books illustrated with engraved plates. The first popularizer of the picturesque was William Gilpin, an artist and a critic of painting and landscape, who made numerous trips through various parts of England and wrote travel books in which he described and analyzed the best 'prospects' in each area of the country. In this way he helped to confirm the middle class audience in its preference for the effects of untamed nature over the artful ones of artists such as Brown. The term picturesque was at last explicitly defined by Uvedale Price in his *An Essay on the Picturesque* (1794), and thereafter became a concept for public attention and debate. Burke had believed that all natural objects have inherent emotive forces that they convey to the perceiver's mind according to fixed laws; two other theorists, Richard Payne Knight and Archibald Alison, argued the opposite, that picturesque emotion was due to associations a person made between a scene or picture and what he had experienced in the past and had been taught to interpret as pleasurable. The religious aspirations of the era caused the audience and most artists to adhere to the Burkean view. It carried the implication that picturesque and sublime emotion was implanted by an All-powerful hand in nature. This gave a higher sanction to the sensual enjoyment of picturesque scenes for their own sakes. Although the prime motives for pursuit

of such experience were aesthetic, the religious or mystic justification was always kept near at hand and referred to with greater or lesser seriousness, according to the bent of the artist. Bartlett's letters and published writings show that he was thoroughly imbued with picturesque attitudes, and his whole career bears witness to his awareness of the interconnection of picturesque art and nineteenth-century art publishing.

Bartlett was apprenticed in 1822 to John Britton, an artist and author who produced many works on picturesque landscape, art and architecture. It was in Britton's works, such as *Christian Architecture in England* (1826) and *Picturesque Antiquities of English Cities* (1830), that Bartlett's first published work appeared, along with engravings after such landscapists as J. M. W. Turner, Samuel Prout and John Sell Cotman. His apprenticeship ended in 1829, and by the time of his 1836 trip to the United States he was already experienced in depicting a wide variety of scenes according to the principles of topographical art and picturesque theory. Thus, he brought to the United States a mature artistic manner, which can be detected in his interpretation of American scenes. Although not a major artist, he possessed a rare and valuable ability to combine feeling and interpretation with accuracy. He was able to choose vantage points and handle light, shade and color in order to suggest wildness, grandeur, vastness and the solitude of man within the environment, while at the same time providing an accurate record that respected both the actual appearance of the scene, and a specific feeling or meaning that it suggested; his best work avoids the fault of applying a generalized picturesque patina to everything. Thus, his American pictures are at once valuable records of the United States in the late 1830s and interesting artistic interpretations of the country. The fascination of this English viewpoint is heightened by the fact that, at the very moment when Bartlett was touring and sketching in this country, the innovations of the great American landscape painter Thomas Cole were beginning to be felt by the public both through his own work and his influence upon artists such as Asher Brown Durand. It is probable that Willis and Bartlett were aware of these American artistic developments. The two plates in *American Scenery* that are not by Bartlett were designed by Thomas Doughty (1793-1856). Doughty was possibly the first American painter to devote himself exclusively to landscape (both he and Cole began working about 1820) and is a forerunner of the Hudson River School, a loose-knit group of Amer-

ican landscapists including Cole, Doughty, Durand, J. W. Casilear, John F. Kensett, Sanford Gifford, Alvan Fisher, Frederick Church, James and William Hart, Homer Martin, Jasper Cropsey and others. One of Bartlett's illustrations is of the village of Catskill, New York, and at the time it was made Cole was living there and making his historic paintings of the Hudson Valley and his grandiose picturesque allegories.

A comparison between the work of Bartlett and that of the American painters is made easier by the fact that the English artist's itinerary covered the same areas they favored: the Hudson Valley and other already famous scenic spots in the northeastern United States, from the White Mountains of New Hampshire to Springfield, Virginia (the natural bridge), from Boston to Niagara Falls. Bartlett sketched throughout New Hampshire, New York and Massachusetts. He went through Pennsylvania, taking the Columbia Railroad from Philadelphia to the Susquehanna River and then crossing the center of the state, north and south, by traveling along the river. He sketched parts of New Jersey, Maryland and Virginia, touching present West Virginia at Harper's Ferry. He drew several scenes in the District of Columbia. He passed through Rhode Island and Delaware without making pictures. He viewed Vermont across the Connecticut River and Maine across the Salmon Falls River, without registering his impressions, although Doughty contributed one illustration of the Maine coast. These places were already known and celebrated for their scenic beauty, and had in many cases been the subjects of widely circulated engravings after earlier artists. In 1821, when Cole and Doughty had just begun to paint, the publication of William G. Walls' picture book *Hudson River Portfolio* attested to a growing appreciation for Hudson River scenery. By the 1830s guidebooks were being published in New York that pointed out to lovers of scenery the beauties of the Hudson and surrounding areas such as the Catskills, specifically recommending stops at many of the places Bartlett illustrated. His work in *American Scenery* totals 115 full-page plates and two vignettes, all steel-engraved. He was the first (and only) European artist of any stature to create an extensive visual record of the landscape and culture of the entire area, and he did so just when major American artists were beginning to take the same geography as their workshop for the development of a specifically American picturesque art.

The Picturesque and the United States

The American painters of the day, Bartlett, and his confrere Willis, all were concerned with the adaptation of picturesque standards to the United States. The landscape features and flora of the eastern United States were different from those of Europe where the picturesque had been formed. Still more important, America was a continent without ruins, as William James was to remark later in the century. The picturesque was presumably inseparable from ruins and what they symbolized: man's contingent place in nature, and the age-old human associations which clung to such places as the Alps and the Holy Land, investing them with a poetic sense of historic depth. Thomas Cole, in his 1835 "Essay on American Scenery," showed his awareness of this question:

> There are those who through ignorance or prejudice strive to maintain that American scenery possesses little that is interesting or truly beautiful — that it is rude, without picturesqueness, and monotonous without sublimity — that being destitute of those vestiges of antiquity, whose associations so strongly affect the mind, it may not be compared with European scenery ... I am by no means desirous of lessening in your estimation the glorious scenes of the old world — that ground which has been the great theater of human events — those mountains, woods, and streams, made sacred in our minds by heroic deeds and immortal song — over which time and genius have suspended an imperishable halo. No! But I would have it remembered that nature has shed over *this* land beauty and magnificence, and although the character of its scenery may differ from the old world's, yet inferiority may not therefore be inferred; for though American scenery is destitute of many of those circumstances which give value to the European, still it has features, and glorious ones, unknown to Europe.

Cole's ability to discover a new type of picturesqueness in American scenery came partly from his own originality, and partly from the American mind of his times operating upon European, especially English, traditions.

Thomas Cole (1801-48) had come from England as a child. Raised in Ohio, he had taught himself to be a painter of the American frontier. Recognizing that he required further education, he came east to study in Philadelphia, and shortly afterwards was able to travel to Europe. By the mid-1820s he was painting the large-scale scenic canvasses of the Hudson River Valley that constituted a revolution in American art. These won him great prominence and gave impetus to the school of eastern landscape painters that came to be known as the Hudson River School.

This loose association of painters did not coalesce as a group and gain public recognition as a coherent art movement until the late 1830s, when Bartlett was sketching in the United States. But Doughty, at least, who contributed to *American Scenery*, must have been known to Bartlett, through Willis if not in person. Cole himself was the most important and influential of the new American painters. The originality of his work comes, in part, from the fact that he began as a self-taught artist in the American wild and learned European theories and styles later. He always focussed his gaze sharply upon the distinctive features of American scenery, although his later absorption of European influences was honest and complete, resulting during his later career in the creation of large-scale allegorical canvasses such as his series of five paintings entitled *The Course of Empire*. These works, completed and exhibited in 1836, the year of Bartlett's American trip, remain full of picturesque and sublime feeling. Some of them closely resemble works of Claude Lorrain in style and compostition. In the same way, it can be said that Cole's earlier landscapes have something of the flavor of Salvatore Rosa, although Cole's roughness and drama are more refined, and flow from the motive of portraying America's wilderness reality rather than from the pursuit of a certain kind of effect.

Cole was an American nationalist and patriot on the subject of landscape. "It is a subject," he wrote,

Desolation, from The Course of Empire, by Thomas Cole,
Art in America, 1872

"that to every American ought to be of surpassing interest; for, whether he beholds the Hudson mingling water with the Atlantic ... or stands on the margin of the distant Oregon, he is still in the midst of American scenery — it is his own land; its beauty, its magnificence, its sublimity — are all his ..." His attitudes were part of the burgeoning sense of identity and self-confidence in the young country, and found reinforcement in the literature of the time. Cole was a friend of the Romantic poet William Cullen Bryant, often quoted Bryant's work, and was indebted to his ideas; the same was true of Willis, who quotes often from Bryant in *American Scenery*. After Cole's death, his disciple Asher Brown Durand painted the famous *Kindred Spirits*, a wonderful and typically picturesque composition that shows Cole and Bryant in the midst of a forested wilderness, with which they seem to commune on friendly and familiar terms from a jutting rocky cliff in the foreground. Durand's gravitation to Cole formed the nucleus of the Hudson River School. Durand had earned success partly through engraving the plates of Cole's work that made it known throughout the country.

A Study From Nature, by Asher B. Durand,
Art in America, 1872

Bryant remained a proselytizer for American landscape all his life; he was the nominal editor of *Picturesque America* (1872) and thus forms one of the many connections between that book and the earlier works on American scenery done by Bartlett and the first Hudson River painters.

In *American Scenery*, which Bartlett was drawing in 1836 and which must have been written around the same time, Willis shows an awareness of American landscape painting by including two pictures by Doughty and by complimenting his work. He does not mention Cole, but his remarks on American and European scenery throughout the book demonstrate familiarity with the European concepts of the picturesque and with the American climate of opinion on this country's scenery that is expressed by Cole's "Essay" and Bryant's poems. In his "Preface" to *American Scenery*, Willis comments:

> Either Nature had wrought with a bolder hand in America, or the effect of long continued cultivation on scenery, as exemplified in Europe, is greater than is usually supposed. Certain it is that the rivers, the forests, the unshorn mountain-sides and unbridged chasms of that vast country, are of a character peculiar to America alone — a lavish and large-featured sublimity, (if we may so express it), quite dissimilar to the picturesque of all other countries.

Cole's "Essay" stated that "the most distinctive, and perhaps the most impressive characteristic of American scenery is its wildness. It is the most distinctive, because in civilized Europe the primitive features of scenery have long since been destroyed or modified ..."

Cole places himself among those "who regret that with the improvements of cultivation the sublimity of the wilderness should pass away." For Cole, the "scenes of solitude" which have never been modified by human contact "affect the mind with a more deep toned emotion" than any human accomplishment: "Amid them the consequent associations are of God the creator — they are his undefiled works, and the mind is cast into contemplation of eternal things."

Cole then lists and comments on chief elements of American scenery, confining himself — after a bow in the direction of the Far West, the prairies and "the central wilds of this vast continent" — to his chosen field, the northern and eastern states, chiefly Pennsylvania, New York and New England. He takes up mountains, lakes, waterfalls, rivers and forests. Cole's remarks, when compared with the

contents of *American Scenery*, seem almost to have been used as a guide by Willis and Bartlett. The "Essay" appeared in *The American Monthly Magazine* for January 1836, and Willis, a central figure in the journalism of his day, may well have seen it by the time that he and Bartlett began their sketching and writing tour later that year. Although Cole was expressing a credo and a program of work for the present and succeeding generations of American landscapists, it is unlikely that his remarks would have done more for Bartlett than direct him to scenic features and impress upon him what he clearly saw for himself, that American scenery was different. The similarities and differences between his American and his other pictures show the degree to which a strongly personal picturesque interpretation, combined with a gift for faithfulness and accuracy, was the determining factor in Bartlett's presentation of American scenery.

Cole, like many major artists, was both an innovator and a voice for ideas that were "in the air" of his time. It is this, as much as any direct influence, that accounts for the similarities between his remarks and Willis's, between the list of places he describes and the places Bartlett chose to illustrate. Cole recommends the Catskills and the White Mountains of New Hampshire, where, he says, the lover of scenery "sees the sublime melting into the beautiful, the savage tempered by the magnificent." Bartlett painted and drew several pictures in both ranges. Among the lakes, Cole pays a quick tribute to the Great Lakes and passes on to "those smaller lakes, such as Lake George, Champlain, Winnipisiogee, Otsego, Seneca, and a hundred others, that stud like gems the bosom of this country." He expands at some length on the qualities of Lake George and Lake Winnipisiogee (Winipiseogee as Willis spelled it, Winnipisaukee as it is called today), and Bartlett pictured each of these several times. He seemed to share Cole's love for those smaller "exquisitely beautiful lakes that are so numerous in the Northern States, and particularly in New Hampshire," and chose Squawm Lake, New Hampshire, to represent them. In commenting on that scene, Willis contradicts Cole's encomium of American lake scenery. "The great defect in American Lakes, generally," Willis writes, "is the vast, unrelieved expanse of water, without islands and promontories, producing a fatigue on the eye similar to that of the sea. Squawm and Winipiseogee Lakes are exceptions to this observation." The comment, and the fact that Bartlett limited himself to these two lakes and Lake

George, indicates that both men lacked Cole's inventive and visionary ability to perceive the essence of scenes that did not conform fairly closely to established standards of the picturesque. Or perhaps it is only that Cole was more attuned to the pleasure that Joseph Addison could feel in a vast expanse of water.

Of the waterfalls that Cole mentions, Bartlett sketches all but one. Cole recommends the falls of Kaaterskill (Catterskill), Trenton, the Genesee, and Niagara, and Bartlett presents each, adding the Silver Cascade of the White Mountains and the falls of the Mohawk River. River scenery is next on Cole's list, and Bartlett agrees with Cole in picturing many scenes on the Hudson, including the Highlands and the Tappan Sea near the village of Sing Sing. Of other rivers listed by Cole, Bartlett sketched on the Connecticut, the Susquehannah and the Potomac, missing only the Ohio.

Cole's final feature of the land was its forests, which is "that which occupies the greatest space, and is not the least remarkable; being primitive, it differs widely from the European." The paintings of both Cole and Durand show a remarkable ability to por-

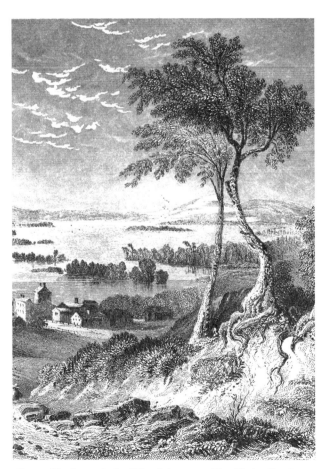

Centre Harbour, Lake Winnipisseogee (detail), by Bartlett, *American Scenery*, 1840

tray the forest directly, either as a main subject or as a massive, detailed background. In fact, the two painters are unsurpassed masters in the very difficult art of finding effective compositions in this subject, with its tangled confused masses, its huge proliferation of tiny and densely packed details, its abundance of subtly varied forms. The 'idealization' practiced by European landscape masters from Claude to Corot seldom had had to work on such an intractable subject as the American forest; European scenes were already idealized by the hand of man to a great extent, or else — as in the case of mountains — they presented clear forms and a limited number of features. For Bartlett, the overwhelming presence of the forests was a difficulty, a burden, rather than the opportunity it was to Cole and Durand. Bartlett's handling of them has in it something of the emotion of early European pioneers in North America, who termed the woodland a 'desert' and felt in it an almost unbearable weight of solitude. Bartlett avoids the forest, choosing scenes in which it does not figure or removing it to the far background. There, it can successfully become for him an impressionistic indication of the verdure that softens America's eastern mountains, a phenomenon which Cole described:

> American mountains are generally clothed to the summit by dense forests, while those of Europe are mostly bare, or merely tinted by grass or heath. It may be that the mountains of Europe are on this account more picturesque in form, and that there is a grandeur in their nakedness; but in the gorgeous garb of the American mountains there is more than an equivalent; and when the woods "have put their glory on," as an American poet has beautifully said, the purple heath and yellow furze of Europe's mountains are in comparison but as the faint secondary rainbow to the primal one.

Cole suggests the color of the forests here, and elsewhere refers directly to the autumn changing of the leaves, that great North American event which foreign visitors have ranked with the wonders of the world. Color is, of course, largely beyond the range of engraving, and is only lightly indicated in Bartlett's sketches (sometimes done in watercolors or sepia); yet he and his engravers manage to suggest the soft shadings of distant peaks and slopes shrouded in trees, and the dramatic tonal differences that exist in different types of foliage in sun or shade. Not only does Bartlett deemphasize and generalize the forest, but he is unable to see the trees clearly. Cole enthusiastically names oaks, elms, birches, beeches, planes, and pines, and even devotes a few specifically descrip-

tive phrases to the maples and "the hemlock, the sublime of trees, which rises from the gloom of the forest like a dark and ivy-mantled tower." Bartlett often places trees, singly or in groups, in the foreground or middle ground, or around the sides of his pictures. The lonely, twisted, leaning, or 'blasted' foreground tree, often with human figures under it, is a well-beloved element of picturesque art, and appears in Bartlett's pictures from every corner of Europe and the Near East. His North American trees are versions of these. Sometimes their prominence and the manner of their depiction suggest the kind of emotion Cole expresses, and they seem to be almost recognizable as belonging to one species or another. But however different from one another they may be, and however picturesque in shape and details, they are seldom if ever identifiable as any plant occurring in nature. For instance, trees are prominent in Bartlett's very effective, moody rendering of "The Tomb of Washington, Mount Vernon," but none of them can be matched with the actual trees that Willis clearly describes: "The tomb is surrounded by several large native oaks ... overhanging the tomb is a copse of red cedars ..."

Just as Bartlett and Cole had important similarities and equally important differences in details of landscape interpretation, there is a suggestive comparison to be made between Cole and Willis (presumably speaking for Bartlett) in matters of picturesque theory as it applied to the United States. First, both Cole and Willis emphasized water as perhaps the greatest scenic wealth of North America. Cole devotes much of his attention to lakes, rivers and waterfalls. He regards water as an essential element of scenic beauty, and comments on America's wealth in this regard:

> I will now speak of another component of scenery, without which every landscape is defective — it is water ... In this great element of scenery, what land is so rich?

After praising lakes and waterfalls for nine paragraphs, he turns to rivers with the remark that "The river scenery of the United States is a rich and boundless theme." The sentiments of Willis are exactly parallel. In commenting on the peculiar beauties of the United States, it is water that springs to his mind:

> In comparison with the old countries of Europe, the vegetation is so wonderfully lavish, the outlines and minor features struck with so bold a freshness, and the lakes and rivers so even in their fullness and flow, yet so vast and powerful, that (the European traveler) may well imagine it an Eden newly sprung from the ocean.

Later, he states directly that "It is in *river scenery* ... that America excels all other lands; and here the artist's labour is not, as in Europe, to embellish and idealize the reality; he finds it difficult to come up to it." Water is virtually omnipresent in Bartlett's American pictures, but this in itself is nothing surprising, since water appears prominently in many of his European pictures and is of prime importance in the whole picturesque tradition. It is the prevalence, and the original handling, of river scenes and waterfalls that show how well Bartlett could respond to a new and different land, absorbing the concepts that were forming the perception of American landscape and using them to enrich his own picturesque style.

Willis, like Cole, was concerned with the fact that America had no ruins and was relatively lacking in historic associations. Cole recognized this as a barrier to the immediate appreciation of American scenery in the terms of the European picturesque, but thought that the ultimate advantage lay with the New World: "You see no ruined tower," he wrote, "to tell of outrage — no gorgeous temple to speak of ostentation; but freedom's offspring — peace, security, and happiness, dwell there, the spirits of the scene." He pointed out, also, that "American scenes are not destitute of historical and legendary associations." Willis's opinions are similar; in his text he recounted the histories of many sites, providing literary quotations where possible, and only occasionally paused to lament that generations would have to pass before the American rocks were as thickly encrusted with quotations as the European ones.

On one important point all three men — Cole, Willis and Bartlett — seemed to have their own divergent thoughts. Bartlett in his pictures seems to find a sense of time to come, a brooding but rich emptiness suggesting a limitless human future, that compensates for the lack of a classical and legendary European past. Cole's concentration is upon the present scene, but he is aware of the future, its importance both as a fact and as an aesthetic theme. For him, however, it is ambiguous in value, if not threatening.

> The beauty of such landscapes are quickly passing away — the ravages of the axe are daily increasing — the most noble scenes are made desolate, and oftentimes with a wantonness and barbarism scarcely credible in a civilized nation. The way-side is becoming shadeless, and another generation will behold spots, now rife with beauty, desecrated by what is called improvement; which, as yet, generally destroys Nature's beauty without substituting that of Art. This is a regret rather than a complaint; such is the road society has to travel; it may lead to refinement in the end ...

Willis also looks to the future, but is a booster for 'improvement' and even locates the essential poetry of the American scene in the prospect of development:

> The picturesque views of the United States suggest a train of thought directly opposite to that of similar objects of interest in other lands. There, the soul and centre of attraction in every picture is some ruin of the *past* ... The objects and habits of reflection in both traveller and artist undergo in America a direct revolution ... His mind, as he tracks the broad rivers of his own country, is perpetually reaching forward. Instead of looking through a valley, which has presented the same aspect for hundreds of years ... he sees a valley laden down like a harvet wagon with a virgin vegetation, untrodden and luxuriant; and his first thought is of the villages that will soon sparkle on the hill-sides, the axes that will ring from the woodlands, and the mills, bridges, canals, and railroads, that will span and border the stream that now runs through sedge and wild-flowers.

The American, says Willis, does not trouble himself with the thoughts of heroic antiquity, but sits calculating what the population of villages will be in ten years, and how much land values will increase and "whether the stock of some canal or railroad that seems more visionary than Symmes's expedition to the centre of the earth, will, in consequence, be a good investment."

Bartlett, if his pictures can be read for their ideas, shares Willis's sense that the future replaces the past in the American picturesque, but not his eager belief that the rosy prospects of 'improvement' are what define the future. Bartlett's concept of the United States seems to be the high romantic one, of a new Greece or Rome rising in a virgin continent, founded upon the principles of reason and freedom. His *History of the United States* indicates an admiration for the young republic and a bias in its favor in the dispute with Britain. His pictures include many — such as buildings in Washington, D.C., the city of Boston, Yale College, monuments in Baltimore, Philadelphia's Schuylkill Waterworks and United States Bank, the tombs of Washington and Kosciusko, the Catholic Chapel of Our Lady of Coldsprings (on the Hudson) — that clearly represent America in the image of picturesque classical Rome and Greece. But it is a young, rising classicism, in which all the buildings are new, fresh and unspoiled, beautifully

27

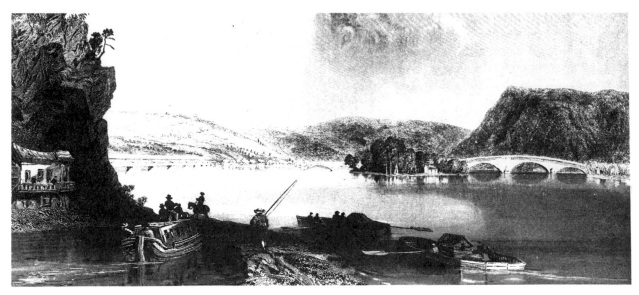

Northumberland, on the Susquehanna (detail), by Bartlett,
American Scenery, 1840

framed in lush vegetation rather than consumed by it.

As compared with Cole, Bartlett places great emphasis upon buildings, monuments, villages, rural structures and characteristic occupations of the people. This is part of his picturesque vision of the American scene, but he is refreshingly free of the condescending and even immoral exploitation of suffering or impoverished humanity for aesthetic effects that can be found in Rosa and other picturesque artists; this questionable quality of the picturesque was pointed out by Bartlett's near contemporary John Ruskin. Bartlett is genuinely and attentively interested in the doings of the people before him. He treats them repectfully. At the same time, his understanding of them is clearly influenced by the picturesque landscape tradition and its philosophical-religious underpinnings. He sees human dwellings, settlements and occupations as things belittled by the looming vastness of nature, on which they depend. Villages, mills, bridges, canals, boats, trains — for all of which Bartlett has a lively eye — are often seen clinging precariously to cliffs, dangling above precipitous gorges, or virtually burying themselves in the vast recesses of river, hill, forest and sky. If his classicizing and idealistic depiction of Yale College or the Schuylkill Waterworks shows nature harmoniously seconding man's efforts, the overall impression given by his work is of a small nation planted in an environment vastly more powerful and impressive than itself. Usually even the cities and great buildings seem to be small, fragile things fostered by nature for their virtue and their youthful beauty. If any of the pictures of this neoclassical America might encourage the viewer to dream of human power, there are many reminders of the insignificance within nature of the individuals who make up the nation: the tiny hut and nearly invisible woodsmen in "A Forest on Lake Ontario," the lonely bargemen passing beneath bettling cliffs in "A View on the Erie Canal near Little Falls," the goatherd and the rider overshadowed by "Pulpit Rock, White Mountains," the rickety spectacle of Rochester, New York, perched on the edge of "Genesee Falls," and many more.

Bartlett's poetic sense was attuned to a picturesque concept of nature, man and history in which technology and development were not important factors. Ancient buildings had become ruins not because their culture had violated the environment but because of moral failure and the inevitable cycle of human glory and decline, a gloomy spectacle in which the picturesque soul delighted. Thus, Bartlett is relatively free of the prophetic sense of man's growing technological power which worried Cole and delighted Willis. In Bartlett, the future is a vast expanse in which the picturesque cycle of human life and death in the bosom of the vast, mysterious, encompassing wilderness will continue until the distant end of time. And for him, the United States is blessed because its origins in truth and freedom make it a young Greece with the potential of limitless peace, abundance and harmony with nature.

The Rise of American Wood Engraving

The enterprise of Bartlett's publisher, George Virtue, guaranteed that Bartlett's books — not only *American Scenery* but others about Europe and Palestine — sold thousands of copies throughout North America, Britain and continental Europe. He was one of the most popular artists of his time, and today he is known to people who have scarcely heard of contemporary landscapists whom art historians generally rate higher, such as Samuel Prout and J. S. Cotman.

The whole genre of deluxe travel books illustrated with engravings, to which Bartlett contributed so much, was widely appreciated in the United States, but remained for the most part a British product. It was not until the new technique of wood engraving had appeared, and had developed in the United States until it rivaled the best metal engraving, that publishers in New York and Boston were able to produce illustrated books equal to the best Europe had produced. Prior to the 1820s and 1830s, American book publishers ventured few expensively printed and illustrated books. Many factors prevented the development of art publishing in the United States: the pioneer mentality of the country, the still relatively small population, the availability and prestige of European books, the relative scarcity of talent in the areas of drawing, engraving and printing, the fact that printing technology was not as advanced as in England and the printing process was more expensive here. As mid-century approached, these conditions began to vanish. The United States became a more populous, more sophisticated, more technically advanced and prosperous nation. By 1840, the ground had been prepared for the high quality publishing which appeared in the succeeding decades.

The most important single factor in the rise of nineteenth-century American art publishing was the development of wood engraving, both as an art and as a method for the printed reproduction of pictures. Before the early nineteenth century, engraved illustrations had been reproduced from metal plates. In the United States, no tradition of copper-engraved illustration of significance by European standards ever emerged. Steel engraving, however, was brought to a high level of excellence. In fact, S. G. W. Benjamin wrote in his 1872 book *Art in America* that the three arts in which the United States had distinguished itself were landscape painting, portraiture and steel engraving. Benjamin also paid tribute to the great advances that wood engravers had recently made. Ultimately, it was wood engraving — which had been invented and had come to dominate illustration just when modern American publishing was beginning — that accounts for the largest, finest and most distinctive body of nineteenth-century illustration in the United States.

Prior to 1800, America had its native copper engravers and woodcut artists who produced the generally crude illustrations of the era. The best work of the engravers was devoted to popular prints: pictures of news events, buildings and cities, political cartoons, portraits, reproductions of topical paintings, and similar images, which were printed on single sheets. American illustration began about 1670 with a woodcut portrait of the Rev. Richard Mather, probably produced by the first engraver in the American colonies, John Foster (1648-81). In the succeeding years, woodcut seals and decorations appeared on pamphlets, broadsides and government proclamations, and in 1708 the first American newspaper illustration appeared in the *Boston News-Letter*. America produced several good copper engravers during the late colonial period and the decades after the Revolution. The most famous of these is, of course, Paul Revere (1735-1818), whose engraving of the Boston Massacre is one of the country's best known prints. Prints and broadsides, along with business cards, labels, sheet music and the like, accounted for most of the copper engravers' work, although they also did cuts for magazines and books. However, the expense and technical difficulties of printing from copper plates prevented the production of true illustrated periodicals and books. Most would display as illustration only a trademark seal,

Vignette after Thomas Bewick, by Alexander Anderson, *American Art Review*, 1880

29

one or two crude pictures, or a frontispiece, like the one in William Hill Brown's *The Power of Sympathy* (Boston, 1789), the first novel published in America.

Around the turn of the nineteenth century, American engraving and illustration were experiencing a modest growth, spurred by the development of domestic steel engraving and the introduction of other print-making processes, such as mezzotint. Steel-engraved pictures, especially fashion plates, were the staple of such magazines as *Godey's Lady's Book* (published in Philadelphia beginning in 1830) and *Graham's Magazine* (published in Philadelphia beginning in 1840, famous for printing Poe, Cooper, Bryant and other important American writers), as well as some predecessors that appeared briefly in the first three decades of the century. In addition to magazine publishing, American steel engraving flourished in the fields of art prints, the elaborate keepsakes and annuals that were popular at the time, commercial applications such as the making of bank notes, and the illustration of volumes of explorations. Thomas Cole's sequence of allegorical paintings, *The Voyage of Life*, was completed in 1839 and became his most popular work, largely through the superb steel-engraved prints of James Smillie, one of the best steel engravers on either side of the Atlantic. Steel-engraved landscape illustration occurred primarily in the few outstanding books of exploration and ethnology that the United States produced prior to the Civil War, and later in *Picturesque America*'s forty-nine plates. Among the books of exploration, two are especially noteworthy. Schoolcraft's monumental report on the Indians of the United States contained engravings after several artists, principally Seth Eastman. The engravers included James Smillie, his son James D. Smillie, who later became a painter and designed for both steel and wood engraving in *Picturesque America*, and Robert Hinshelwood, whose career of well over thirty years extended to steel engraving for *Picturesque America* and wood engraving ten years later for *Picturesque Canada* (1882-84). Equally interesting from the standpoint of steel engraving is Charles Wilkes' *Narrative of the United States Exploring Expedition During the Years 1838, 1839, 1840, 1841, 1842* (New York, 1844), a five-volume work with steel-engraved plates and wood-engraved text illustrations after the drawings of A. T. Agate and J. Drayton. Wilkes' sprawling epic of an expedition covered much of the Atlantic and Pacific oceans and is famous for, among other things, the discovery of Antarctica and the mapping of the Fiji Islands. The American government had been spurred to authorize it by public interest in the theories of John Cleves Symmes, a War of 1812 veteran who believed that the earth was hollow and that openings at the poles would reveal fertile new areas for territorial expansion inside: this was the Symmes to whom Willis had referred jokingly in his preface to *American Scenery*. In the Pacific the Wilkes expedition touched Hawaii and the Oregon Territory. In Hawaii especially the expedition's artists made excellent pictures which, translated into steel engravings, added a fresh dimension to the picturesque image of the Islands that Webber had begun to create a half century earlier.

While American illustration was pursuing these directions, England was producing the artistic and technical methods which allowed large popular editions of pictorial publications, and made the mid-nineteenth-century publishing industry a fountainhead of abundant and exuberant illustrative art. The first of these breakthroughs was the creation of what is now termed wood engraving, by the English artist and engraver Thomas Bewick (1753-1828) near the end of the eighteenth century. Trained as a metal engraver, Bewick wished to print copies of his own drawings and experimented with engraving on a less expensive material, wood. He needed a wood that would accept the delicate lines and cross-hatchings made by his metal-engraver's tool, the fine-pointed burin. Blocks from the boxwood tree, cut across the grain rather than with the grain as for woodcuts, proved ideal. Bewick worked on his 'endgrain' boxwood block to prepare a relief image, one printed by inking its raised surface. In this way his technique was similar to woodcut. But he approached the patterning of his image as a metal engraver would, drawing the lines with his burin. When ink was

Vignette, by Thomas Bewick,
British Birds, 1797

The Great Plover, by Bewick,
British Birds, 1797

applied to the block's surface, the incised line would remain ink-free. Thus Bewick developed his famous 'white line' technique: when printed, the positive outlines and contours of an image appeared as white lines and areas, whereas the negative or blank portions, which are generally left white in drawings, were black because they were printed from the inked surface of the block. Bewick and later practitioners of wood engraving were also able to create black line images as in a woodcut but with the fineness of a metal engraving, and even to combine both black and white line techniques in the same image.

All modern wood engraving descended from Bewick, although the term was used in his day to cover a variety of crafts. A 1796 advertisement placed in the *Pennsylvania Gazette* by an "engraver in wood, stone and ivory" probably did not refer to printed pictures at all, but rather to decorative images carved into implements, furniture and tableware. In England, Bewick popularized his new art both by training apprentices who carried it to London from the master's shop in Newcastle, and by publishing books lavishly illustrated with his own engravings, which have never been surpassed. The most popular of his books, *British Birds*, was first published in 1797. The boxwood is a tree of small diameter, and Bewick kept his images to a size that could be printed from a single block, though later engravers developed methods of bolting together many blocks (or using inferior woods from larger trees) to provide a larger surface.

Bewick's detailed and delicate images could not have been printed without the new grades of smooth paper developed in the late eighteenth century. The wide popularity that wood engraving achieved during the nineteenth century depended both on the potential of Bewick's technique and on other, more far-reaching developments in printing technology. These include machines for making paper and new presses constructed of iron, rather than wood, and powered by steam rather than by hand. It was soon noticed that wood engraving was ideal for use with the new printing technology: it was a relief process, like letterpress, so that pictures could be printed with text, and boxwood was so extremely hard and durable that it could stand up in the press to editions as large as 100,000. Later in the century, such inventions as the 'electrotype,' a metal copy made of a woodblock by electrolysis, allowed an unlimited number of duplicate plates to be taken from each wood engraving.

Increasing industrial prosperity and more widespread public education had created a larger literate class. It was the world's first mass audience, and its hunger for reading materials, combined with possibilities of the new printing technology, gave rise to the popular press. Illustration, most of it wood-engraved, was a prominent feature of this press from its beginnings, usually dated at 1832, the year of the first publication in London of the *Penny Magazine* and *Saturday Magazine*. Within one year the *Penny Magazine* had achieved a circulation of 200,000; its steam presses could print 16,000 sheets on both sides in eight hours, as opposed to the 1,000 copies that early hand presses had been able to produce in a day. The popular satirical magazine *Punch* was inaugurated in 1841, followed in 1842 by the *Illustrated London News*, which published an average of 15,000 pictures each year.

None of these developments occurred quite as early in the United States as in England. Wood engraving was developed here semi-independently by a remarkable man, the New Yorker Alexander Anderson (1775-1870). Trained as a doctor, he was a hobbyist in engraving on copper and type metal from his youth, and by the age of 18 was the finest engraver in the country, employed by all of the printers and publishers then operating in New York, as well as others in Philadelphia, New Jersey and as far away as Charleston. Word of Bewick's discoveries reached him, and the descriptions of them were enough to enable him to follow Bewick's path, using a metal engraver's burin and techniques on the endgrain of boxwood. In 1794 he produced an American copy of the pictures in Bewick's book *The Looking Glass of*

Vignette, by Anderson,
The Calendar of Nature, 1815

the Mind. After the 1798 New York yellow fever epidemic, in which Anderson lost his infant son, wife, father, mother, brother, mother-in-law and sister-in-law, he turned away from medicine and devoted the rest of his long life to the art he loved, also becoming a something of a poet, author, musician, artist and naturalist. He engraved numerous pictures for early nineteenth-century American books and magazines, and many prints in addition. Most of his work was routine, due to a publishing climate that did not appreciate and would not pay for fine craftsmanship, but his best engravings are excellent examples in the tradition of Bewick. Among the American books Anderson engraved (some on type metal, some on wood) prior to 1843 were *Emblems of Mortality*, a version of Holbein's *Dance of Death* in which he copied wood engravings after Holbein by John Bewick, and a treatise on picturesque landscaping, Andrew J. Downing's *Landscape Gardening.*

Anderson trained several pupils, who in turn trained one or two others; but until the 1840s, these few men, along with some English immigrants, were the only wood engravers to be found in the United States. Anderson's pupils included Garrett Lansing, John H. Hall and J. A. Adams. In the late 1830s Hall executed fine illustrations for Thomas Nuttal's *Manual of Ornithology of the United States and Canada*, published in Boston. However, the age of American wood engraving was really opened by Adams in the latter half of the 1840s. His accomplishment, which signaled the great potential wood engraving held for the country's growing publishing industry, was the printing and illustration of a famous Bible, *The Illustrated Bible, Containing the Old and New Testaments* (Harper and Brothers, New York, 1846). Joseph Alexander Adams (1803-80) had been an apprentice printer who was pressed into engraving by his employer and became interested. He sought out Anderson and received some instruction from him,

and then in 1831 journeyed to England, possibly with letters of introduction to leading British wood engravers from Abraham Mason, an English wood engraver who came to the United States in 1829. Throughout the 1830s Adams, like other American wood engravers, was employed making occasional illustrations and prints, as well as standardized cuts used in advertisements, broadsides, and almanacs. Some of his illustrations were equal to the best wood engraving that has ever been done, and probably earned him the reputation that caused Harper and Brothers to seek him out when the firm decided to produce an illustrated Bible.

The Bible was "embellished with sixteen hundred historical engravings by J. A. Adams, more than fourteen hundred of which are from original designs by J. G. Chapman." Actually Adams and Chapman (1809-90), one of America's important early artists and illustrators, served as art directors. Besides using about 200 English cuts and half-page landscape vignettes, Chapman left the drawing of many of the numerous small landscapes in the book to his pupils. Similarly, Adams designed the frontispiece to the two testaments, the headings of *Genesis* and *Matthew*, and most of the book's ornamental borders, but employed and directed many engravers in the preparation of the other pictures. In his complete set of proofs of the illustrations, Chapman wrote the engraver for each one, and the list contains names that become familiar to anyone examining the wood engraving that issued from New York and Boston in the succeeding four decades: Roberts, Benjamin F. Childs, Minot, William Howland, Gordon, Butler, Morse, Nathaniel Orr, John J. Hall, Hart, Henry Kinnersley, Augustus Kinnersley, Peckham, E. Bookout, Holland, Weeks. Few of the Harper Bible's illustrations are distinguished for their origi-

Chapter heading for Matthew (detail), by Joseph
A. Adams, *The Illuminated Bible*, 1846

nality, but they are attractive, very finely engraved, and well integrated with the text. In addition, the craftsmanship of its printing, also owing to Adams, was such that it constituted a revolution in this respect in the United States. Adams was not only an artist and an engraver, but also an innovative printer. He was the first American electrotyper, and invented several improvements in that process. He also developed the first method whereby engravers could transfer a print to a woodblock and save the original drawing, rather than attaching the drawing to the block and cutting through it, or having the artist make a copy of his picture on the block, as had been done previously. *The Illuminated Bible*, the first attempt to produce a fully illustrated American book, was successful on all accounts, and for years to come set the standard for printing, engraving and illustration.

The Illuminated Bible was a sudden and immense step forward in wood-engraved illustration for books, but during the 1830s and 1840s the art was making steady if less dramatic strides in the periodical press. *The Family Magazine* was begun on April 1, 1833 in New York and survived through 1840; all its illustrations were wood engravings. In 1834, Abel Brown, who had pioneered wood engraving in Boston a few years after Anderson in New York, formed the American Engraving and Printing Company, later called the Boston Bewick Company, and in 1836 brought out two numbers of a wood-engraved periodical, the *American Magazine*, modeled after England's *Penny Magazine*. At this time, there were already two American editions of the *Penny Magazine* itself, one printed in New York from imported British plates and one printed in Boston with the illustrations re-engraved there. These works were crude, as were the early newspaper engravings that began to appear in 1828 or earlier in the New York *Mirror* and in the 1830s in the New York *Herald*, where James Gordon Bennett pioneered the use of illustrations to depict news events, as he did most important aspects of the modern news press. In the 1850s, shortly after the success of *Harper's New Monthly Magazine* (begun in 1850), wood engraving became a feature of newspapers, and special illustrated newspapers sprang up. Among the earliest illustrated papers were several efforts by the engraver and publisher T. W. Strong, most notably the *Illustrated American News*, which appeared for ten months in 1851-52 and was the first true illustrated newspaper in the country, and *Yankee Notions*, which survived from 1852 to 1867 and is the paper

which the young Thomas Alva Edison sold when a newsboy. Also important was *Frank Leslie's Illustrated Newspaper* (begun in 1855), along with several other wood-engraved publications of the English-born publisher and engraver "Frank Leslie," whose real name was Robert Carter.

The heart of the wood-engraved illustration phenomenon, however, lay in magazines and elaborate gift books, which were produced for the most part by a small group of publishers. Many of these had been founded in the early decades of the century; they include many names still prominent in American publishing: Harper, Putnam, Scribner and Appleton. When the possibilities of wood engraving began to be appreciated, these houses were already publishing the elegant steel-engraved annuals and keepsakes that had grown dear to American tastes in the 1830s and 1840s. Harper and Putnam (the publisher of Wilkes' *Narrative*), in particular, were quick to understand and exploit the potential of the technique. In June 1850, Harper inaugurated *Harper's New Monthly Magazine*, which was not at first profusely illustrated, but which was the antecedent of *Harper's Weekly Journal of Civilization*. *Harper's Weekly*, which first appeared on January 3, 1857, was the *Life* and *Time* magazines of its era rolled into one, and in addition it tried, often successfully, to live up to the cultural and artistic aspirations that were such an essential part of the Victorian popular press. The magazine's first volume included wood engravings of designs by Winslow Homer and J. W. Hennessey, who, like many other artists of the time, learned their craft in the illustrated periodicals. Boston, which had vied with New York for supremacy in the field of wood engraving ever since Abel Bowen had begun work in 1805, challenged such periodicals as *Harper's* and the Leslie papers with Gleason's pictorial publications, later Ballou's. The most famous of these was *Ballou's Pictorial Drawing Room Companion*. Homer, a Bostonian, had his first studio as a freelance artist in the Ballou building, and his earliest engravings appeared in *Ballou's Pictorial* in 1857 some months before his work for *Harper's Weekly*; he did not move to New York until 1859.

From these beginnings a nineteenth-century American magazine industry grew which was as varied as that of our own century and which depended upon wood engraving for its illustrations until the 1880s, when usable methods for the printed reproduction of photographs began to be introduced. Among the magazines most notable for the quality of their art were the following, given with their city and

A Composition, by Frederick E. Church,
Art in America, 1872

first year publication: *Every Saturday* (Boston, 1870), *Our Young Folks,* (Boston, 1865), *Riverside Magazine* (Boston, 1867), *Scribner's Magazine* (New York, 1871), Scribner's magazine for children, *St. Nicholas* (New York, 1873), *The Aldine, the Art Journal of America* (New York, converted in 1874 from an illustrated advertising paper to a high-quality art magazine), *Appleton's Art Journal* (New York, 1875) and the *American Art Review* (Boston, 1879). The magazines of the time were diverse in their quality, their special areas of interest, and the size and social levels of their audiences, but all of those listed above, and many others, had an interest in publishing art by Amercian and international masters, and in producing original illustration of artistic quality. The publishers' pride in this aspect of their endeavors is witnessed by the publication of lavish books in which the finest engravings of the magazines were collected. These included *Art in America* (1872) by S. G. W. Benjamin and *Contemporary Art in Europe* (1877), the best of *Harper's Monthly; Portfolio of Proofs* (1879), the best of *Scribner's* and *St. Nicholas;* and two books of outstanding work from *Appleton's Art Journal, Landscape in American Poetry* (1879) and *American Painters* (1878; expanded 1881) by George Sheldon.

The 1881 *American Painters* contained 104 engravings of work by sixty-eight artists, including many of the important figures of nineteenth-century American art: Frederick E. Church, Sanford R. Gifford, Winslow Homer, George Inness, Worthington Whittredge, Thomas Moran, Asher Brown Durand, Albert Bierstadt, Louis C. Tiffany and Elihu Vedder. Many of the other artists included were prominent in their own time and produced much memorable work in both painting and illustrations: M. F. H. de Haas, James M. Hart, William Hart, R. Swain Gifford, Francis Hopkinson Smith, J. W. Casilear, Albert F. Bellows, James D. Smillie, George H. Smillie, and several others. In *American Painters*, the predominant genre was picturesque landscape, especially pictures of the United States. Typical works indicate the aesthetic inclinations of the magazines and their artists: "Sunset in the Adirondacks" by Sanford Gifford, "A Tropical Moonlight" by Frederick Church, "The Path by the River" by William Hart, "Brook, and Vista in the Mountains" by Asher Durand, "Mount Corcoran, Sierra Nevada" by Albert Bierstadt, and "The Temple of Peace" by George Loring Brown. Homer and a very few others are represented by portraits, genre pictures (scenes from daily life) or historical subjects, rather than by picturesque American or foreign scenery.

Besides the magazines, sumptuous gift books were the main vehicle of high quality wood-engraved illustration. After Harper's Bible, the first notable

examples of this tradition are the editions of Washington Irving's works produced by Putnam beginning in 1848. The earliest of these (including notably *The Sketch Book,* 1848, *The Alhambra,* 1851, and *A History of New York,* 1854) were illustrated by Felix Octavius Carr Darley (1822-88), one of the finest illustrators the United States has produced. Darley did his first important work for the wood-engraving medium in these books; in them and other works, the confident Americanism of his style contributed to the growth of a native artistic tradition, as did the work of magazine illustrators and the important painters who contributed their art as designs for wood engravings. The phenomenon of the wood-engraved *edition de luxe* had scarcely begun before many distinguished artists, already publishing in the steel-engraved drawing-room keepsakes, were publishing their paintings and designs in gift books. Anne C. Lynch, the poet and friend of writers and painters, published her *Poems* in 1849, a richly illustrated volume including work by Durand and other noted artists. Scribner's published J. W. Palmer's *Folk Songs* in 1861 with illustrations by Charles Parsons. Thomas Nast, Darley, J. W. Hennessey, John Frederick Kensett, G. H. Smillie, Augustus Hoppin, and others. In 1864, Putnam brought out its "artists' edition" of *The Sketch Book,* with illustrations after not only Darley but Samuel Colman, Albert Bellows, J. W. Casilear, Charles Parsons, and many other artists.

The histories of the artists who designed for the magazines and gift books show how intimately related were the wood-engraved illustration industry, the American painting community of the day, and the widespread love among both artists and public for picturesque art. For instance, one of the prominent illustrators of the day was Casimir Griswold (1834-1918), who had been a wood engraver in Cincinnati before coming to New York in 1850 to launch a painting career notable primarily for landscapes and coast scenes. As has been mentioned, Asher Durand began life as an engraver, and became acquainted with Doughty and Cole in this capacity. He took up landscape painting in the mid-1830s, and his career as engraver influenced the detailed intimacy of his style. He was a teacher of several engraver-painters who became associated the the Hudson River School, for instance, John W. Casilear (1836-1910). Homer, although not an engraver, spent the first half of his career primarily as a designer of wood-engraved illustrations. George and James D. Smillie became noted painters of landscapes, and

Untitled illustration, by Durand,
Lynch's *Poems,* 1849

James especially was known for western mountain scenery. Both had begun as engravers, and were sons of one of the finest steel engravers of his time, the Canadian James Smillie, who had immigrated to New York in 1829. George Loring Brown, a painter included in *American Painters*, was one of the first engraving pupils of the early wood engraver Abel Bowen of Boston. Similar connections between wood engraving and American painting at the time are numerous and intricate, and insured that illustrated books and magazines received the best efforts of excellent artists who understood and respected the medium for which they were designing.

Picturesque America

Picturesque America was an unsurpassed product of the maturity of American wood engraving, and was a high point of American steel engraving as well. In 1,144 royal quarto pages it contained forty-nine steel-engraved plates and hundreds of wood-engraved full-page pictures and smaller text illustrations. It is virtually devoid of genre subjects, shows relatively little interest in the depiction of workplaces and modes of transportation, and has no portraits or news pictures. But in its chosen field, landscape illustration, it was supreme.

The book was the product of D. Appleton and Company, Publishers, then located at 549 and 551 Broadway, New York. It was intended from the first that art would constitute *Picturesque America*'s major appeal, but the publisher took care to make the literary department as attractive as possible. William Cullen Bryant, the romantic nature poet who had been a friend of Thomas Cole and a patron of American artists, was chosen as titular editor. Born in 1794, Bryant was 78 in 1872, the year of *Picturesque America*'s copyright. He was a logical choice to lend stature to this ambitious project, for he had long argued the cause of what was specifically American in painting and literature, although his own work is now seen to be more derivative of European models than that of many of his contemporaries. Nonetheless, he had helped to enrich Americans' feeling for their land with such poems as "To a Waterfowl," "Thanatopsis" and "The Prairies." Bryant contributed his blessing, his name, and a preface, at the end of which he explained:

> The letter-press has passed under my revision, but to the zeal and diligence of Mr. Oliver B. Bunce, who has made the getting up of this work a labor of love, the credit in obtaining the descriptions from different quarters is due. To his well-instructed taste also the public will owe what constitutes the principal value of the work, the selection of subjects, the employment of skillful artists, and the general arrangement of the contents.

O. B. Bunce, then was not only the working editor but the overall art director of the project.

Bunce had a formidable task of organization to bring this mammoth undertaking together. In order to produce the sixty-five wood-engraved chapters, averaging more than ten illustrations each, and the forty-nine steel engravings, he employed twenty-two artists, over forty engravers or engraving firms, and thirty-one writers. He himself contributed the chapters "On the Coast of Maine," "Lookout Mountain and the Tennessee," "Mauch Chunk," "Neversink Highlands," "Charleston and Its Suburbs," "Scenes on the Brandywine," "Watkins Glen," "Scenes in Eastern Long Island," "Our Great National Park (Yellowstone)," "Lake George and Lake Champlain," "Chicago and Milwaukee" and "New York and Brooklyn." Bunce and the other writers are not remembered now, but his staff of artists is a gallery of nineteenth-century notables, and his engravers include many of the best men ever to practice the craft. The artists who designed for both

wood and steel engravings were Harry Fenn, Granville Perkins, James D. Woodward, Alfred R. Waud, Thomas Moran, James D. Smillie, W. L. Sheppard, R. Swain Gifford, Casimir Griswold and William Hart. Those who designed for steel only include A. C. Warren, David Johnson, F. O. C. Darley, J. W. Casilear, Albert F. Bellows, John Frederick Kensett, Worthington Whittredge, C. Rosenberg, Homer Martin, and A. S. Hazeltine. The work of Jules Tavernier and W. H. Gibson appeared in wood engraving only.

Picturesque America, like *American Scenery* before it, was first published as a periodical. Its monthly numbers began in 1872 and continued through 1874, necessitating a complex schedule of travel and production. The writers and artists often had to make extensive journeys, sometimes into regions that were still little explored, and then the results of their work had to be prepared for the press and printed. The monthly periodical numbers each contained a standard number of pages, which was not coordinated with chapter length, so that one number could contain parts of two or more chapters and could begin or end in the middle of a chapter. Subscribers to the periodical issue of the publication could frame individual pictures or save the numbers and have them privately bound. When publication was complete, the book was issued in a magnificent and ponderous two volume, royal octavo format with embossed leather covers, under the full title, *Picturesque America: or, The Land We Live In. A Delineation by Pen and Pencil of the Mountains, Rivers, Lakes, Forests, Water-falls, Shores, Cañons, Valleys, Cities, and Other Picturesque Features of Our Country. With Illustrations on Steel and Wood, by Eminent American Artists.*

The "general arrangement of the contents," which Bryant ascribes to Bunce, must have been largely determined by the order in which the chapters could be completed. In both volumes there is an attempt to intersperse sufficient sections on the western, central and northern parts of the country with the somewhat fuller material on the northeast and Dixie. Among many chapters devoted to the eastern seaboard from Maine to Florida and the Middle Atlantic States are sections entitled "Up and Down the Columbia," "The Lower Mississippi," "Mackinac," "Our Great National Park," "Lake Superior," "Northern California," "The Yosemite Falls" and "On the Coast of California." The second volume is also eastern in emphasis, but contains among its

thirty-one chapters "On the Ohio," "The Plains and the Sierras," "The Upper Mississippi," "The Rocky Mountains," "The Cañons of the Colorado," "Chicago and Milwaukee," "A Glance at the Northwest," "The Mammoth Cave," and a foray into Canada, "St. Lawrence and the Saguenay." All of these chapters, as well as those from the deep south, represent areas that Bartlett did not visit. The sites selected in New England, New York, Pennsylvania, Virginia and West Virginia show that *Picturesque America* covered this area more thoroughly than Bartlett had. Bryant, in his preface, stated that the goal of *Picturesque America* was "to present full descriptions and elaborate pictorial delineations of the scenery characteristic of all the different parts of our country," and commented:

> It is quite safe to assert that a book of American scenery ... will lay before American readers more scenes entirely new to them than a similar book on Europe. Paintings, engravings, and photographs, have made us all, even those who have never seen them, well acquainted with the banks of the Hudson, with Niagara, and with the wonderful valley of the Yosemite; but there are innumerable places which lie out of the usual path of our artists and tourists; and many strange, picturesque, and charming scenes, sought out in these secluded spots, will, for the first time, become familiar to the general public through these pages. It is the purpose of the work to illustrate with greater fullness, and with superior excellence, so far as art is concerned, the places which attract curiosity by their interesting associations, and, at the same time, to challenge the admiration of the public for many of the glorious scenes which lie in the by-ways of travel.

The chapters varied greatly in length and in the extent of territory they covered, some surveying an entire state or mountain range or river basin, while others confined themselves to a single locale, such as "St. Augustine, Florida" or "Water-falls at Cayuga Lake."

Picturesque America reflected changes and developments in picturesque taste and Americans' awareness of their country that had occurred since Willis and Bartlett had made their 1836 tour. Many new beauty spots had become popular in the northeast, and appreciation of the scenic southeast, earlier confined to Virginia in English and northern taste, had greatly broadened. Areas that had been frontier, such as Ohio and the Chicago to Milwaukee region, had become vital parts of the country, not only for agriculture and stock-raising but also for their growing cities and industries. *Picturesque America* also

Barnett's Stair, in Winter, by Harry Fenn, *Picturesque America*, 1872

encompassed the new sceneries of the west, as different from eastern landscape as eastern America had been from European scenes. The opening of the west had been followed with avid interest in illustrated publications since 1812, when crude and inaccurate woodcuts had decorated Peter Gass's *Journal of Explorations*, the first published account of the Lewis and Clark expedition. Although Bryant could write in his Preface of 1874 that the valley of the Yosemite was already familiar to American readers, he was also aware of other areas still being explored. Some of these were newly accessible to travelers, but would as yet have been seen by very few persons:

> By means of the overland communications lately opened between the Atlantic coast and that of the Pacific, we have now easy access to scenery of a most remarkable character ... A rapid journey by railway ... brings the tourist into the region of the Rocky Mountains rivalling Switzerland in its scenery of rock piled on rock, up to the region of the clouds. But Switzerland has no such groves on its mountain-sides, nor has even Libanus, with its ancient cedars, as those which raise the astonishment of the visitor to the Western region ...

Just as his friend Cole had done in the east, Bryant saw the forests and wooded mountains of the west as an essential American scenic element.

Picturesque America has links to the tradition of illustrated narratives of exploration that are just as interesting as its more evident connection to the popular picturesque travel and art books of the century. The best instance of this is in the chapters on the southwest and Rocky Mountains. Of the Rockies, Bryant commented that for landscape-lovers "who would see Nature in her grandest forms of snow-clad mountain, deep valley, rocky pinnacle, precipice, and chasm, there is no longer any occasion to cross the ocean," and then went on to bestow special attention on one of the west's distinctive formations:

> Another feature of that region is so remarkable as to have enriched our language with a new word; and cañon, as the Spaniards write it, or canyon, as it is often spelled by our people, signifies one of those chasms between perpendicular walls of rock — chasms of fearful depth and of length like that of a river, reporting of some mightly convulsion of Nature in ages that have left no record save in these displacements of the crust of our globe.

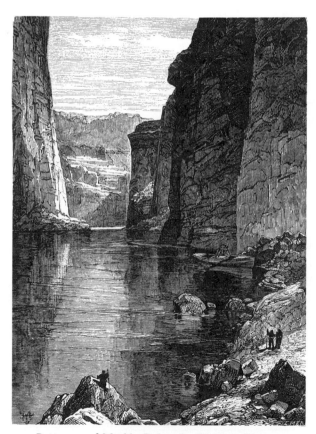

Buttresses of Marble Cañon, by Thomas Moran, *Picturesque America*, 1872

Thomas Moran made pictures, some published in *Picturesque America*, of such areas as they were opened up by U.S. Geological Survey explorations then in progress, those of Dr. Ferdinand Vandiver Hayden in Idaho, Nevada, Colorado and Utah and of Major John Wesley Powell down the Colorado. From the time that Seth Eastman's pictures had been steel-engraved and published in Henry Schoolcraft's monumental 1851-57 report on the Indians of the United States, the engravers and illustrators of America's publishing industry had been involved in the reporting of western exploration. Some of the wood engravers of Eastman's pictures worked also in *Picturesque America*. Robert Hinshelwood, who engraved Eastman, was the principal steel engraver of the later book; another of Eastman's engravers was James D. Smillie (1833-1906), who had turned his attention to painting by 1872, contributing designs for the steel engravings of Mount Shasta and the Golden Gate, and for the wood engravings in the chapters "St. Lawrence and the Saguenay" and "The Yosemite Falls," the latter of which he also wrote.

Moran (1837-1926) illustrates the connection between American painting, popular illustration and western exploration as well as any other artist. In some respects, his career parallels that of Thomas Cole half a century earlier. Although he is not as significant or original an artist as Cole, he exhibits much the same mixture of familiarity with the European picturesque tradition and concern to adapt it to the new vistas of the United States. Moran was born in England in 1837 and, like Cole, was brought to the United States by his family when he was a young child. At eighteen he was apprenticed to a wood engraver in Philadelphia, the city to which Cole had come from Ohio to study painting. Like Cole, he was at first a self-taught painter, but in 1862 was able to study in England, and in 1866 to tour England, Italy and France, where he met Corot, who influenced him deeply. In 1871, Moran accompanied Hayden's U.S. Geological Survey expedition to the Yellowstone River. Sketches from this trip were the basis of his painting "Grand Cañon of the Yellowstone," which immediately won him attention. By the mid-1870s he was already widely known as an interpreter of landscape, especially western scenery, which he sketched and then worked up in the studio on epic canvasses. From the 1890s until his death, he was recognized as the dean of American painting and is still remembered along with Albert Bierstadt as the best of the nineteenth-century "Rocky Mountain" painters.

Moran's painting can be criticized for containing overly idealized elements, especially of light and mist, and in general for distorting American realities in the direction of the European picturesque. But it is generally forgotten that Moran was one of the most productive illustrators of his time, and that his illustration work is superior in many respects to his painting. It is fresher, more directly taken from the scene itself, less subject to studio re-thinking, and yet retains the stamp of Moran's strong, picturesque interpretive sense. During the period of his greatest activity as an illustrator, 1853-83, Moran is estimated to have produced 1,500 designs, at least two-thirds of them for wood engraving. He contributed to the finest of the wood-engraved publications, especially *Scribner's;* just before *Picturesque America* began to appear, *Scribner's* printed in impressive set of Moran's illustrations in an article, "Big Trees in Yosemite," in the January 1872 issue. Though Moran specialized in Western subjects, he was versatile. The finest of the elegant landscapes that decorated the era's parlor-table editions of popular writers such as Longfellow and Hawthorne came from the pens of Moran and of Harry Fenn (1845-1911), another English-born American artist, who was a founder of the Society of Illustrators and who drew more of *Picturesque America*'s scenes than any other artist.

By mid-1872, Oliver Bunce had already had Moran's drawing of the Upper Yellowstone Falls engraved on steel. He then commissioned the artist to draw scenes along the Union and Central Pacific Railroads. Moran left on August 24, 1872 for his trip west, and could not accept an invitation from his friend Dr. Ferdinand Hayden to accompany a part of the U.S. Geological Survey exploration that was to be described in Hayden's *The Yellowstone National Park and Mountain Regions of Portions of Idaho, Nevada, Colorado, and Utah* (Boston, 1876). Moran was later commissioned by Bunce to illustrate W. H. Rideing's chapter on the Rocky Mountains. Rideing had accompanied Hayden, but Moran had to make his drawings from photographs taken by William H. Jackson, the expedition photographer. One such picture was of the Mountain of the Holy Cross in the Sawatch Range, about 100 miles west of Denver. Jackson's photograph so intrigued Moran that he journeyed to the site in 1874, and made one of his major paintings of the mountain.

In July 1873, between the completion of his drawings along the railroads and the commission to illustrate Rideing's chapter, Moran felt free enough of work obligations to accept one of the repeated invitations of John Wesley Powell to participate in the exploration of the Colorado River area. That month he joined Powell along with a young New York Times writer, J. E. Colburn, whom Bunce had hurriedly hired to write a short chapter on Powell's trip down the canyon of the Colorado. In addition to "The Cañons of the Colorado" in *Picturesque America*, Moran illustrated Powell's account for *Scribner's* of his first conquest of the Green River. In the final published book about the entire sequence of explorations, Powell and his assistant, Captain Clarence E. Dutton, used thirty-nine wood engravings after Moran's drawings, including several reprinted from *Picturesque America*. Like Captain Cook and earlier Europoean voyagers, American explorers such as Powell and Hayden appreciated how valuable the visual record of a fine artist could be in enlisting public support for their efforts.

Moran's dual attraction to American topography and to the picturesque idiom, with its love of the exotic, the rough-textured, the ancient, the legendary, the ruined and the mystical, can be glimpsed in a list of the titles of his famous paintings: "Mountain of the Holy Cross," "The Pictured Rocks of Lake Superior" (depicting Indian glyphs), "The Groves Were God's First Temples," "The Remorse of Cain," "The Flight Into Egypt" and "The Track of the Storm." Moran's theory of art subordinated the goal of topographical accuracy to that of idealized representation of the essential spirit of each place painted. In this, his masters were Claude, Corot and Turner. He praised Turner in these terms:

> His aim is parallel with the greatest poets who deal not with literalism or naturalism, and whose excellence cannot be tested by such a standard. He tries to combine the most beautiful natural forms and the most beautiful natural colors, irrespective of the particular place he is presenting. He generalizes Nature always ... In other words, he sacrificed the literal truth of the parts to the higher truth of the whole. And he was right. Art is not Nature; an aggregation of ten thousand facts may add nothing to a picture ... The mere restatement of an external scene is never a work of art, never a picture.

Elsewhere he says, "I never painted a picture that was not the representation of a distinct impression from Nature." Such an emphasis on painting not the scene itself but the impression it made upon the artist is in tune with late nineteenth-century theories such as Impressionism and symbolism, which were contem-

39

A Cross-Street in Dubuque, by Alfred R. Waud,
Picturesque America, 1872

porary with Moran and which sprang in part from the matrix of picturesque theory and practice. American landscape art had long been fertile ground for such seeds as Impressionism planted, as can be seen from comments identical in implication to Moran's that were published by Asher Durand in the mid-1850s: "We see yet perceive not, and it becomes necessary to cultivate our perception so as to comprehend the essence of the object seen."

Barbizon or Impressionist tendencies can be detected in some of the pictures by W. L. Shepherd, Granville Perkins, Albert Bellows, R. Swain Gifford and others, when they are compared with the strongly line-oriented graphic style of Alfred R. Waud and F. O. C. Darley, or the comparatively middle-of-the-road picturesque style of Moran and Harry Fenn. But in *Picturesque America*, the presence of Impressionism is only beginning to be felt in the wood-engraved pictures. Soon afterward it became a major interest for some illustrators and engravers, but for the time there existed a common style that was graphic, flexible and based upon line. *Picturesque America*, for all its size and diversity, exhibits an overall unity of impression springing from the broad consensus of illustrators and engrav-

ers as to the uses of wood engraving. (The book's steel engravings are more concerned with color and light, as befits a medium that had been prized since its discovery for tonal subtlety.) It is this consensus among engravers and artists, who were able to regard themselves as line illustrators in a medium they respected, which made *Picturesque America* a book of such even quality.

Picturesque America also benefited from a dramatic improvement in the artistry of American wood engraving that can be dated from 1867, the year the English master engraver William J. Linton (1812-1910) immigrated. Upon his arrival, Linton found a busy industry of facsimile wood engraving: journeymen engravers, copying as faithfully as they could from illustrators' drawings, produced thousands of undistinguished cuts to fill the pages of *Harper's Weekly*, *Frank Leslie's Illustrated Newspaper* and similar publications with images of news events and daily life. Linton set about to change this situation, and his vigorous efforts were largely responsible for a significant heightening of the artistic goals and abilities of American engravers. Linton was a dynamic man: an engraver, artist, poet, satirist, publisher, political activist, and early champion of the rights of women — one of the first things he did in the United States was teach wood engraving to female students. He arrived in this country at the age of fifty-five, with a reputation as one of the world's leading wood engravers, and he used the influence this background won him to promote better engraving by precept and example. He was accepted as a model by many New York engravers, and was seconded in his efforts by the arrival around this time of other excellent British craftsmen, including F. O. Quartley and Alfred Harral.

Linton's basic principles were simple. Wood engraving is linear art and line, not tone, should be the basis of every cut. The engraver's burin is a tool with which to draw, and should not be used to make minute cross-hatchings, shadings and other 'meaningless' lines, which to Linton were nothing but inferior substitutes for the tonal resources of painting, steel engraving and photography. Every line in a wood engraving should fulfill a clear purpose, as in a good drawing. Finally, the wood engraver is, for Linton, an interpretive artist, not simply a reproducer of another individual's work. Like Bewick, Linton engraved his own designs, although his livelihood, like that of all other Victorian wood engravers, was dependent upon the interpretation of illustrators' drawings and paintings. His belief in the engraver as

artistic interpreter rather than copyist followed from his background and his theory that wood engraving was a linear form often asked to present paintings. It was clear to him that the wood engraving was something quite different from the original picture, and that to be excellent it must exploit its own special characteristics. As he wrote:

> ... the mass of landscape drawing is tint; and ... the engraver has to express that in lines. The fault of which I accuse almost all work of later days is that the engraver seems to care only for color, for the general effect of his cut, neglecting the making out of forms and the expression of different substances, letting two or three sets of unmeaning lines serve for everything. I hold that, on the contrary, the engraver should be always aware of the many differences of form and substance, texture, nearness, distance, etc., and use his graver as he would a pencil in distinctly and accurately rendering them.

These words come from Linton's *The History of Wood-Engraving in America* (1880), in which he praised *Picturesque America* for its freedom from the faults he found in much of the engraving of the later 1870s. He gave special mention for their work on the book to F. O. Quartley, W. H. Morse, John Filmer, James L. Langridge, John Karst, Nathaniel Orr, Andrew Varick Anthony and several other engravers. Some, like Orr, had descended directly in the American tradition of Anderson; others were English natives or Americans influenced by Linton. The improvement they wrought in the quality of American wood engraving can be read in a chronological examination of the work of many important illustrators of the period: Winslow Homer, for instance. Homer produced dozens of designs from 1857 through 1867, including his famous Civil War pictures. As interesting as his compositions and subjects are, it is only after 1867 that his wood-engraved illustrations begin to have a finish and impressiveness similar to that of the general level of work in *Picturesque America*. It is around that year that the signatures of engravers such as Orr, Morse, Karst, Langridge and Linton begin to appear on Homer's work.

The engravers, and the painters and illustrators with whom they worked, were just as devoted to picturesque landscape as Bartlett and Cole had been in the 1830s. *Picturesque America*'s view of the United States differs greatly from Bartlett's both because it shows the results of Cole's revolution in the portrayal of American scenery and because it reflects the great changes the country had undergone in forty

years. Its artists and illustrators, including several second-generation members of the Hudson River School, display two major qualities encouraged by Cole in his paintings and writings: detailed attention to the characteristics of American landscape and an emphasis upon America's settled peace and relative freedom from the scars of history. In *Picturesque America* the triumvirate of beautiful, sublime and picturesque is fully represented. As Bryant recommended, the artists found the true sublime in the Rocky Mountains and other western areas that had been opened up since Bartlett's time. The bucolic beauty of the country's villages and farmlands, the splendor of its cities viewed in their natural settings, are major elements of *Picturesque America*: Bartlett found relatively few such scenes in 1836.

Given its size and the hundreds of pictures it contains, the book could scarcely avoid recording many aspects of life in the 1870s. It does not stress them, however; nor does it emphasize the portrayal of such things as workplaces, typical occupations and means of transportation, although there are notable exceptions to this: the depiction of Philadelphia and St. Louis streets, foundries at Poughkeepsie, barge loading on the Tennessee River, and others. Nonetheless, most of the book's illustrations are thoroughly picturesque in their concentration upon either scenery or the tumble-down, ruined, isolated or quaint aspects of man's works. The beautiful, also, comes to the fore, for instance in the city views, a genre that had long been popular in individual prints. In *Picturesque America* it is represented mainly by A. C. Warren's nine steel engravings, although J. D. Woodward, Granville Perkins and others also contributed fine examples.

Such glimpses of individuals and daily life as do appear are often within the picturesque idiom. 'Exotic' people, who would be unfamiliar to the book's middle class audience, are selected: black inhabitants of the North Carolina backwoods, fishermen mending nets near New Jersey's Neversink Highlands, or an Indian mother and child in a leanto on the Columbia. Human life is often suggested by oblique glances aside, or is merely implied, as in Harry Fenn's picture of a Florida date palm growing among the sagging fences and discarded objects of neglected backyards. In other illustrations, mankind is represented in traditional picturesque style by the tiny figure of the laborer, traveler or observer. One of the most charming of these is a Linton engraving after Fenn of a figure throwing up its arms and running in terror before the spouting giant geyser of

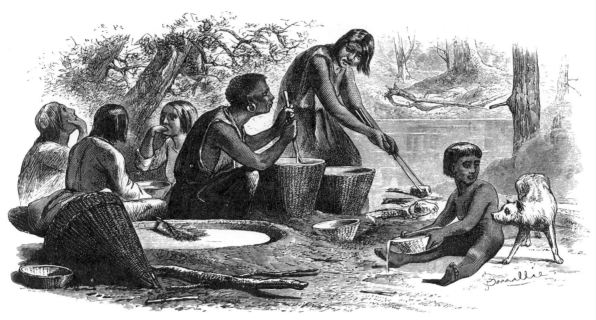

Indians Making Chemuck, by James D. Smillie,
Picturesque America, 1872

Yellowstone National Park. The artists sometimes picture themselves rowing in canoes, crawling out on crags, or perching in trees, as they often must have done, to make their sketches. Although *Picturesque America* at first seems ponderous in its two elephantine leather-bound volumes, and although its artistic aspirations and accomplishments were high, it is in fact a book whose pictorial tone is sunny, open, sometimes even humorous. Its pictures were intended as an interpretation of the poetry of nature and historic associations in the United States, but this left the artists scope to express their fondness for what they saw and their relish of the role of traveler-illustrator. Above all, *Picturesque America* conveys the sense of exuberance and creative energy that belongs to an artistic community conscious of its own identity and strength.

The Achievement of American Engraved Illustration

Picturesque America stands at the beginning of the brief period of American eminence in engraved illustration, which may be dated from 1872 until approximately 1890, when wood engraving was wholly replaced by other media. The book spurred a renewed interest in the de luxe travel book and a great appreciation of the artistry possible in wood engraving. No longer could it be considered only the medium of generally crude and hurried illustrations in the popular press. *Picturesque America* had gathered up in itself all the momentum of the artistic renaissance of wood engraving in the late 1860s, which had shown early results in the improved quality of *Harper's Weekly* illustrations around 1870, and in the superb illustration and engraving of many books. Among the most significant of these were Palmer's *Folk Songs* (New York: Scribner's, 1866-67), *Enoch Arden* (Boston: Tichnor and Fields, 1865-66; illustrated in part by Elihu Vedder), *Women of the Bible* (New York: American Tract Society, 1868), Whittier's *Snowbound* (Boston: Tichnor and Fields, 1869, illustrated by Harry Fenn), Bryant's *Song of the Sower* (New York: Appleton, 1870) and the first of the books collecting outstanding wood engravings from the magazines, Harper's *Art in America* (1872).

This movement strengthened the development of American engraved illustration begun in such work as Darley's illustrations of Washington Irving, and the genre scenes and fiction illustrations of Winslow Homer during the 1850s and 1860s. The new upsurge of high quality illustrated publications also confirmed the tendency of artists, engravers and publishers to prefer landscape subjects for their most ambitious efforts. Like Harper's *Illuminated Bible* of 1843, the new illustrated books featured landscapes that contributed to the mood of the text. The magazines displayed landscapes prominently among their art pictures, and emphasized them even more heavily in their books of selected engravings.

Untitled illustration, by Charles T. Parsons,
Folk Songs, 1861

The artistry and popularity of *Picturesque America* increased the impetus of engraved landscape illustration, and the public appreciation of wood engraving. Seventy years after the prime of Bewick and William Blake, the art's earliest and still unsurpassed masters, the potential of wood engraving was being explored again, although in a different country and under totally different social and technological circumstances. The separation that had occurred between the artist and the wood engraver, who had become merely a craftsman trying to copy a work as best he could for printed reproduction, was partially closed by the conscious artistry of men such as Linton and the understanding respect for the wood engraving medium of such artists as Homer, A. R Waud, Darley, Fenn, Durand, Kensett, Church and many others. Among the illustrated books that followed upon *Picturesque America*'s success were two others by Appleton, *Picturesque Europe* (1875-79) and *Picturesque Palestine* (1881), and an edition of *The Poetical Works of Longfellow* issued in 1879 by the Boston firm of Houghton, Osgood and Company. But the finest of *Picturesque America*'s descendants was *Picturesque Canada*, a joint Canadian and American accomplishment that was printed in Montreal and published at Toronto exactly ten years after its American prototype. In 1880 two transplanted Chicago atlas publishers, Howard and Reuben Belden, took profits from their thriving Ontario atlas business to produce a book on the model of *Picturesque America*. The art director, Lucius O'Brien, and the literary editor, George M. Grant, were Canadians, but many of the artists and engravers selected by O'Brien were Americans. Among the American artists who designed for *Picturesque Canada* were W. T. Smedley, H. A. Ogden, William Hart, R. Swain Gifford, J. A. S. Monks,

Thomas Moran, Harry Fenn, George Smillie, A. B. Frost, H. P. Share, Francis Hopkinson Smith and Fred B. Schell. Schell (d. 1905?), who remains a shadowy figure to present research, became one of the most frequently published of American illustrators during the 1870s, working especially for *Harper's Weekly*. Like Harry Fenn, he was a fine illustrator who could produce indefatigably in the established picturesque style of the day, always performing with competence and sometimes with originality and distinction. Schell by himself drew or painted 207 of *Picturesque Canada*'s more than 550 illustrations, and with his *Harper's Weekly* sketching partner, J. Hogan (of whom nothing but his name is known), he executed another 125.

Picturesque Canada was issued serially from 1882 to 1884 and its excellence, fully comparable to that of *Picturesque America*, is a tribute both to the Canadian art director and painter, O'Brien, and to the American artists and engravers who formed the bulk of his staff. The Canadian book represents the tendencies in American wood engravings during the 1880s. The engraving shows the artistic and technical influences of the new schools of painting, especially Impressionism, and of photography. Both of these had encouraged some engravers to emphasize light, color and tone, conveyed by means of incredibly fine lines and line patterns. Wood engravers were engaged in a struggle, which they would eventually lose, to maintain the popularity of their craft in competition with photography. It is significant that this book, containing many of the best examples of nineteenth-century American wood engraving in the last two decades of the century, was produced in and for Canada, where both printing technology and the growth of an indigenous art lagged somewhat behind the American pace of development due to social factors like those that had affected the United States sixty years earlier. Schell, with the experience and reputation gained from his work in Canada, went later to Australia where he worked as artist and art director of another excellent *Picturesque America* descendant, *The Picturesque Atlas of Australasia* (1886), employing two of *Picturesque Canada*'s American artists, William T. Smedley and William Crothers Fitler. Compared to its American ancestor, *Picturesque Canada* shows an increased use of devices and styles that were not possible to contemporary photography, and which had appeared in the engraved magazines during the 1870s. These include visual tricks like the framing of scenes with still-life motifs, for instance, a rural scene might be outlined

43

Some Art Connoisseurs, by William H. Gibson,
Art in America, 1872

sive labor by artist-craftsmen of such skill that there could never be more than a few capable of the best results. As methods of photographic reproduction improved, it became increasingly easy and inexpensive to produce faithful copies of paintings and drawings. Finally, wood engraving was always an interpretation, no matter how the engraver might try to subordinate himself to the ideal of exact reproduction; artists, especially those loyal to the new schools that exalted light and color, preferred photographic reproductions because they simply recorded a painting and did not add the artistic contribution of another hand.

The New School, with its tonal clarity that excelled contemporary photographs and still reminds us of the sharpness of a Canaletto miniature or a modern super-realist painting, was a wholly American development, and greatly impressed European observers. By the late 1870s, American wood engraving had split into the traditional school led by W. J. Linton and many of the engravers who had worked on *Picturesque America*, and the New School partisans, including another English immigrant, Timothy Cole (1852-1931), and such engravers as Frederick Juengling and Henry Wolf, who were employed on *Picturesque Canada* (along with members of the older school including Nathaniel Orr, John Filmer, and R. Hinshelwood). Linton expressed the objections to the New School in eight articles first published in *The American Art Review* in 1880 and then collected in his *The History of Wood-Engraving in America*. He regarded the introduction of photography as, potentially, a benefit for wood engraving. It could remove the reproductive burden from the art's shoulders, and should allow the wood engraver to become more of an artist, truly interpreting paintings, or designing his own works, as the early masters of the 1790-1835 period had done. He disparaged the work of New School engravers as "clever" and commented that "photographs ...would however well replace them and we ...would no longer be annoyed with the pretense of engraving." This, of course, is precisely what happened. The methods of reproducing photographs in print became ever better and less expensive, until wood engraving as a reproductive process was obsolete.

by an enlarged spray of wildflowers. In some cases, a group of scenes would be arranged on the same page with the help of *trompe l'oeil* devices, such as the presentation of illustrations as if they were on art paper pinned to the page, complete with shadows under curling corners and pins to fasten the pictures down.

Picturesque America and the books that followed it within the next twenty years appeared in the last decades of wood engraving's importance, and all during this period the forces that would supplant it were gathering strength. By 1875 the influences of photography and Impressionism had given rise to the so-called New School of American wood engraving, which refined the art until it could express the subtlest gradations of tone. The skill of the New School engravers and the development of tools such as 'multiple gravers' (burins with many fixed points which could engrave sets of minute, closely-spaced lines) allowed wood engravings to achieve the detailed fineness of steel engravings and created pictures of a tonal subtlety that is still comparable to the best printed reproductions in black and white. However, such effects required long, difficult and expen-

Although no longer visible to a large audience, wood engraving continued and still continues to be practiced. In the 1890s in England it came to be associated with private art and literary presses, distinguished by the work of such artist-engravers as William Morris, Edward Burne-Jones,

The Adirondacks, by Homer Martin,
Art in America, 1872

Charles Ricketts and T. Sturge Moore. In America, Linton and others kept the art alive in a similar manner, designing and printing their own books illustrated with wood engravings. In the twentieth century it has been continued by Rockwell Kent, Rudolph Ruizicka and others. Almost all of these artists have taken advantage of the suppleness of line provided by the burin and by engraving techniques, but have moved the wood engraving back in the direction of the older woodcut form, with its strong contrast between black and white, its dependence upon outline, and its relative lack of intermediate tones. This preference for line is similar to Linton's, but he was a man of his time in taking pride in the tonal mastery that nineteenth-century wood engraving had achieved: he simply did not want to see tone take the place of clear drawing.

Now that the impassioned debates of the 1870s and 1880s are forgotten, we can see that Linton's ideal was often achieved by the engravers of his day, whatever their views in the line versus tone controversy. Nineteenth-century American engraved illustration developed its own rapidly evolving techniques that were products of contemporary tastes and technical means; using these techniques, it achieved timeless results. On both sides of the Atlantic, nineteenth-century wood-engraved illustration produced a body of work that is equal in achievement to seventeenth- and eighteenth-century European etching, Japanese woodblock printing, the late medieval woodcut, and other great eras of print art. Within the art's golden century, the last two decades, the 1870s and 1880s, constituted the period of American dominance, a dominance that was often acknowledged even in contemporary Europe. For instance, the London *Saturday Review* wrote in 1880, "The impartial critic who is asked where the best wood cuts are produced has, we fear, but one answer possible: Neither in England, Germany nor France, but in America ..." In this brief space of twenty years, the United States produced work of such quality in the medium that American artistic self-consciousness was thereby greatly heightened and American art was able to make its first international impact as a whole (rather than through the work of an individual painter).

The first maturity of American art, which occurred in nineteenth-century painting, was closely bound up with the exactly contemporary development of wood engraving both as an art and as the popular visual medium of the era. The connection thus established between the country's serious artists and its graphic arts industry has never been broken. Down to the present day, many of the most important American artists have worked closely with the graphic arts, both to reach large audiences and to be stimulated by the ever changing technical frontiers of the field. Wood engraving has now become a 'lost' medium, without the currency painting has maintained and photography has achieved. Its status as a popular art has rendered it almost invisible to art critics, and the huge size of nineteenth-century editions has made it too common to intrigue collectors and antiquarians. The resulting obscurity is unmerited. This elegant linework deserves to be known and appreciated for its artistic value, for the view it provides of a vanished time, and for the crucial role it played in the growth of American art.

THE PLATES

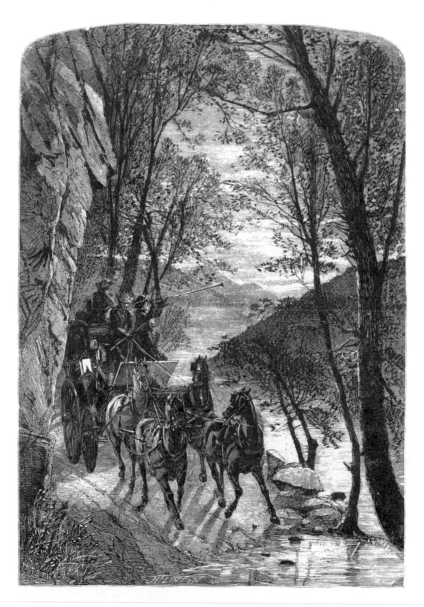

"The Lover's Leap"—Approach by Night, by Harry Fenn,
Picturesque America, 1872

1 Natives of Oonalashka, and their Habitations

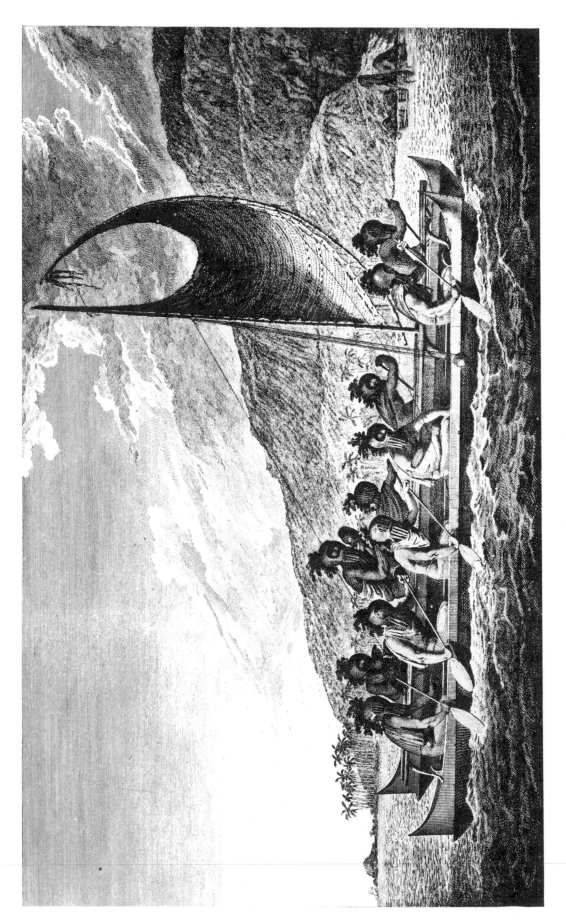

2 A Canoe of the Sandwich Islands, the Rowers Masked

3 Village of Catskill, Hudson River

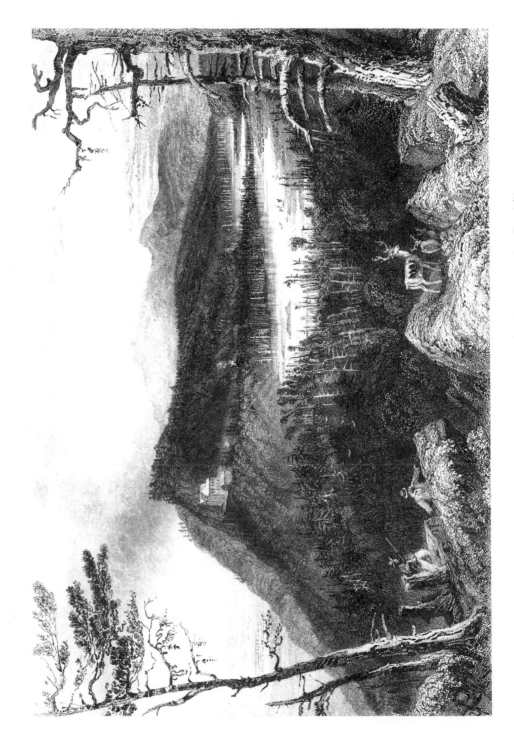

4 The Two Lakes and the Mountain House on the Catskills

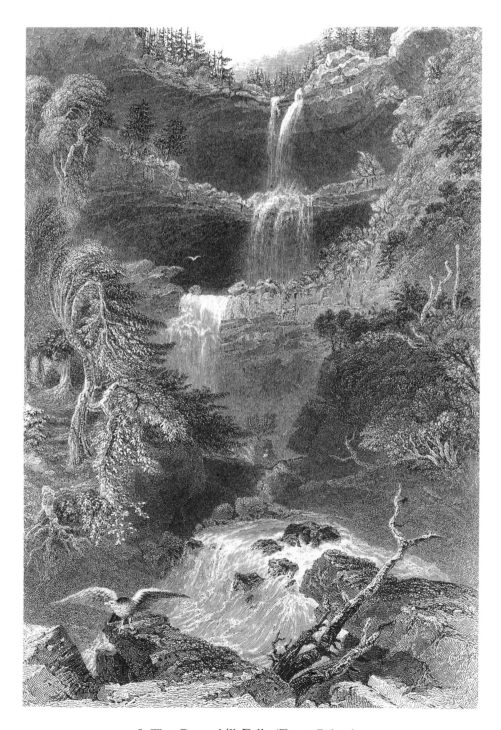

5 The Catterskill Falls (From Below)

6 Winter Scene on the Catterskills

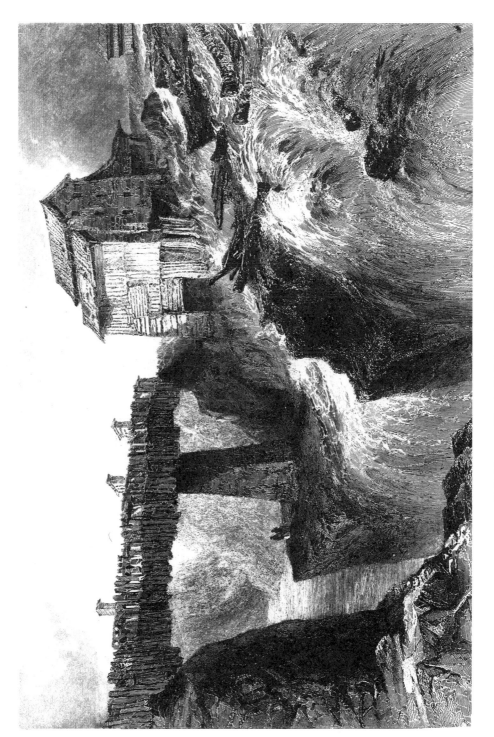

7 Bridge at Glen's-Fall (on the Hudson)

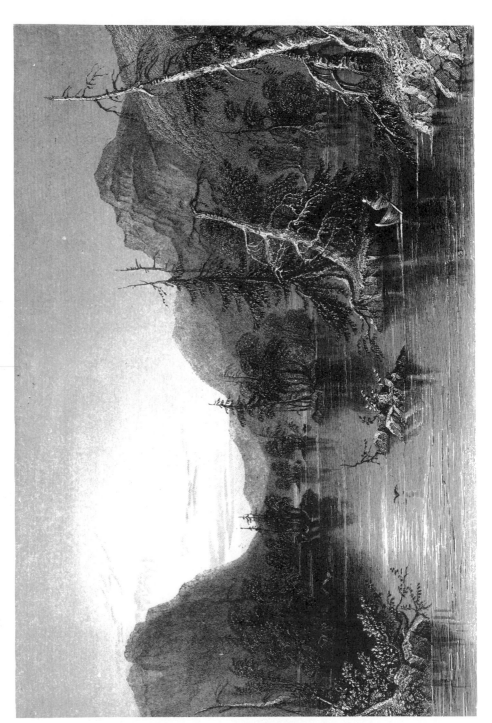

8 Scene Among the Highlands on Lake George

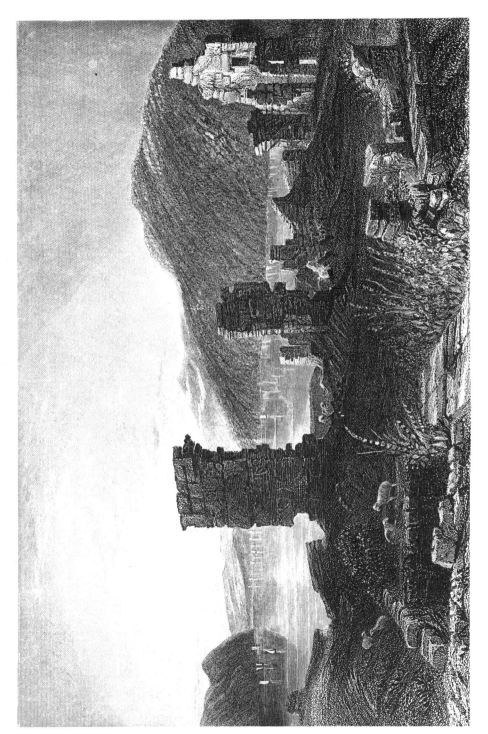

9 View of the Ruins of Fort Ticonderoga

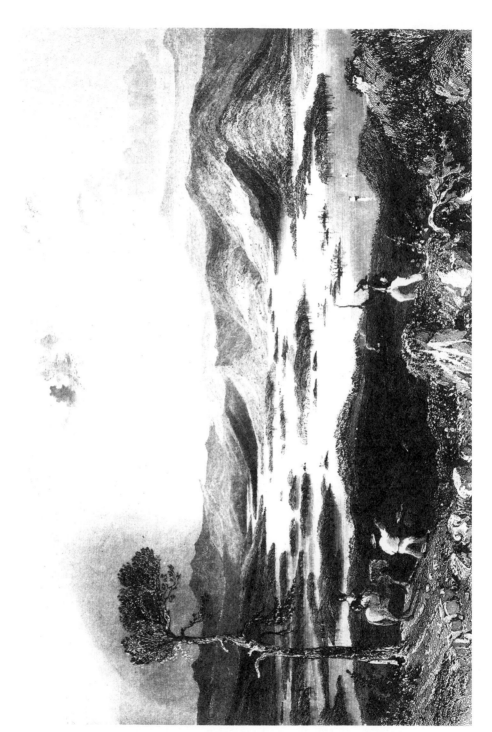

10 Squawm Lake (New Hampshire)

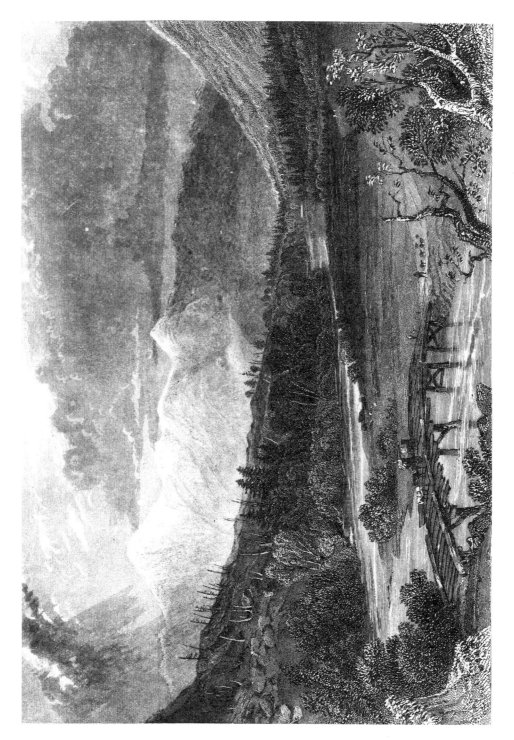

11 Mount Washington, and the White Hills (From Near Crawford's)

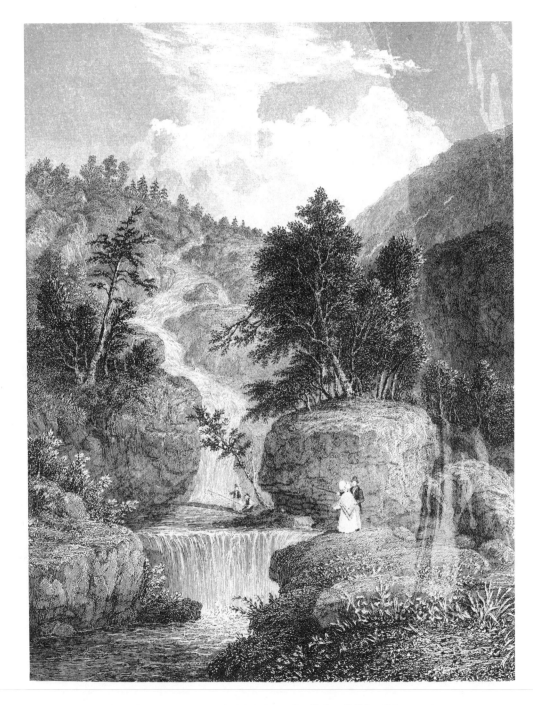

12 The Silver Cascade, in the Notch of the White Mountains

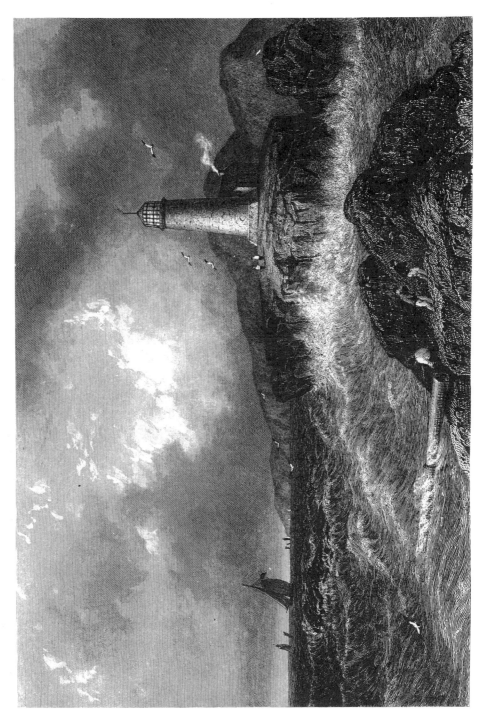

13 Desert Rock Light House (Maine)

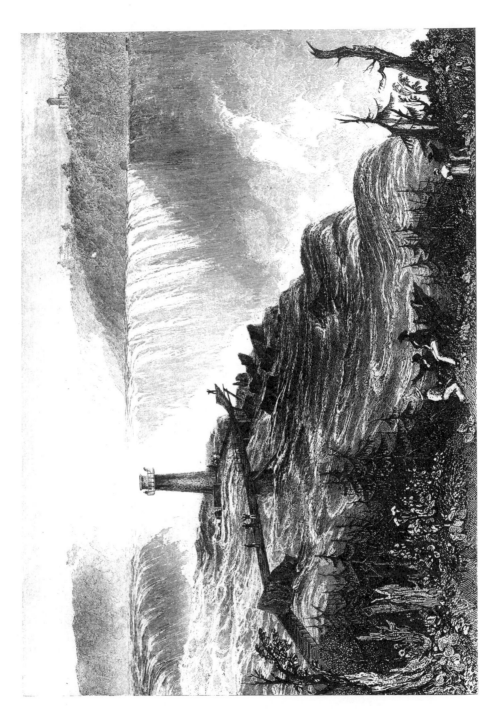

14 The Horse Shoe Fall, Niagara—With the Tower

15 Lockport, Erie Canal

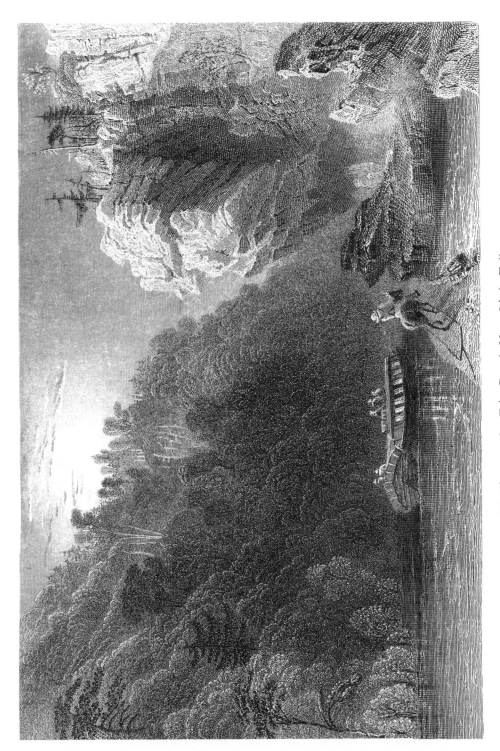

16 View on the Erie Canal, Near Little Falls

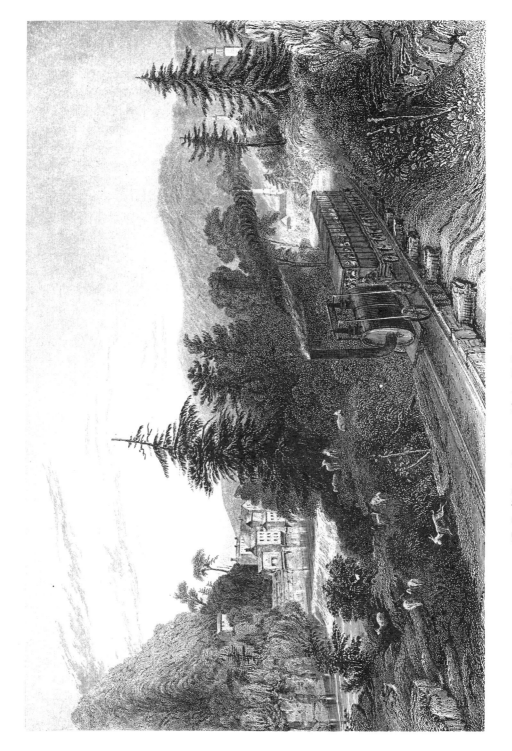

17 Rail-Road Scene, Little Falls (Valley of the Mohawk)

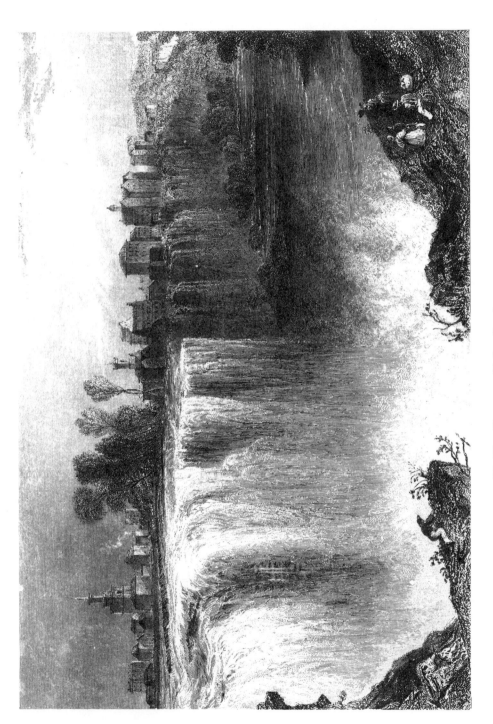

18 The Genessee Falls, Rochester

19 Faneuiel Hall, Boston

20 Yale College (New Haven)

21 Fairmount Gardens, With the Schuylkill Bridge (Philadelphia)

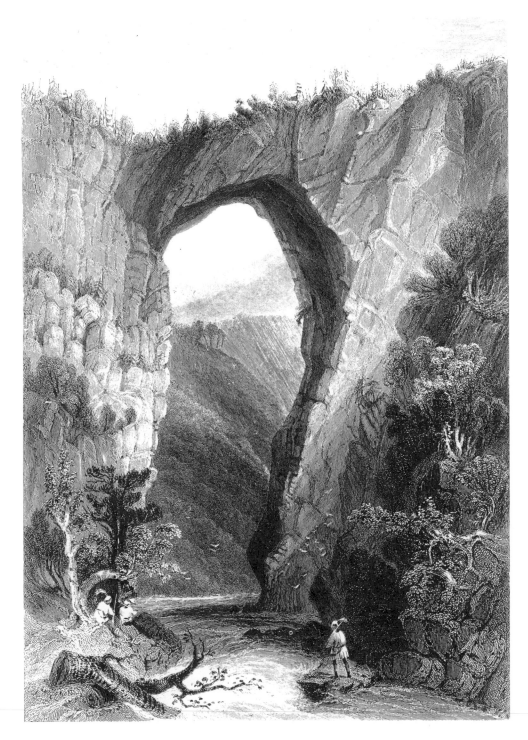

22 Natural Bridge, Virginia

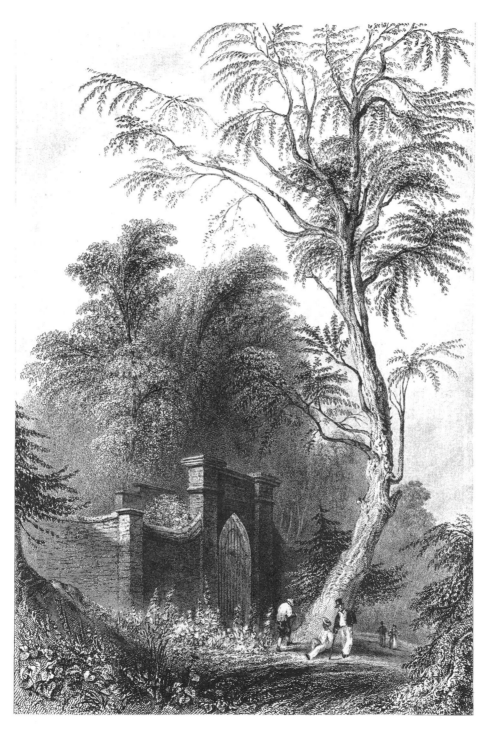

23 The Tomb of Washington, Mount Vernon

24 View of Baltimore

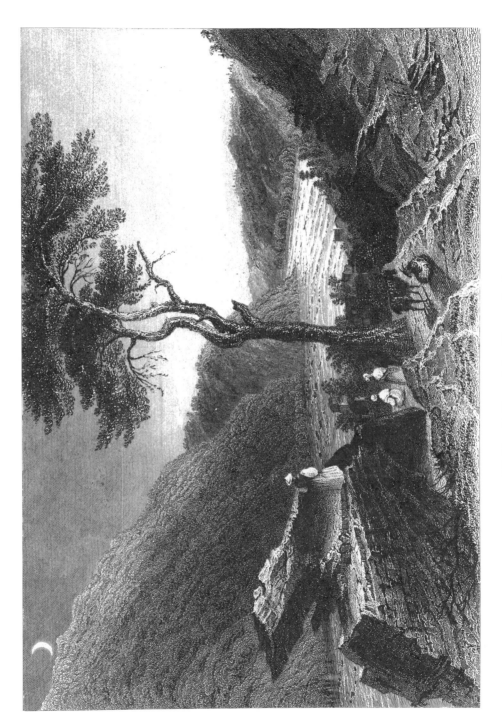

25 The Valley of the Shenandoah

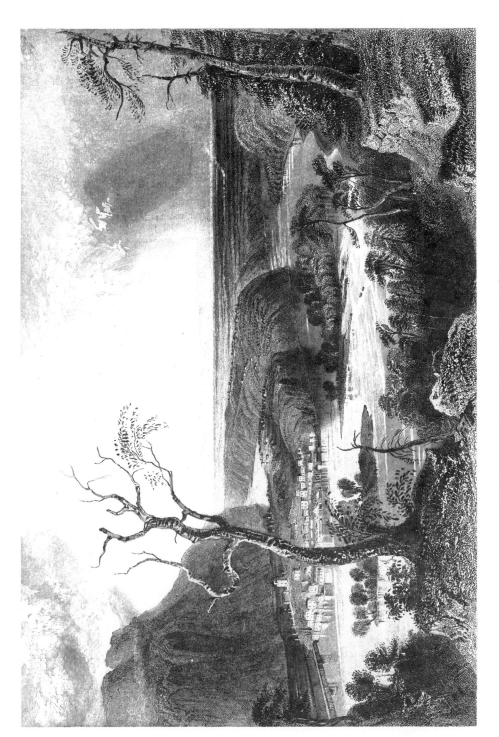

26 Harper's Ferry (From the Blue Ridge)

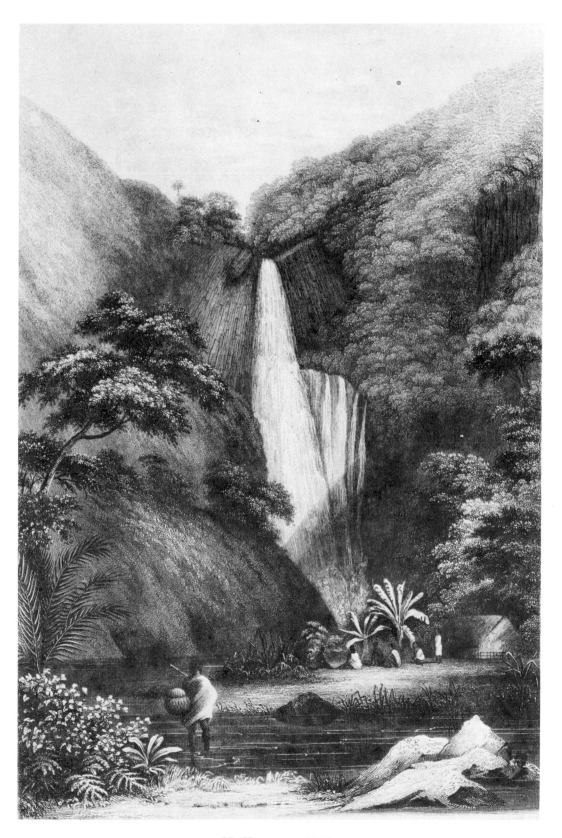

27 Hanapepe Valley

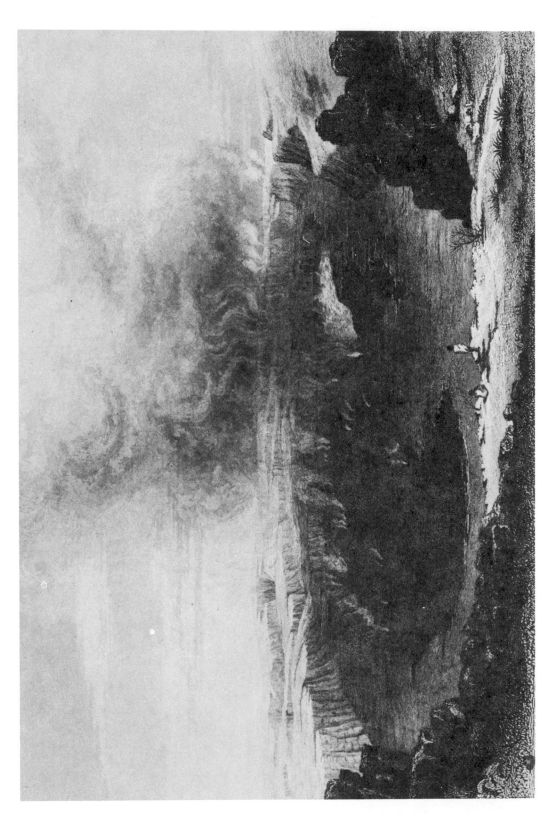

28 View of Crater, Kilauea

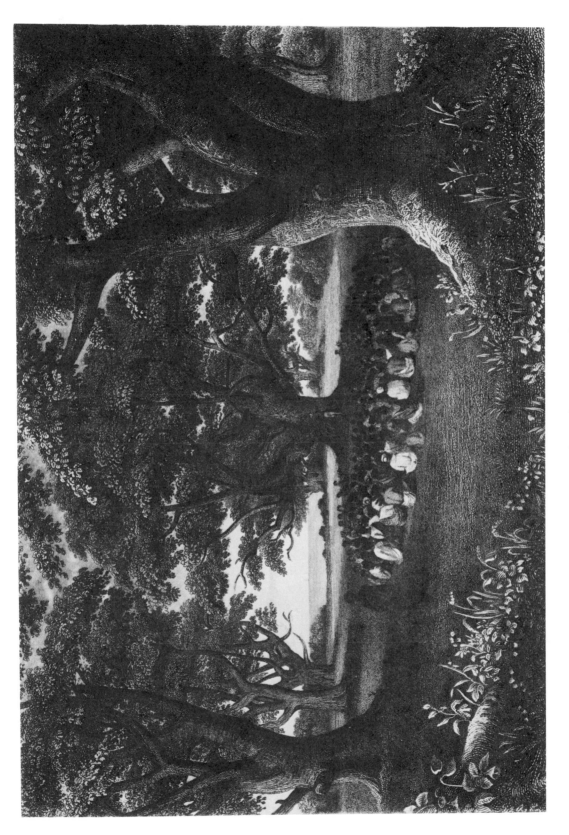

29 Grove of Tutui Trees, Kauai

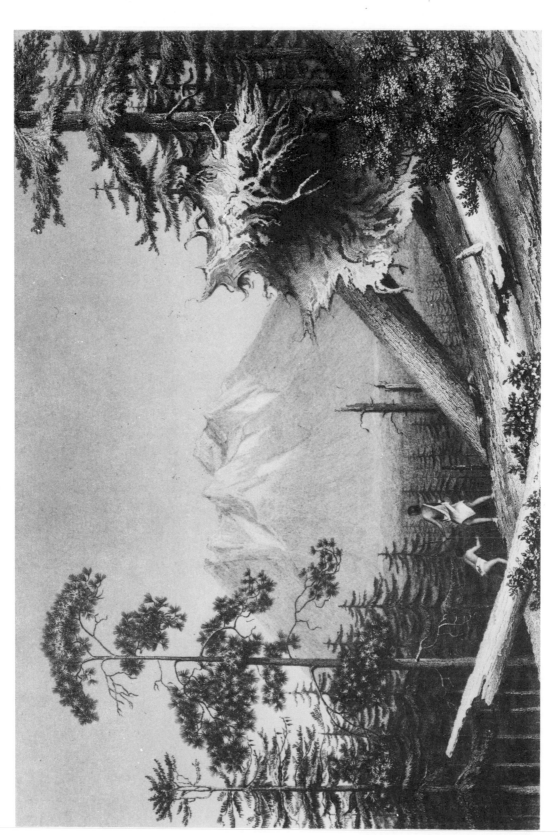

30 Shasta Peak

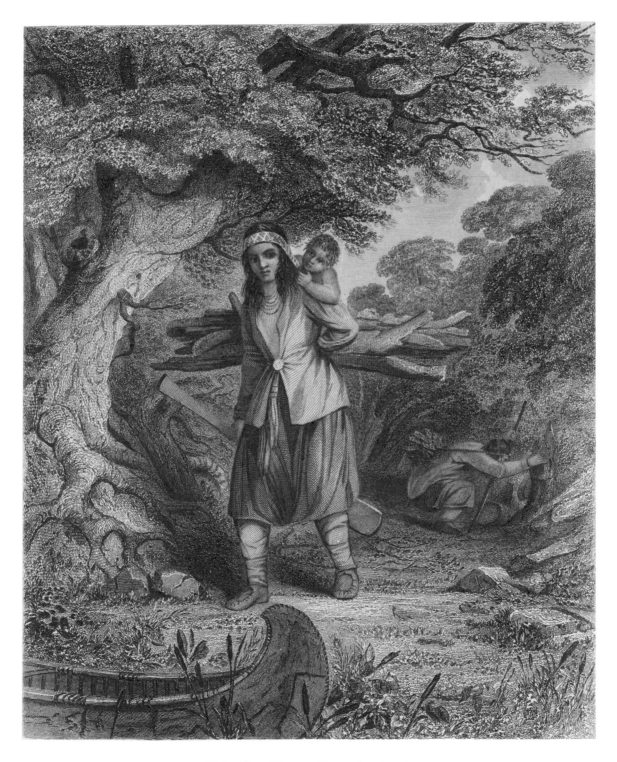

31 Indian Woman Procuring Fuel

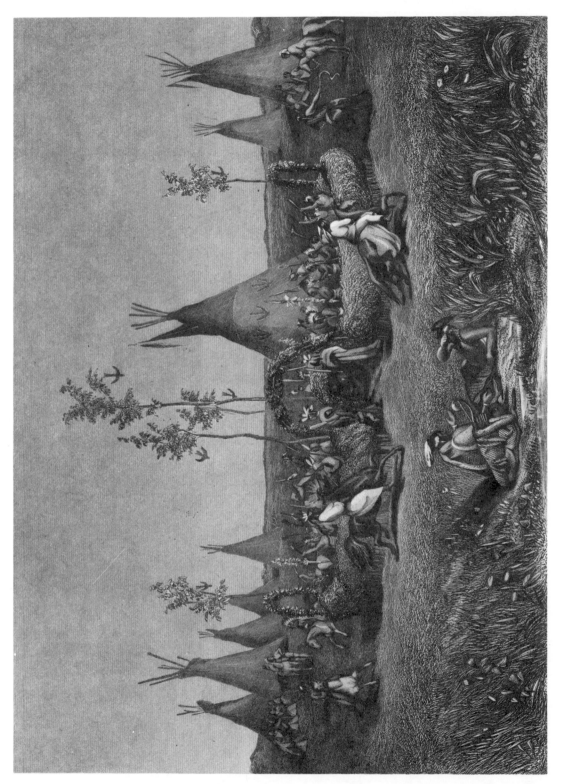

32 Ceremony of the Thunderbird (Sioux)

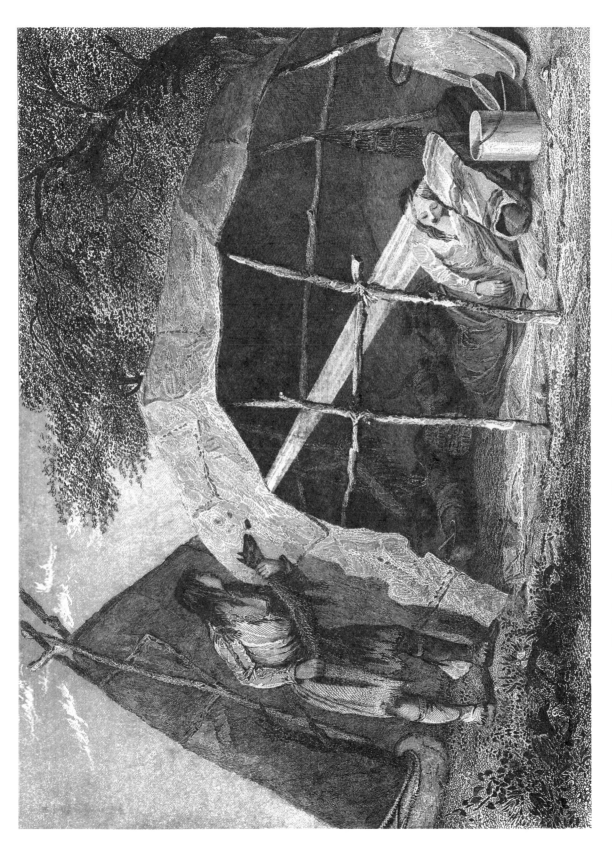

33 A Seer Attempting to Destroy an Indian Girl by a Pencil of Sunlight

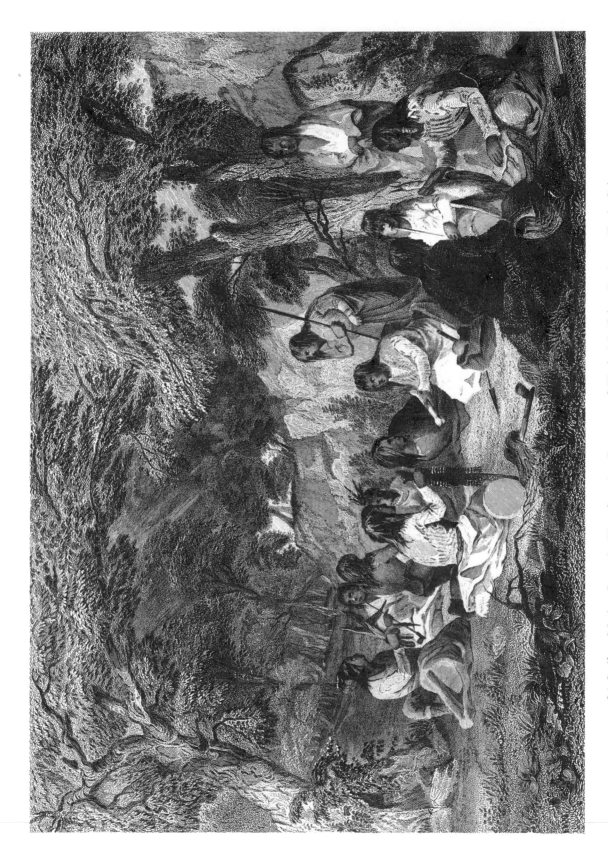

34 Indian Medas Secretly Showing the Contents of Their Medicine Sacks to Each Other

35 Winnebago Wigwams

36 Spearing Fish in Winter

37 Chinook Burial

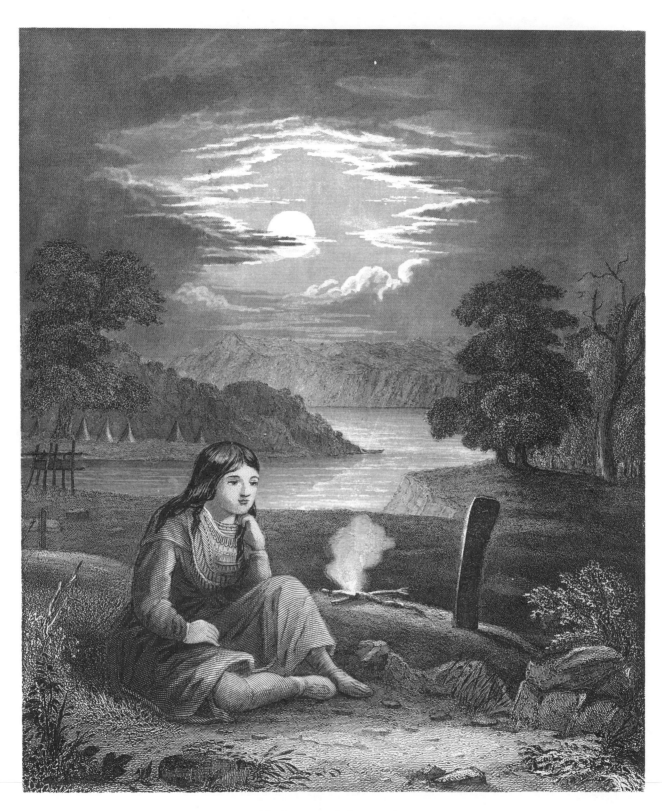

38 Nocturnal Grave Light

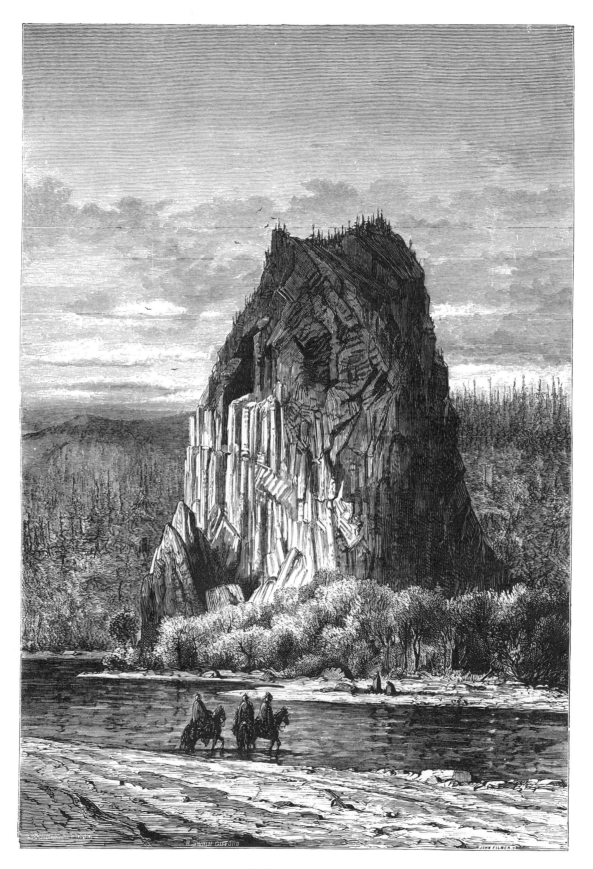

39 Castle Rock

40 Mount Shasta

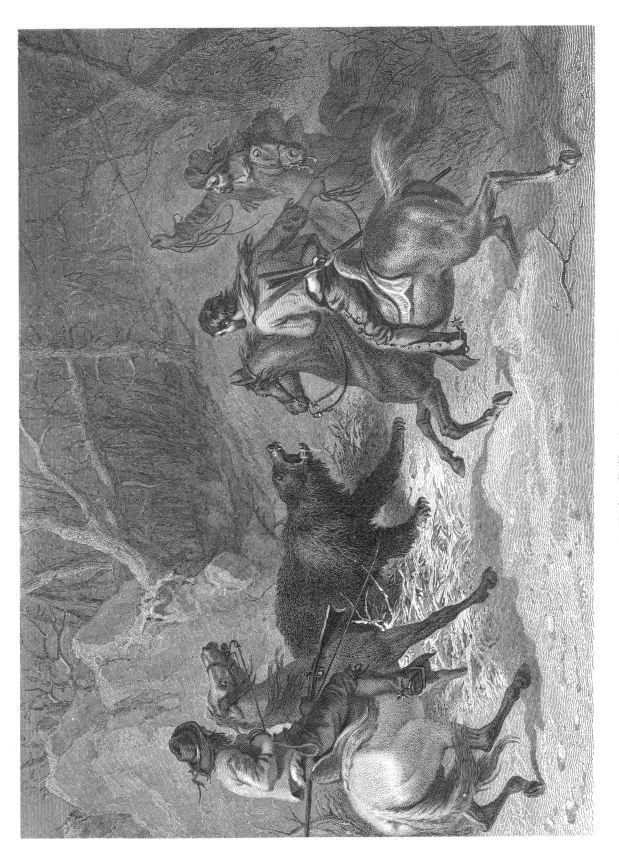

41 Native Californians Lassoing a Bear

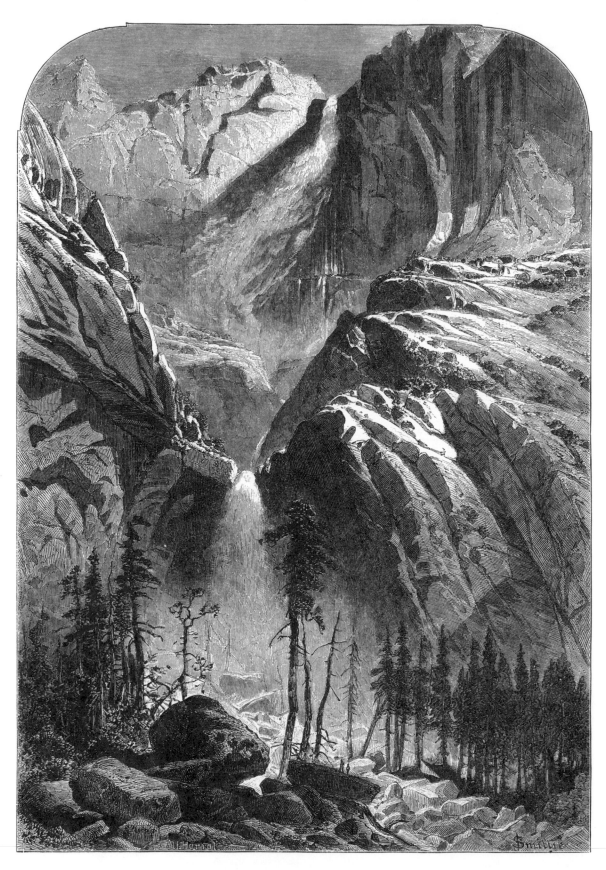

42 Yosemite Falls

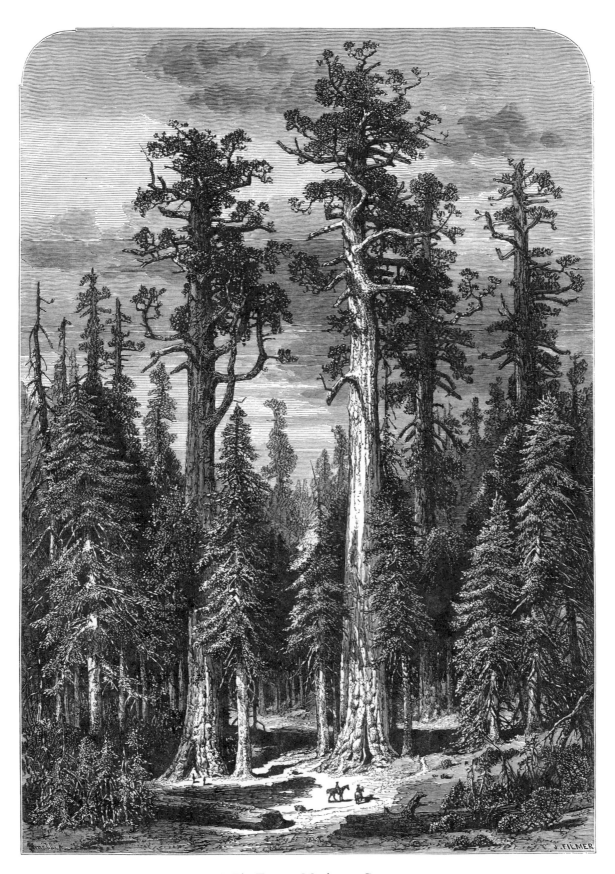

43 Big Trees—Mariposa Grove

44 Mirror Lake, Yosemite Valley

45 Lake Tahoe

46 Emigrants Crossing the Plains

47 Terres Mauvaises, Utah

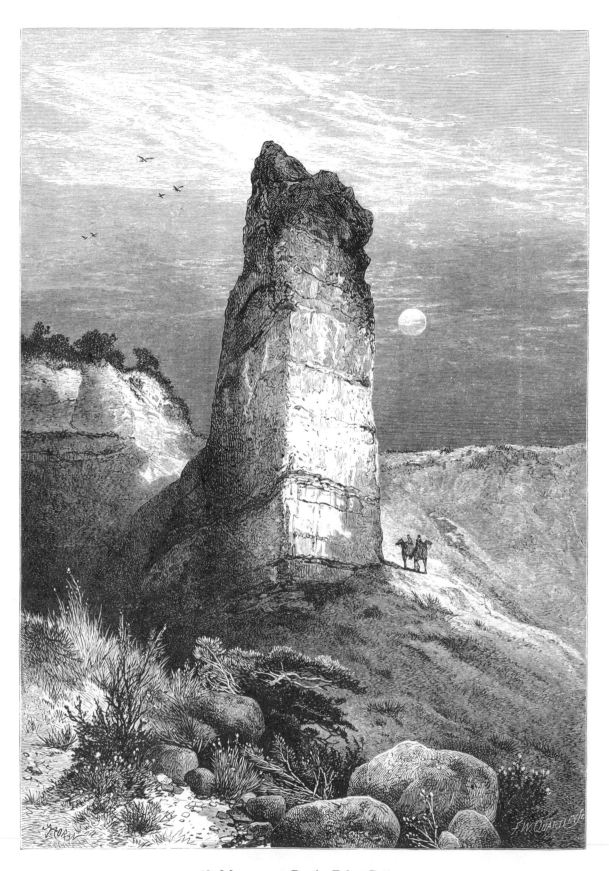

48 Monument Rock, Echo Cañon

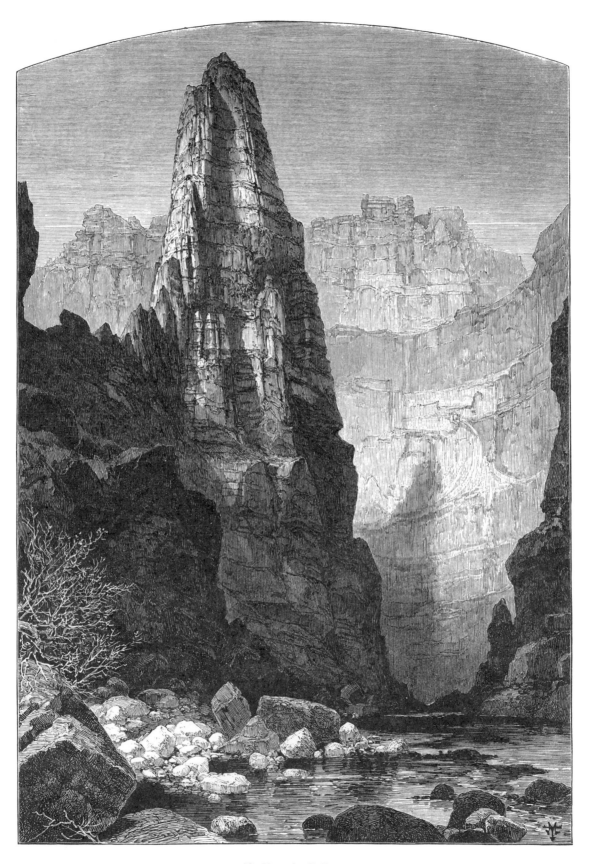

49 Kanab Cañon

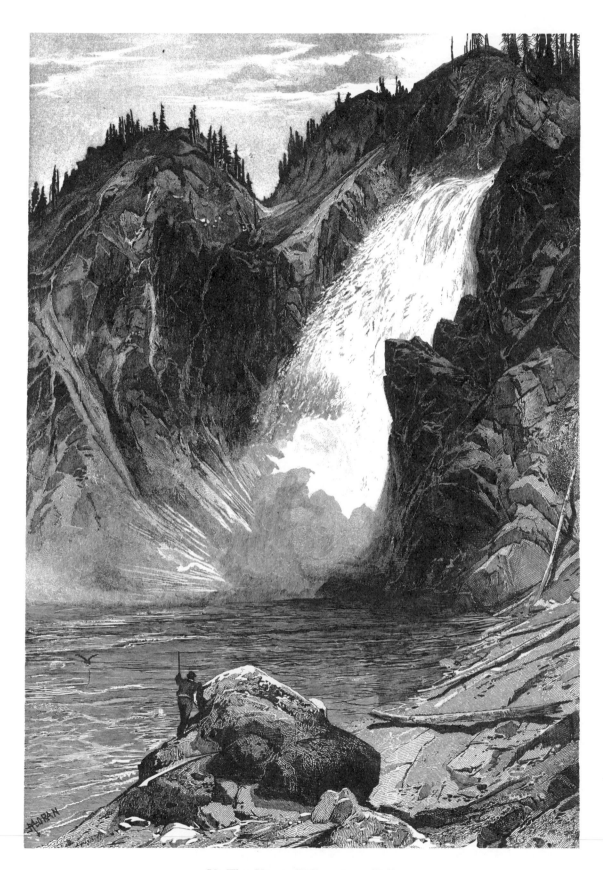

50 The Upper Yellowstone Falls

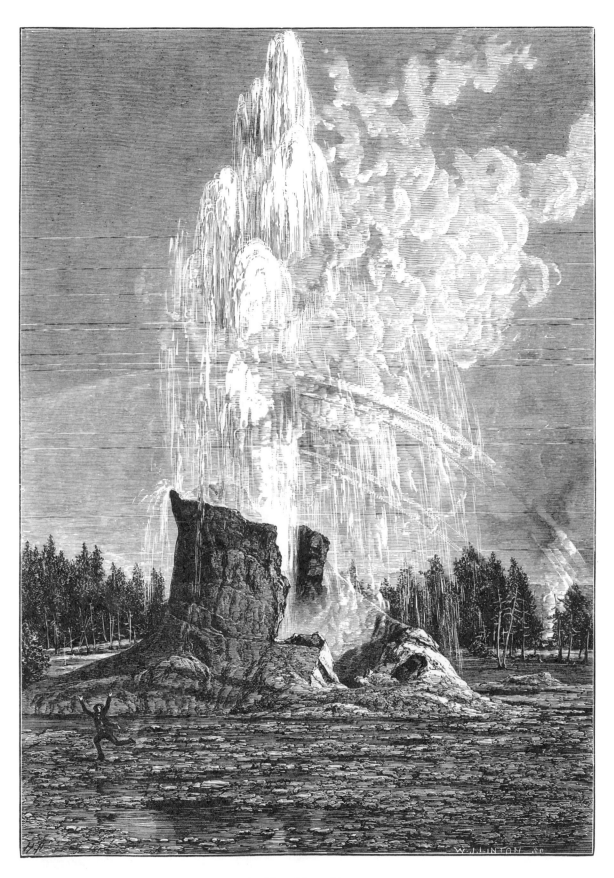

51 The Giant Geyser

52 Cliffs of Green River

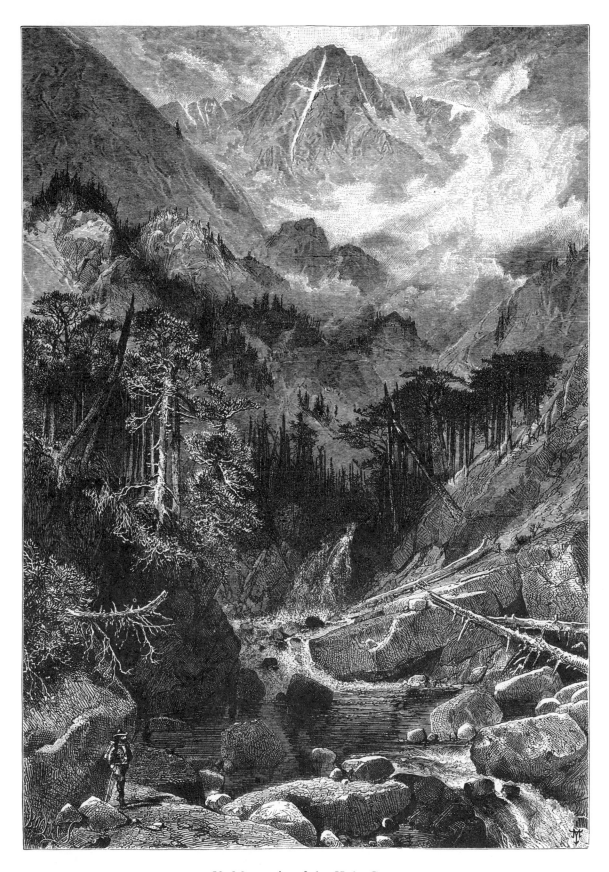

53 Mountain of the Holy Cross

54 The Rocky Mountains

55 The Moss-Gatherers

56 A Garden in Florida

57 Scene in St. Augustine—The Date Palm

58 On the Coast of Florida

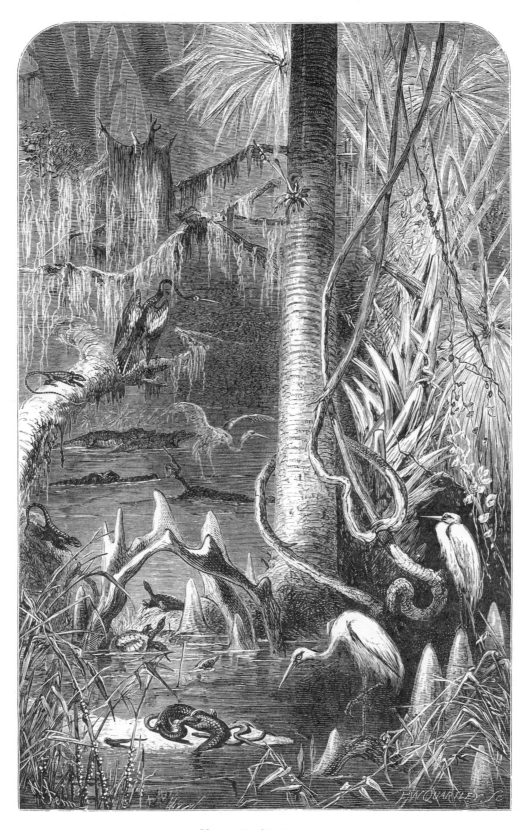

59 A Florida Swamp

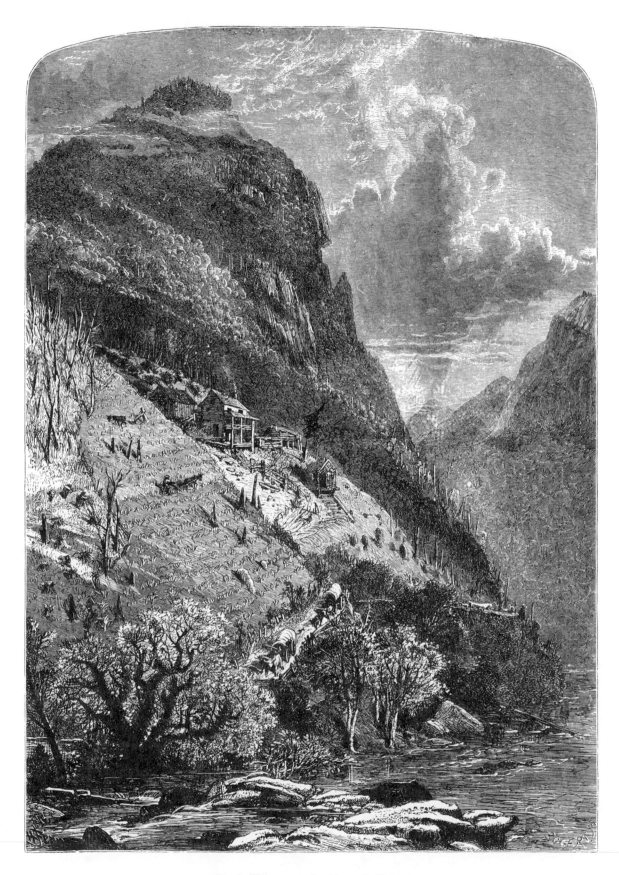

60 A Farm on the French Broad

61 Richmond From the James

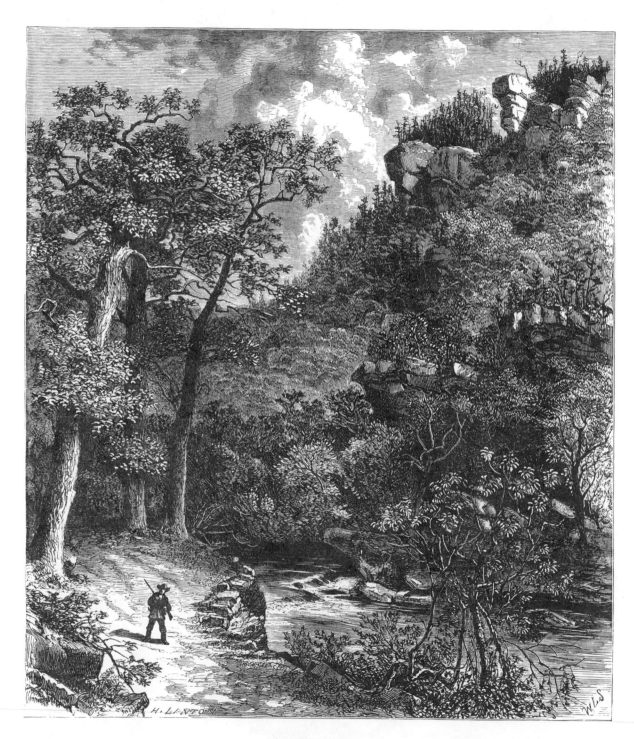

H. LINTON WLS

62 Goshen Pass

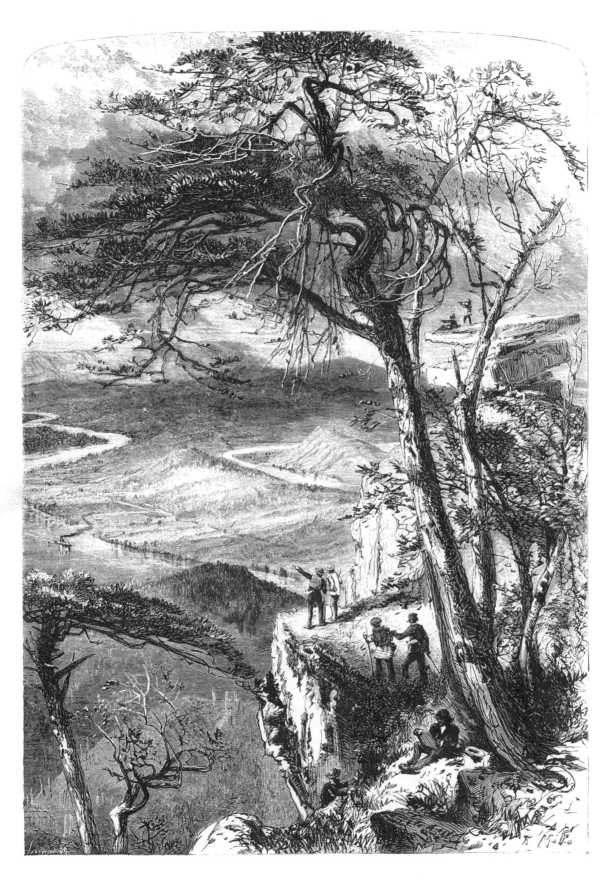

63 Lookout Mountain—View From the "Point"

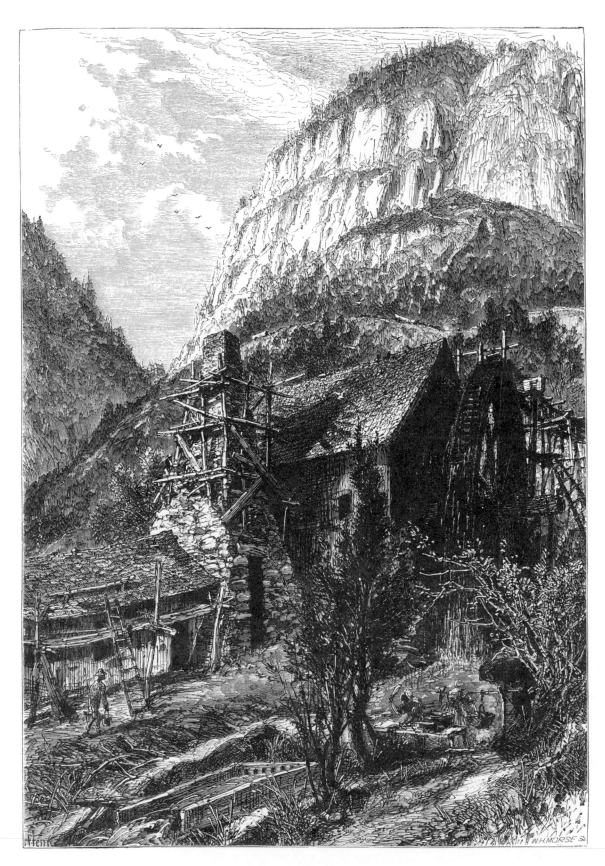

64 Cumberland Gap, From the East

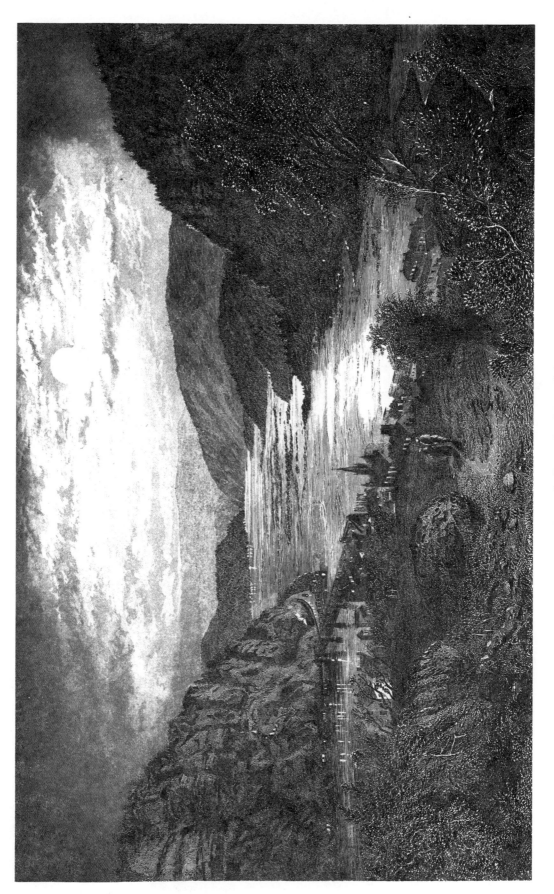

65 Harper's Ferry by Moonlight

66 Great Falls of the Potomac

67 The Cliffs of Seneca

68 The Levee at St. Louis

69 Milwaukee River, at Milwaukee

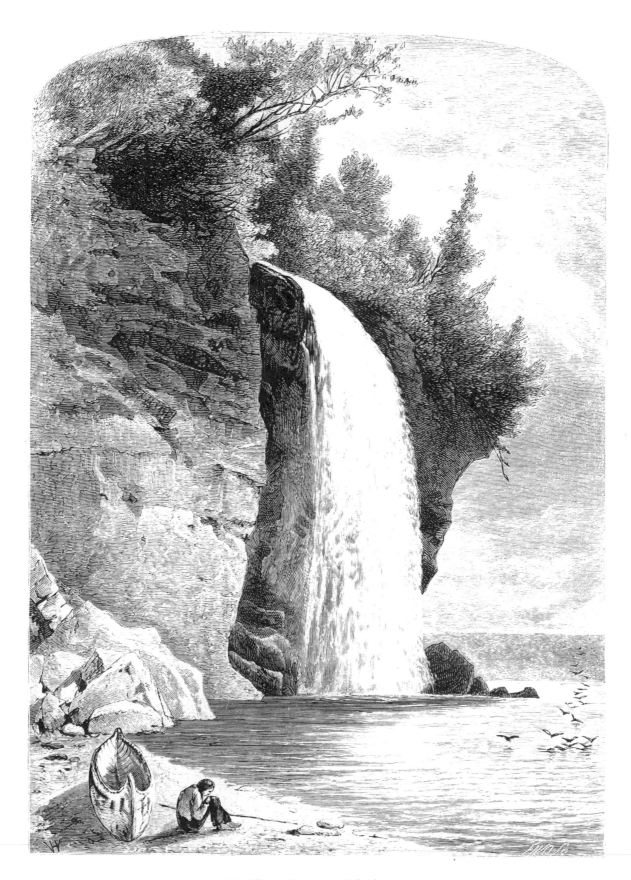

70 Silver Cascade, Michigan

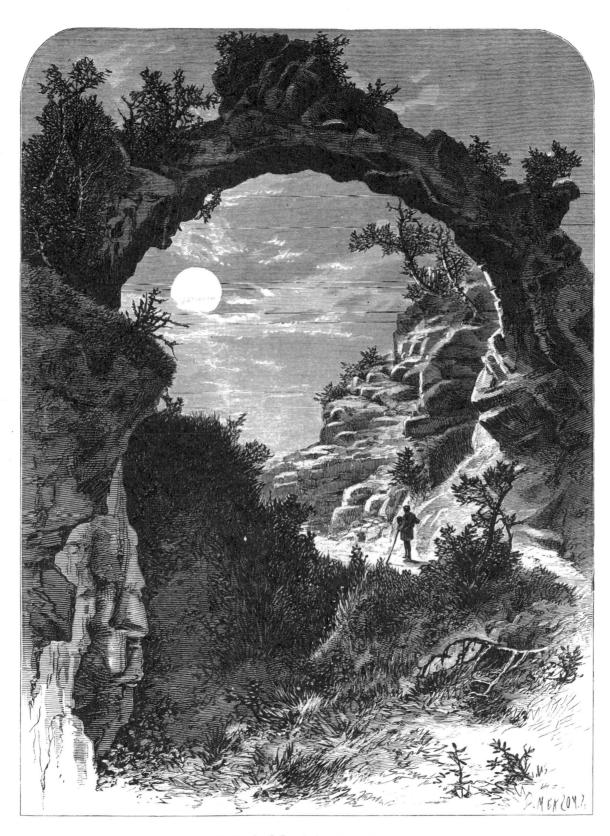

71 Arched Rock by Moonlight

72 City of Cincinnati

73 Lake Erie, From Bluff, Mouth of Rocky River

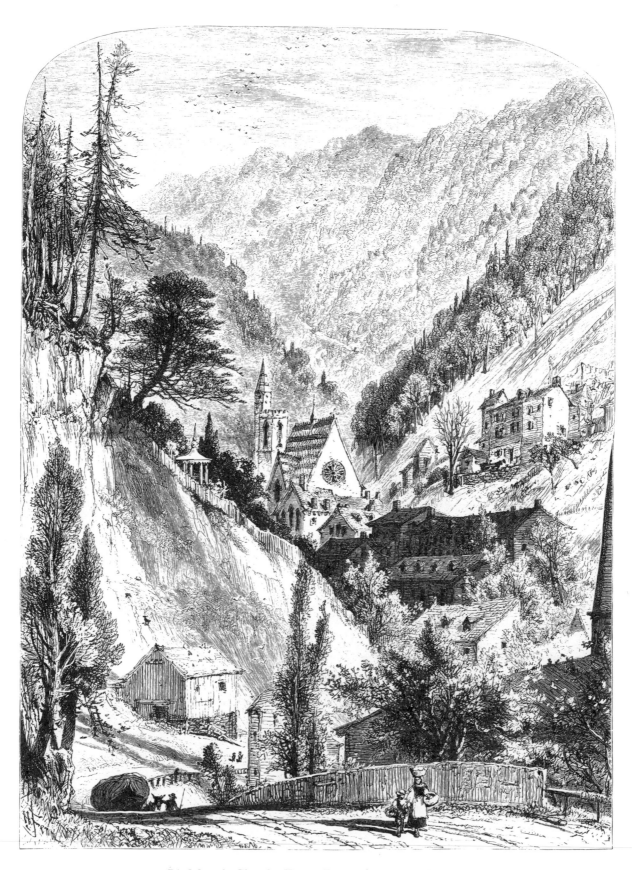

74 Mauch Chunk, From Foot of Mount Pisgah

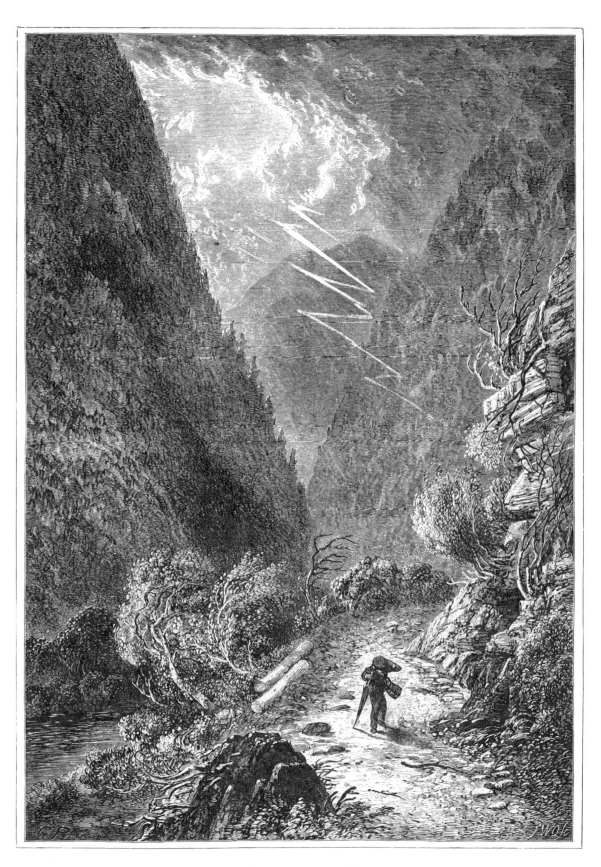

75 Sinking Run, Above Tyrone

76 Niagara

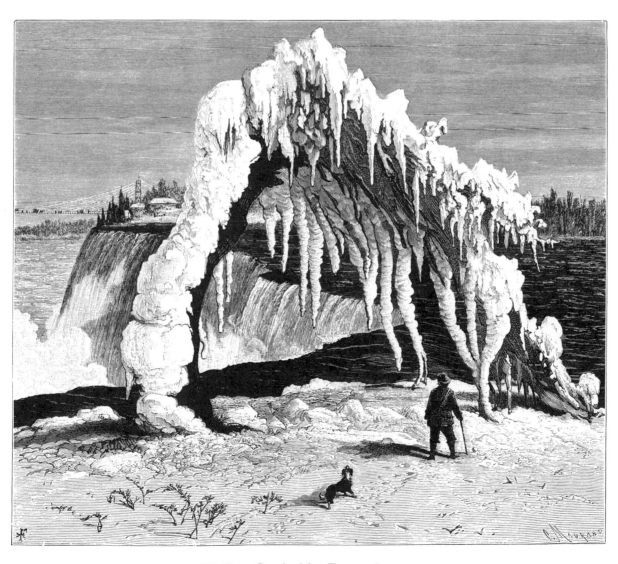

77 Tree Crushed by Frozen Spray

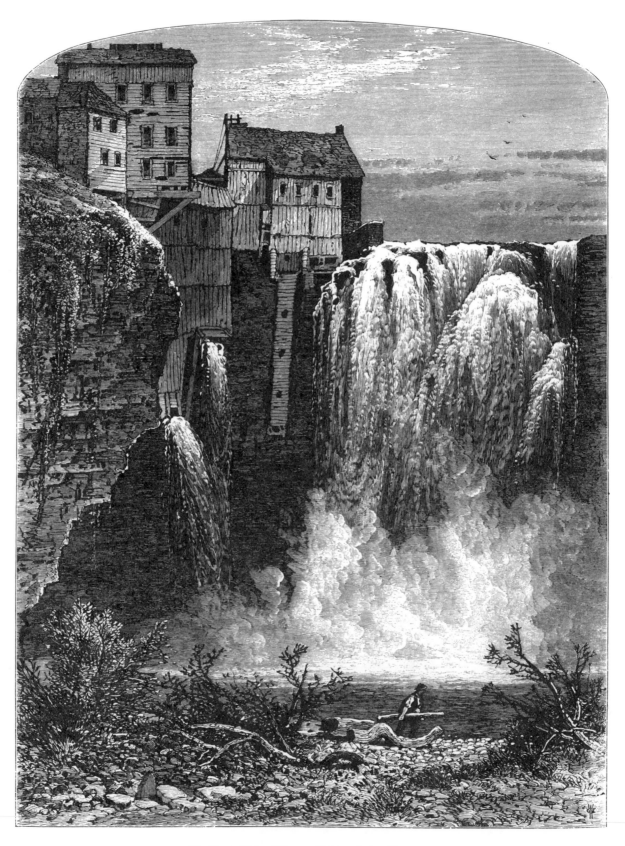

78 East Side, Upper Falls of the Genesee

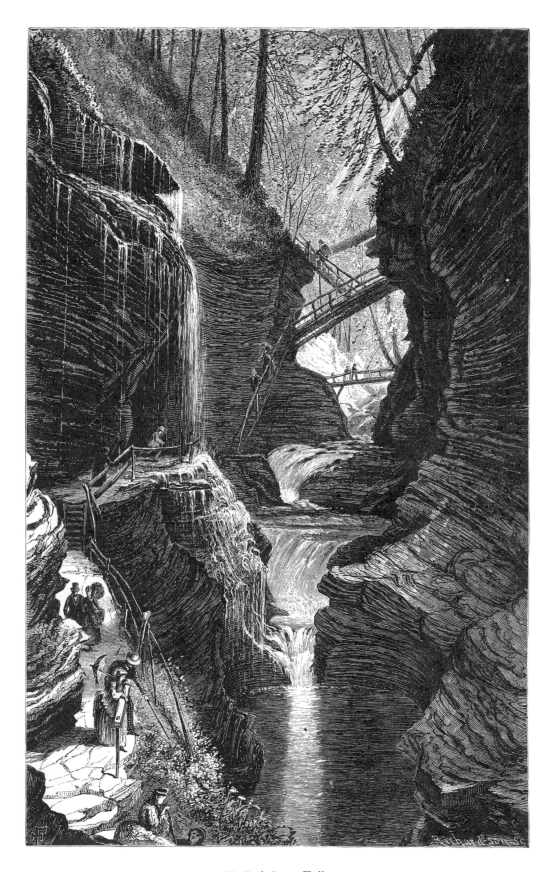

79 Rainbow Falls

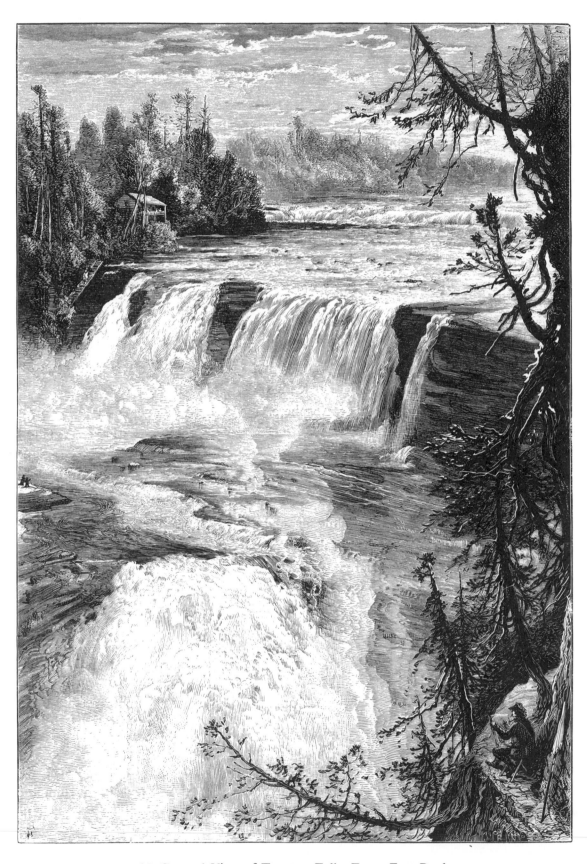

80 General View of Trenton Falls, From East Bank

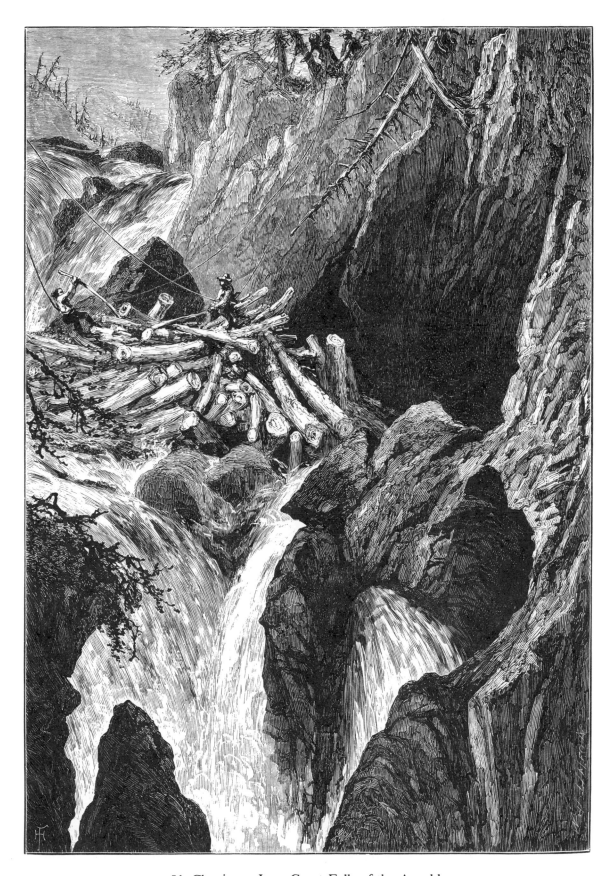

81 Clearing a Jam, Great Falls of the Ausable

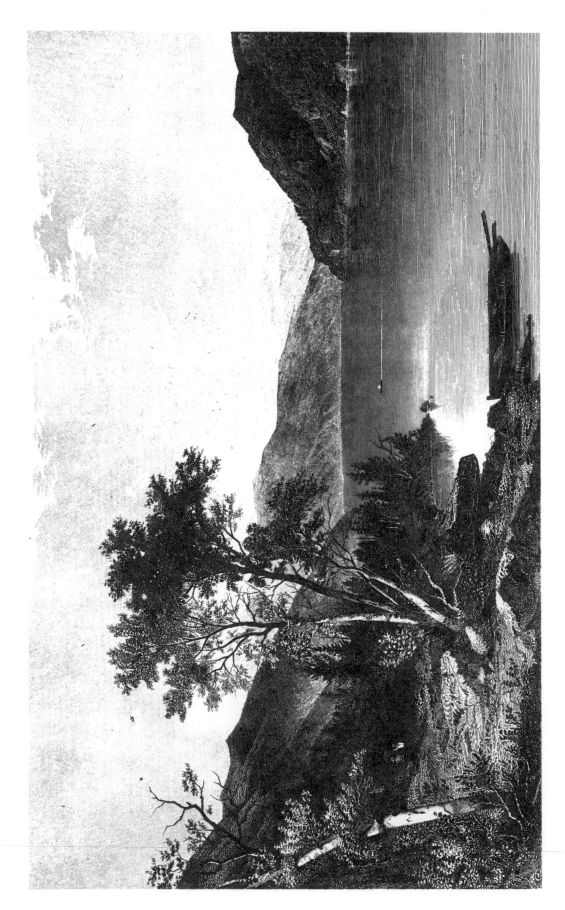

82 Lake George

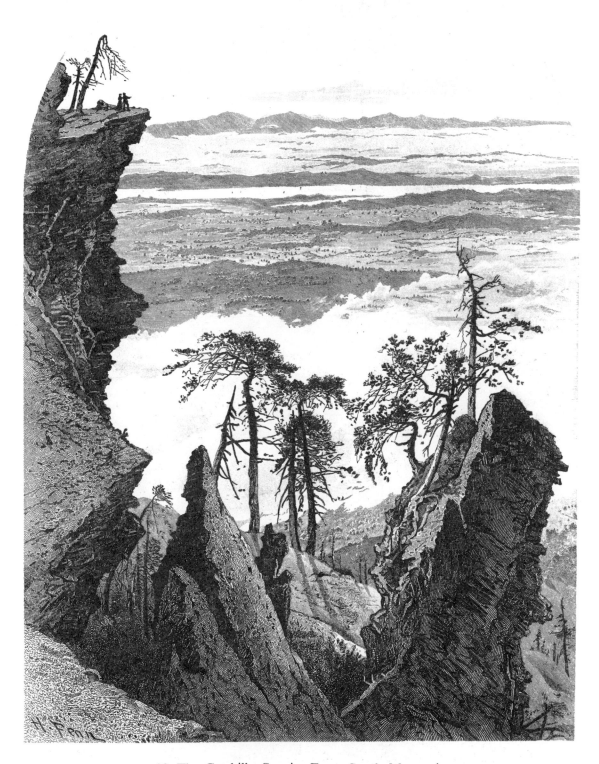

83 The Catskills: Sunrise From South Mountain

84 Adirondack Woods

85 West Point and the Highlands

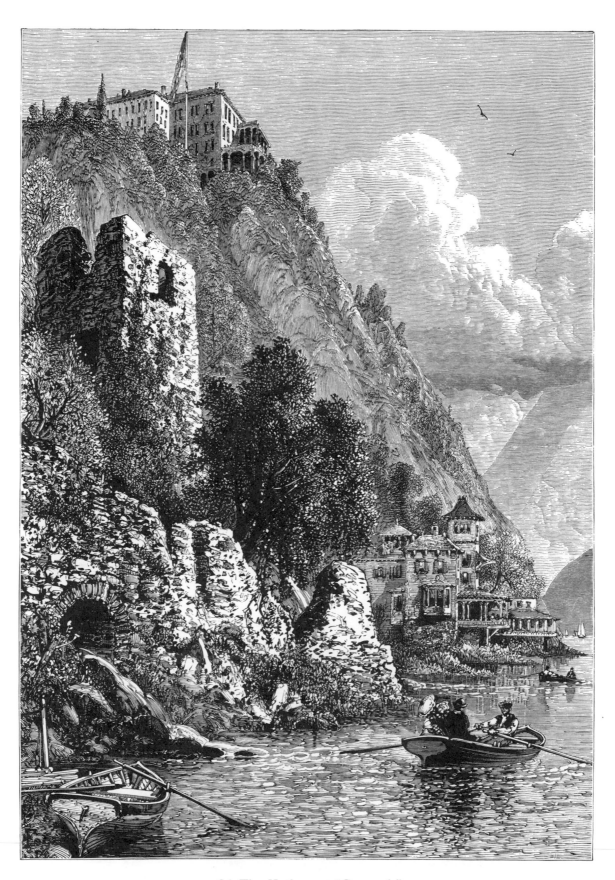

86 The Hudson at "Cozzens's"

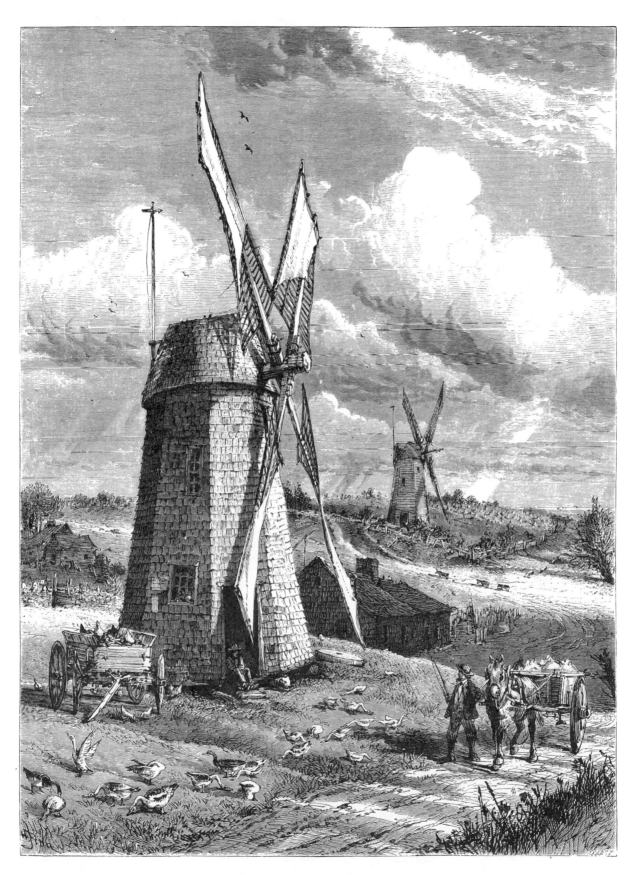

87 Grist Wind-Mills at East Hampton

88 Scene on the East River

89 The Passaic, Below Little Falls

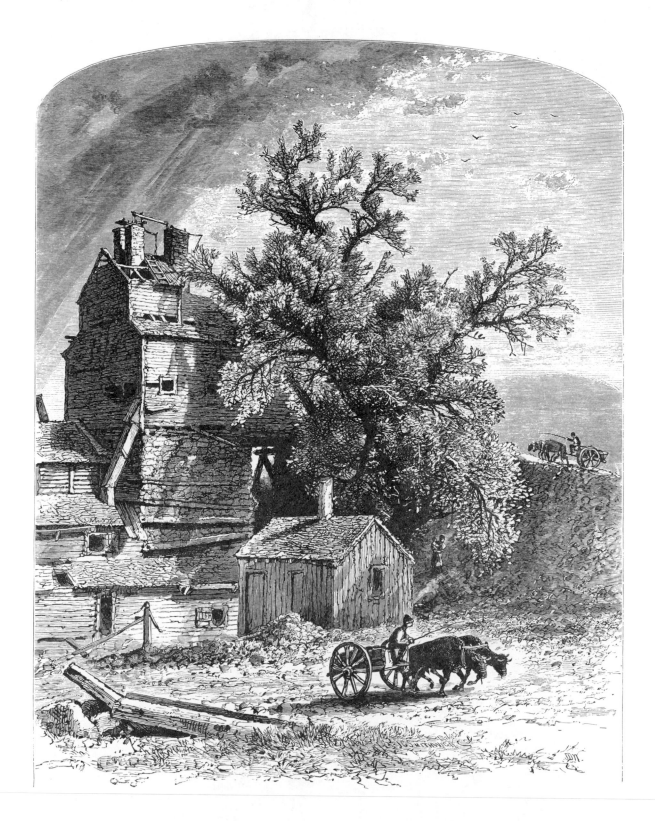

90 Old Furnace, at Kent Plains

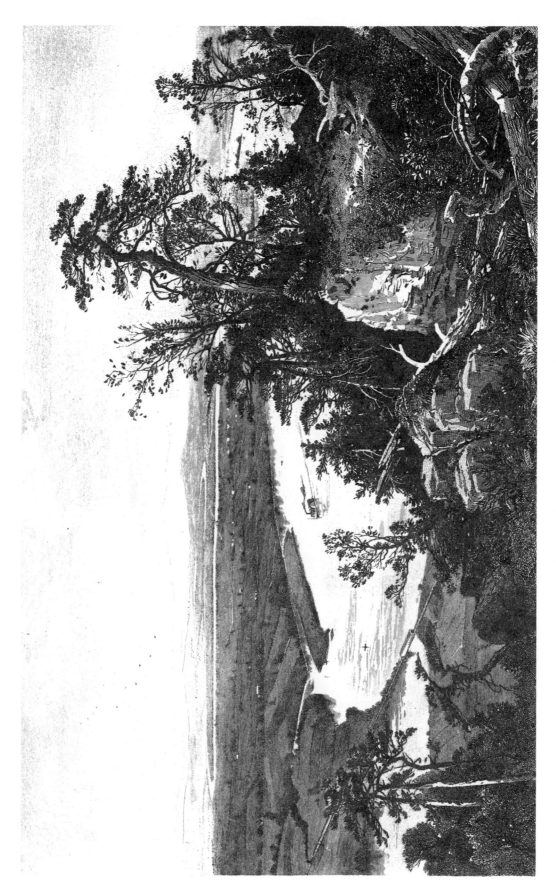

91 Connecticut Valley From Mount Tom

92 East Rock, New Haven

93 The Housatonic

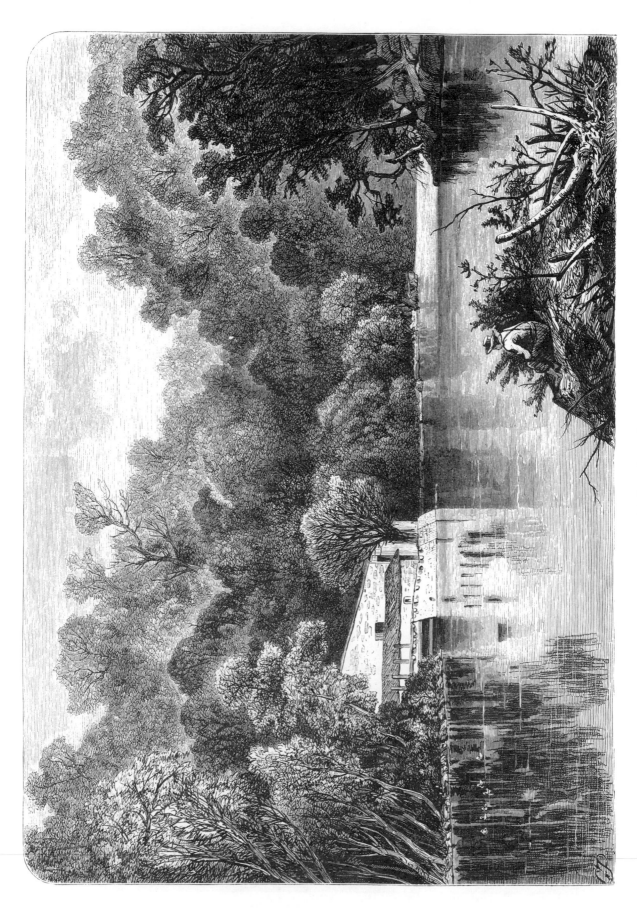

94 Powder-Mills

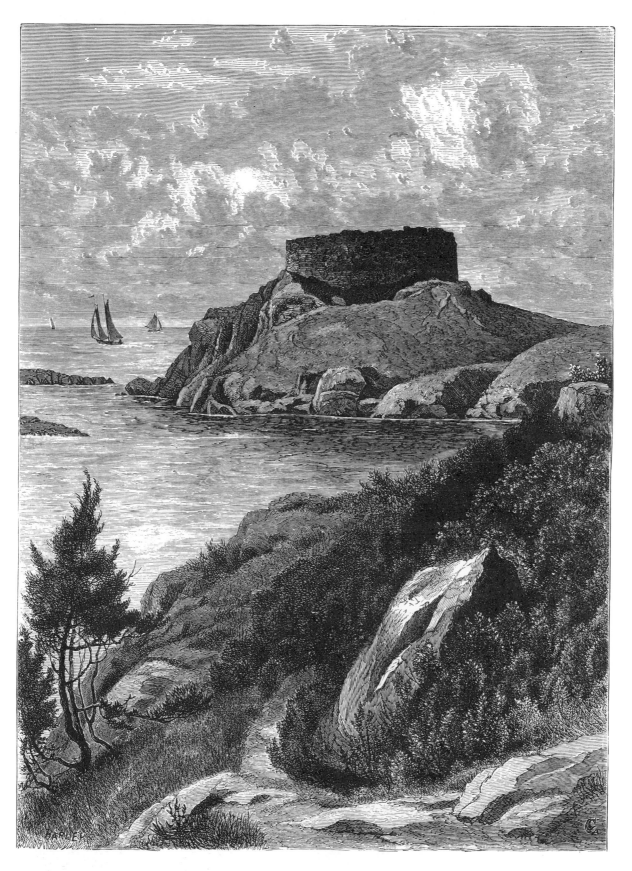

95 Old Fort Dumpling

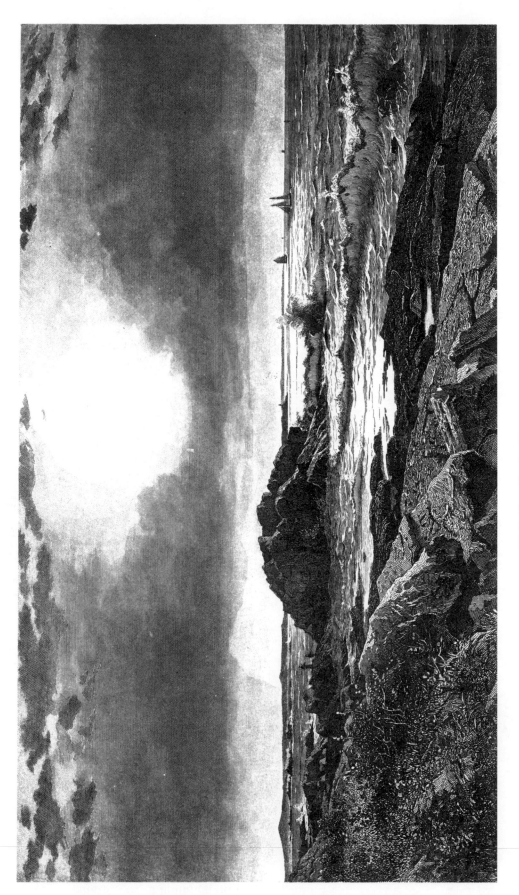

96 Indian Rock, Narragansett

97 Mills on Blackstone River

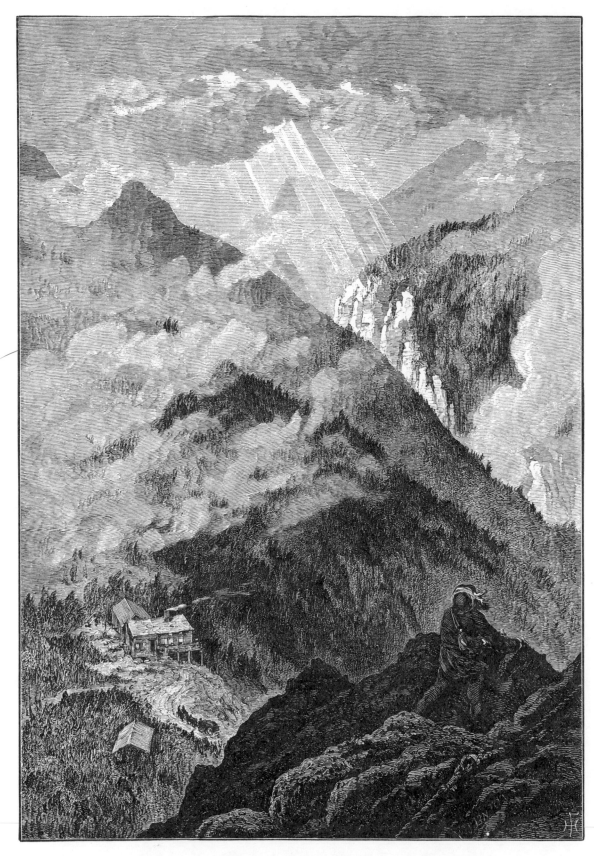

98 Looking Toward Smuggler's Notch, From the Nose

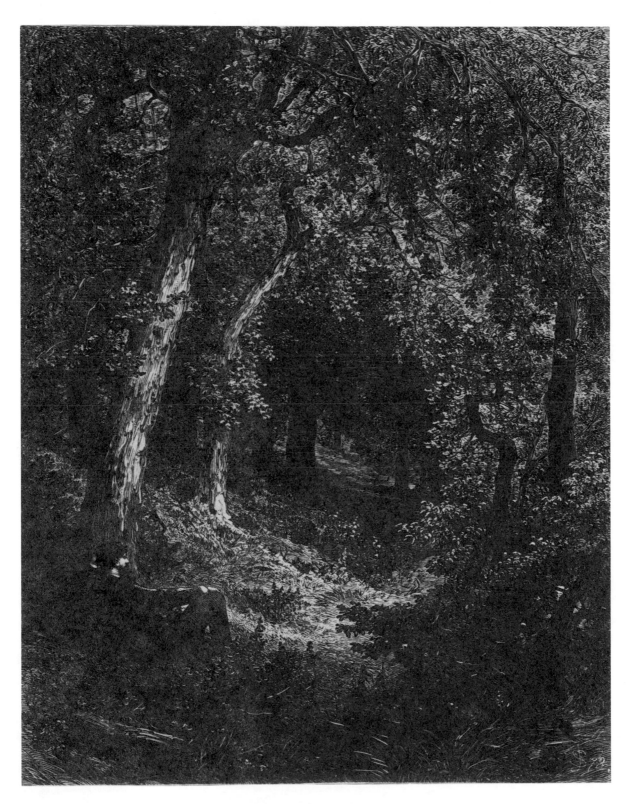

99 Untitled Forest Scene

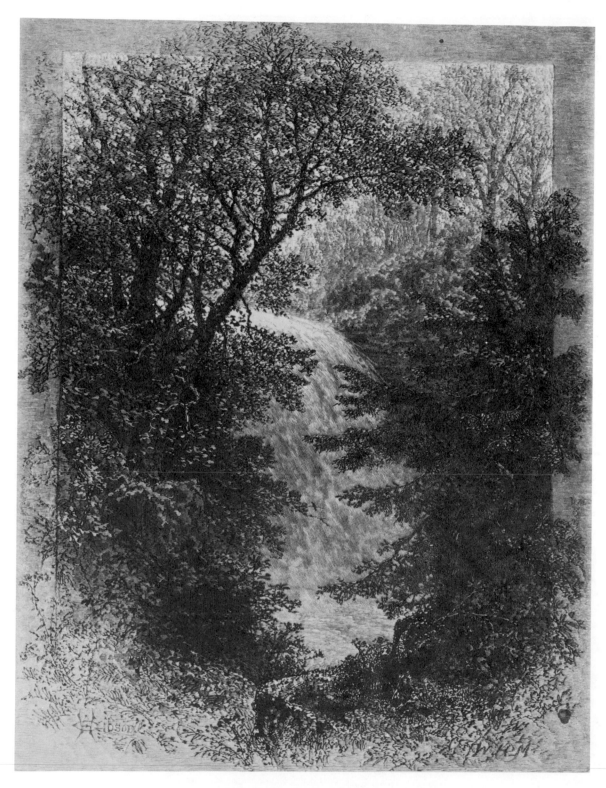

100 Falls of Minnehaha

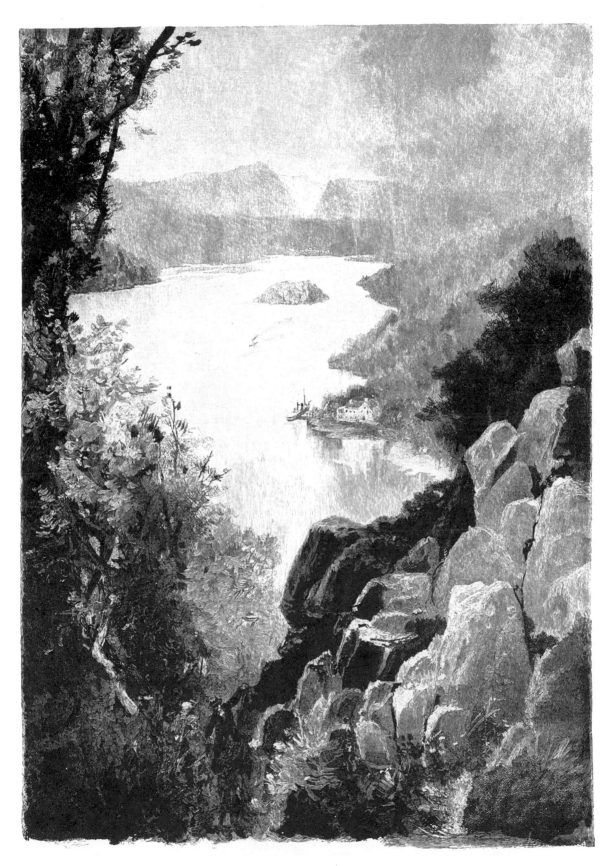

101 Lake Memphremagog, From Owl's Head

102 Sunrise on Lake Superior

103 Lake of the Woods

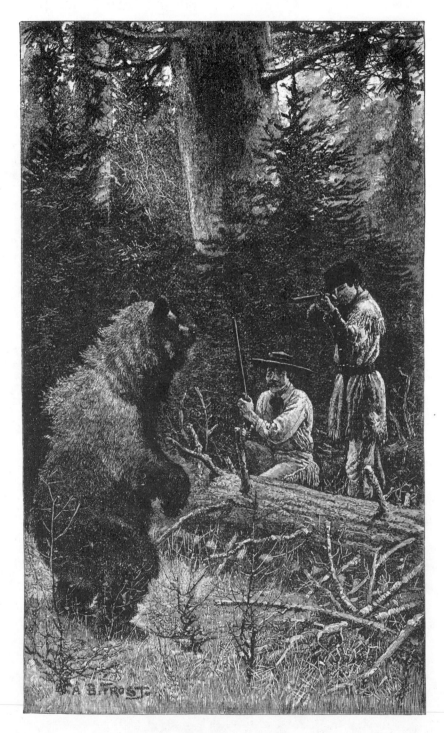

104 The Death of Old Ephraim

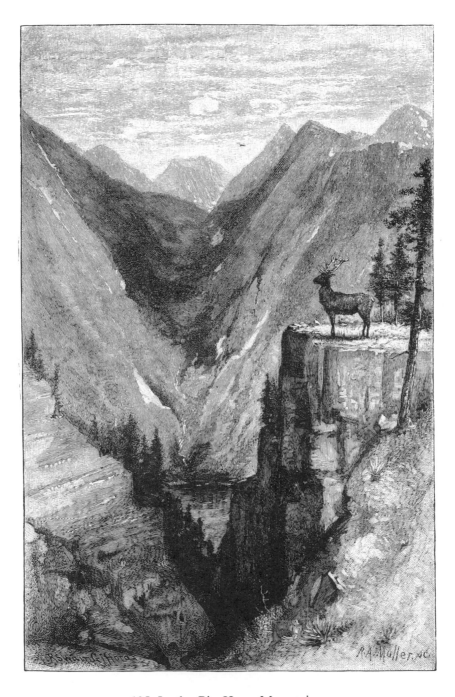

105 In the Big Horn Mountains

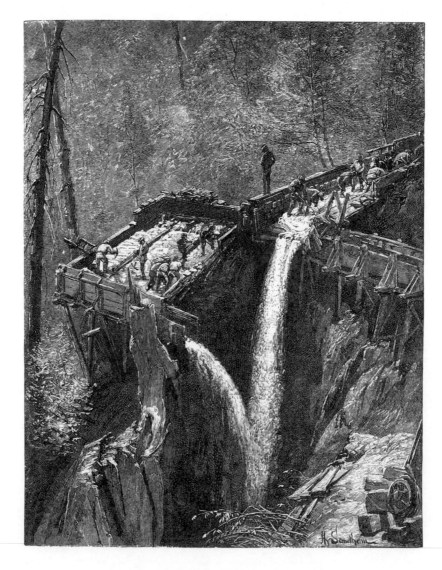

106 Clearing Up Under-Currents

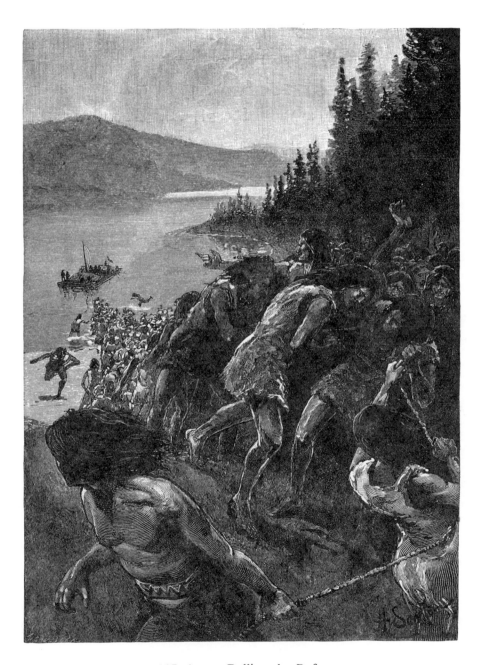

107 Ayans Pulling the Raft

108 Wood-Engraving From Nature

109 Life and Death

The Descent From Mount Washington, by Harry Fenn,
Picturesque America, 1872

Captions
and
Commentary

Note: The fullest or most usually signed form of an artist's or engraver's name is given the first time it is cited; thereafter, initials and surname are used. Vertical dimensions are listed first, horizontal second. *American Scenery* and *Picturesque America* are referred to by abbreviations after their first citations. Spelling and capitalization of titles reflect as closely as possible those that appear in the original publications. The bibliography is selective; although there are few books specifically about nineteenth-century American illustration and engraving, it attempts to provide 'further reading.' Of necessity, some primary sources and specialized secondary sources, difficult to obtain, have been cited for their usefulness in preparing this book.

1 **Natives of Oonalashka, and their Habitations.** Artist: John Webber; engravers: G. Hall and F. Middiman; steel engraving; 8-5/8 × 14-3/4 in.; Captain James Cook and Captain James King, *A Voyage to the Pacific Ocean in the years 1776, 1777, 1778, 1779 and 1780,* atlas volume, 1784. Cook and his party found the villages of the Aleut people distasteful, smelling "most abominably of rotten Fish & other Filth which are suffer'd to lie about," as one officer, David Samwell, wrote. Webber produced this view of the Aleuts, which creates a surreal sense of silence, isolation, and primitive, dispirited activity. Unalaska is one of the largest islands of the Aleutian chain, about 150 miles southwest of the tip of the Alaska Peninsula.

2 **A Canoe of the Sandwich Islands, the Rowers Masked.** Artist: J. Webber; engraver: C. Grignion; steel engraving; 8-5/8 × 14-5/8 in.; Cook and King, *A Voyage...,* atlas volume, 1784. An element of fantasy is added to this dynamic scene by the strange hoods of the rowers, with crests of foliage and hanging tassels. Webber also made a portrait of a man in such a mask. However, the masks are not described in the literature produced by the Cook party members and remain unknown to subsequent investigators.

3 **Village of Catskill, Hudson River.** Artist: William Henry Bartlett; engraver: J. C. Bentley; steel engraving 4-13/16 × 7-1/8 in.; *American Scenery,* Vol. II, 1840 (hereafter designated *AS* II). Thomas Cole first resided at Catskill in 1827 and established a permanent home there after returning from his first European trip in 1829. It was this trip that initiated the markedly picturesque middle phase of Cole's career, exemplified by the five "Course of Empire" pictures completed in 1836. There is no direct indication that Cole and Bartlett knew of one another.

4 **The Two Lakes and the Mountain House on the Catskills.** Artist: W. H. Bartlett; engraver: J. C. Bentley; steel engraving; 4-3/4 × 7-1/8 in.; *American Scenery,* Vol. I, 1840 (hereafter designated *AS* I). Like many of Bartlett's American pictures, this one exemplifies Burke's concept of the sublime. Light is used to create extreme contrasts, the darkened chasm and mountainside framing the glowing level of the lakes. Nature's vastness is seen in the deep distances at left (the Hudson valley) and right. The twisted trees allude to the power of time and the elements, while the hunters on the foreground cliffs suggest the danger posed to man by nature, even in its brooding silent peace.

5 **The Catterskill Falls (From Below).** Artist: W. H. Bartlett; engraver: E. Benjamin; steel engraving; 7-1/16 × 4-3/4 in.; *AS* II. "From thence, literally buried in forest foliage, the tourist will enjoy a very ... striking and picturesque view ... The stream, at a vast height above him, is seen leaping from ledge to ledge—sometimes lost, sometimes sparkling in sunshine, until it courses impetuously beneath the rock on which he is seated, and is lost in the deep unbroken obscurity of the forest. The rocky ledges above, worn by time, have the appearance of deep caverns, and beautifully relieve the fall of the light and silvery stream." (N. P. Willis)

6 **Winter Scene on the Catterskills.** Artist: W. H. Bartlett; engraver: J. Rogers; steel engraving; 4-9/16 × 7-3/8 in.; *AS* II.

7 **Bridge at Glen's-Fall (on the Hudson).** Artist: W. H. Bartlett; engraver: F. W. Topham; steel engraving; 4-3/4 × 7-1/4 in.; *AS* II.

8 **Scene Among the Highlands on Lake George.** Artist: W. H. Bartlett; engraver: J. T. Willmore; steel engraving; 4-13/16 × 7-3/16 in.; *AS* II. In his "Essay on American Scenery" (1835), Thomas Cole conveyed in words the qualities of Lake George so well captured by Bartlett in this picture: "I would rather persuade you to visit the 'Holy Lake,' the beautiful 'Horican,' than attempt to describe its scenery—to behold you rambling on its storied shores, where its southern expanse is spread, begemmed with isles of emerald, and curtained by green receding hills—or to see you gliding over its bosom, where the steep and rugged mountains approach from either side, shadowing with black precipes the innumera-

ble islets—some of which bearing a solitary tree, others a group of two or three, or a 'goodly company,' seem to have been sprinkled over the smiling deep in Nature's frolic hour."

9 **View of the Ruins of Fort Ticonderoga.** Artist: W. H. Bartlett; engraver: T. A. Prior; steel engraving; 4-11/16 × 7-3/8 in.; *AS* I. On the shore of Lake Champlain in northeastern New York, Fort Ticonderoga was captured by Ethan Allen and the Green Mountain Boys in one of the first important actions of the Revolution. In picturesque fashion, Bartlett shows nature's re-absorption of man's work, reduced to inert and broken forms. This inevitable process has its benign and providential aspects, however. The foreground sheep and the sailboats sparkling in the luminous distance suggest that the ancient fort is part of a heritage of freedom and virtue, and is returning gently to the peace of nature.

10 **Squawm Lake (New Hampshire).** Artist: W. H. Bartlett; engraver: G. K. Richardson; steel engraving; 4-11/16 × 7-1/4 in.; *AS* I. "The great defect in American lakes, generally, is the vast, unrelieved expanse of water, without islands and promontories, producing a fatigue in the eye similar to that of the sea. Squawm and Winipiseogee Lakes are exceptions ..." (N. P. Willis) Many American artists have not agreed with Willis on this point, with regard either to the lakes or to the sea. Squawm Lake is in central New Hampshire just to the northwest of Lake Winnipesaukee, as it is called today.

11 **Mount Washington, and the White Hills (From Near Crawford's).** Artist: W. H. Bartlett; engraver: W. T. Davies; steel engraving; 4-7/8 × 7-1/4 in.; *AS* I. Mount Washington, in southern Coos Country, the northernmost of New Hampshire's ten counties, is the state's highest peak (6,228 ft.).

12 **The Silver Cascade, in the Notch of the White Mountains.** Artist: Thomas Doughty; engraver: F. J. Hevell; steel engraving; 6-7/8 × 5-1/16 in.; *AS* II. A self-taught painter, Doughty suddenly abandoned a business career in 1820 to become America's first artist to specialize in landscapes. This engraving, made from one of his paintings, captures the spaciousness, the gentle poetry, and the silvery tones characteristic of Doughty. These qualities influenced such later American painters as the Luminists, including Thomas Worthington Whittredge, and the Mystics, including Albert Ryder.

13 **Desert Rock Light House (Maine).** Artist: T. Doughty; engraver: W. Radclyffe; steel engraving; 4-11/16 × 7-3/16 in.; *AS* II. Willis comments: "Successful as Mr. Doughty is in sketches of this description, his forte lies in scenery of a softer and inland character—in the lonely forest-brook, the misty wood-lake, the still river, the heart of the quiet wilderness. In painting these features of Nature, he has (in his peculiar style) no rivals among American painters—perhaps none in England. His landscapes can scarcely be appreciated by those who have not seen the untouched and graceful wilderness of America ..."

14 **The Horse Shoe Fall, Niagara—With the Tower.** Artist: W. H. Bartlett; engraver: R. Brandard; steel engraving; 4-3/4 × 6-15/16 in.; *AS* I. Willis writes, "The Horse-shoe Fall, as a single object, ... is unquestionably the sublimest thing in nature." This is just what Thomas Jefferson thought of Virginia's Natural Bridge. Bartlett's view of the Falls, from Goat Island in the Niagara River, does not show the American (Rainbow) Falls.

15 **Lockport, Erie Canal.** Artist: W. H. Bartlett; engraver: W. Tombleson; steel engraving; 4-11/16 × 7-3/16 in.; *AS* I. At Lockport, about twenty miles east of Niagara Falls, the waters of Lake Erie were let down sixty feet by five double locks. Bartlett pays homage to this work of man, giving it a picturesque sense of great depth and extent. The lounging figures of the workmen seem full of security, yet Bartlett insists on human contingency in his depiction of buildings, especially the rickety foreground structure with its long, fragile-looking stairs and balconies—an idea repeated in the distant bridge.

16 **View on the Erie Canal, Near Little Falls.** Artist: W. H. Bartlett; engraver: J. T. Willmore; steel engraving; 4-3/4 × 7-7/16 in.; *AS* I.

17 **Rail-Road Scene, Little Falls (Valley of the Mohawk).** Artist: W. H. Bartlett; engraver: R. Sands; steel engraving; 4-3/4 × 7-3/8 in.; *AS* I. Little Falls is about fifteen miles east of Utica.

18 **The Genessee Falls, Rochester.** Artist: W. H. Bartlett; engraver: J. Cousen; steel engraving; 4-11/16 × 7 in.; *AS* I. Cousen, like others of Bartlett's engravers, engraved pictures by many of England's great nineteenth-century artists, including J. M. W. Turner.

19 **Faneuiel Hall, Boston.** Artist: W. H. Bartlett; engraver: H. Griffiths; steel engraving; 4-15/16 × 7-1/4 in.; *AS* I.

20 **Yale College (New Haven).** Artist: W. H. Bartlett; engraver: J. Sands; steel engraving; 4-3/4 × 7-5/16 in.; *AS* I.

21 **Fairmount Gardens, With the Schuylkill Bridge (Philadelphia).** Artist: W. H. Bartlett; engraver: J. Giles; steel engraving; 4-3/4 × 7-3/16 in.; *AS* II.

22 **Natural Bridge, Virginia.** Artist: W. H. Bartlett; engraver: J. C. Armytage; steel engraving; 7-5/16 × 5-1/16 in.; *AS* II.

23 **The Tomb of Washington, Mount Vernon.** Artist: W. H. Bartlett; engraver: J. Cousen; steel engraving; 7-3/16 × 4-3/4 in.; *AS* I. Willis: "A more romantic and picturesque site for a tomb can scarcely be imagined. Between it and the Potomac is a curtain of forest-trees, covering the steep declivity to the water's edge, breaking the face of the prospect, and yet affording glimpses of the river, where the foliage is thickest. The tomb is surrounded by several large native oaks, which are venerable by their years, and which annually strew the sepulchre with autumnal leaves, furnishing the most appropriate drapery for the place,

and giving a still deeper impression to the memento mori. Interspersed among the oaks, and overhanging the tomb, is a copse of red cedar, whose evergreen boughs present a fine contrast to the hoary and leafless branches of the oak, and while the deciduous foliage of the latter indicates the decay of the body, the eternal verdure of the former furnishes a fitting emblem of the immortal spirit."

24 **View of Baltimore.** Artist: W. H. Bartlett; engraver: S. Fisher; steel engraving; 4-3/4 × 7-3/16 in.; *AS* II. Bartlett's Baltimore might almost be Constantinople, and in fact this picture is almost identical in composition to one of that city, "Constantinople, from Scutari," which appeared as a steel engraving in Julia Pardoe's *The Beauties of the Bosphorus* (London: George Virtue, 1839), published just before *American Scenery.* Bartlett's Constantinople too is a white city on a gentle rise, viewed from a rough foreground across a bay dotted with sailing vessels. The nine towers, chimneys and steeples and the two domes that define Baltimore's skyline here give much the same impression as the eighteen minarets and eight domed mosques that can be counted in the Constantinople view.

25 **The Valley of the Shenandoah, from Jefferson's Rock (Harper's Ferry).** Artist: W. H. Bartlett; engraver: J. T. Willmore; steel engraving; 4-3/4 × 7-1/16 in.; *AS* I. Harper's Ferry, near the confluence of the Shenandoah and the Potomac, is in southeastern West Virginia, but belonged to Virginia in the pre-Civil War America that Bartlett visited.

26 **Harper's Ferry (From the Blue Ridge).** Artist: W. H. Bartlett; engraver: G. Mills; steel engraving; 4-3/4 × 7-1/4 in.; *AS* II.

27 **Hanapepe Valley.** Artist: Alfred T. Agate; engraver: Joseph Andrews; steel engraving; 6-1/16 × 4-9/16 in.; Charles Wilkes, U.S.N., *Narrative of the United States Exploring Expedition During the Years 1838, 1839, 1840, 1841, 1842,* 1844; illustrations reproduced from the Putnam edition of 1856. Agate (1812-48) contributed designs for 105 wood engravings, 48 full-page steel-engraved plates and 23 steel-engraved vignettes in Wilkes' *Narrative.* The wood engravings are slight and their execution is indifferent, but the complex steel engravings are in many cases excellent picturesque art works, as here. The Hanapepe River flows from the central highlands to the south shore of Kauai, the northernmost of the major Hawaiian islands.

28 **View of Crater, Kilauea.** Artist: Joseph Drayton; engravers: Jordan and Halpin; steel engraving; 4-5/8 × 7-1/16 in.; Wilkes, *Narrative,* 1856. Drayton was the other artist attached to the Wilkes expedition, and was in charge of finding engravers for the publication. Wilkes wrote, "The distribution among the engravers has given general satisfaction ... and has afforded a national encouragement to this description of art, the benefit of which it will long continue to feel." Kilauea is in Hawaii National Park in the south central region of Hawaii, the largest of the islands.

29 **Grove of Tutui Trees, Kauai.** Artist: A. T. Agate; engraver: J. A. Rolph; steel engraving; 4-13/16 × 7-5/16 in.; Wilkes, *Narrative,* 1856.

30 **Shasta Peak.** Artist: A. T. Agate; engraver: G. B. Ellis; steel engraving; 4-1/2 × 7 in.; Wilkes, *Narrative,* 1856. Mt. Shasta (14,162 ft.) is in Siskiyou County near the northern border of California. In the true sublime manner, Agate portrays Mt. Shasta as the home of a god, or God; the combination of living and fallen trees suggest both the bounty of this deity and its control over the inevitable cycle of life and death, while the attitudes of the foreground Indians convey man's powerlessness and worshipful awe.

31 **Indian Woman Procuring Fuel.** Artist: Seth Eastman; engravers: C. E. Wagstaff and John Andrews; steel engraving 7-7/16 × 5-15/16 in.; Henry Rowe Schoolcraft, *Historical and statistical information respecting the history, condition and prospects of the Indian tribes of the United States,* Vol. II, 1853. Known primarily as one of the earliest painters of the western frontiers, Eastman produced most of the pictorial, non-scientific illustrations for Schoolcraft's six-volume report. Eastman's idealized, bucolic vision here seems to remove all weight from the woman's load, and renders her as a picturesque image of harmonious, if difficult and primitive, association of man with nature. Quite different are Schoolcraft's remarks on the difficulty of woman's lot among the Indians; in his "List of Plates" to the volume, he retitles Eastman's picture "Severity of Female Labor."

32 **Ceremony of the Thunderbird (Sioux).** Artist: F. B. Mayer; engraver unknown; steel engraving; 5-9/16 × 7-7/8 in.; Schoolcraft, Vol. VI, 1856. Most of the Schoolcraft report's pictures of the Sioux (Dacotah) tribe come from the vicinity of the St. Peters River Valley, Minnesota.

33 **A Seer Attempting to Destroy an Indian Girl by a Pencil of Sunlight.** Artist: S. Eastman; engraver: R. Hinshelwood; steel engraving; 6 × 8-5/16 in.; Schoolcraft, Vol. V, 1855. This bizarre scene is apparently an imaginative portrayal by Eastman of an event described to him by Schoolcraft. The only explanation Schoolcraft offers is as follows: "He [the Indian] is under the influence of a set of dreaming priests and necromantic manipulators who ... bind his will down ... to the dark doctrines of daemonology, witchcraft, sorcery, and magic. Such is the subtilty of this belief, that even a beam of light, emitted through an orifice in the wigwam, can become the medium of conveying a malign and deadly influence on the slumbering victim. (An incident of this kind occurred among the Chippewa, during my residence at St. Mary's, at the foot of Lake Superior.)"

34 **Indian Medas Secretly Showing the Contents of Their Medicine Sacks to Each Other.** Artist: S. Eastman; engraver: R. Hinshelwood; steel engraving; 5-13/16 × 8-3/8 in.; Schoolcraft, Vol. V, 1855.

35 **Winnebago Wigwams.** Artist: S. Eastman; engraver: Robert Hinshelwood; steel engraving; 5-5/8 × 8-1/8 in.; Schoolcraft, Vol. II, 1853. This scene is probably also in present-day Minnesota; the Winnebago were a neighbor tribe of the Dacotah. Hinshelwood's signature is found on outstanding steel and wood engravings from the 1850s through the 1880s.

36 **Spearing Fish in Winter.** Artist: S. Eastman; engravers: C. E. Wagstaff and J. Andrews; steel engraving; 5-7/8 × 7-7/8 in.; Schoolcraft, Vol. II, 1853.

37 **Chinook Burial.** Artist: J. M. Stanley; engraver: James D. Smillie; steel engraving; 5-7/16 × 7-15/16 in.; School-craft, Vol. VI, 1856. The scene in Oregon portrays a form of burial among a seafaring tribe that is very similar to the platform burial observed among Plains tribes. The engraving is by the younger James Smillie, whose engravings included illustrations by Darley for the novels of Dickens and Cooper.

38 **Nocturnal Grave Light.** Artist: Captain A. A. Gibson; engraver: J. C. McCrae; steel engraving; 7-15/16 × 6-1/2 in.; Schoolcraft; Vol. V, 1855. Although Eastman was the principal artist for the Schoolcraft report, others contributed to it, including Schoolcraft himself. Eastman, like Gibson, was a United States Army captain at the time the drawings were made. Both artists and writers in the report were very interested in Plains and western Indian burial ceremonies.

39 **Castle Rock.** Artist: R. Swain Gifford; engraver: John Filmer; wood engraving; 8-3/4 × 5-13/16 in.; *Picturesque America*, Vol. I, 1872 (hereafter designated *PA* I). The picture of this rock formation above the cascades of the Columbia glimpses both Washington and Oregon: at this point, as for most of its length, the river lies between the two states.

40 **Mount Shasta.** Artist: J. D. Smillie; engraver: E. P. Brandard; steel engraving; 5-11/16 × 9-1/4 in.; *PA* I.

41 **Native Californians Lassoing a Bear.** Artist: Felix Octavius Carr Darley; engraver: Francis Holl; steel engraving; 5-15/16 × 8-7/16 in.; *Picturesque America*, Volume II, 1872 (hereafter designated *PA* II). Darley achieved his first prominence as an illustrator of Washington Irving. The influence of his earliest work illustrating native humorists never left him, and he specialized in depicting character and dramatic situations through a firm, highly individual drawing style. His work was perfectly adapted to be presented through engravings, and here the steel engraver Francis Holl minimizes the tonal subtlety characteristic of his medium to emphasize Darley's strong draughtsmanship. The picturesqueness of this struggle is enhanced by the silence of the mist-shrouded forest background and the primitive quality of the hunters, seen for instance in their weapons, the lasso and the smoothbore flintlock firearms.

42 **Yosemite Fall.** Artist: J. D. Smillie; engraver: Alfred F. Harral; wood engraving; 8-7/8 × 6-3/16 in.; *PA* I. The Yosemite Valley is in California's Sierra Nevadas about 150 miles east of San Francisco. English-born Alfred Harral here uses all the resources of both black and white line engraving techniques, and a variety of fine shading methods, to create a print of great clarity and beauty.

43 **Big Trees—Mariposa Grove.** Artist: J. D. Smillie; engraver: J. Filmer; wood engraving; 8-7/8 × 6-3/16 in.; *PA* I. Smillie both illustrated and wrote the chapter from which this picture comes, "The Yosemite Falls." His text analyzes the sublime religion-of-nature emotion expressed in his illustration: "the booming of the rapidly-nearing storm, as its echoing waves of sound rolled through the pillared forest that seemed to stand dumbly expectant, was to me the grand original, of which grimly-solemn cathedral and deepest organ-note are but a type."

44 **Mirror Lake, Yosemite Valley.** Artist: Harry Fenn; engraver: S. V. Hunt; steel engraving; 5-1/8 × 7-7/8 in.; *PA* I. The hyper-realistic clarity created by Hunt's extremely fine engraving technique complements Fenn's interpretation of the lake's mysterious mirror, in which the earth is doubled and it is hard to tell whether the upper or the lower reality is most real. So fascinating is this paradox that the eye almost misses the life and death struggle that occurs in the foreground, where hunters in a boat chase a desperately swimming deer through the preternatural calm of the scene.

45 **Lake Tahoe.** Artist: Thomas Moran; engraver: John Karst; wood engraving; 6-1/4 × 9 in.; *PA* II. On the California-Nevada border.

46 **Emigrants Crossing the Plains.** Artist: F. O. C. Darley; engraver: H. B. Hall Jr.; steel engraving; 5-5/8 × 8-7/16 in.; *PA* II. The scene is in Utah.

47 **Terres Mauvaises, Utah.** Artist: T. Moran; engraver: J. Filmer; wood engraving; 6-5/16 × 9-5/16 in.; *PA* II. Near Great Salt Lake.

48 **Monument Rock, Echo Cañon.** Artist: Thomas Moran; engraver: F. W. Quartley; wood engraving; 8-15/16 × 6-3/16 in.; *PA* II. Monument Rock is on the Weber River near Ogden in the northern stem of Utah. E. L. Burlingame, author of the *Picturesque America* chapter from which Moran's picture comes, had this comment on the scene: "It is a great ruin of Nature, not of human structure; and its grandeur is different in kind and in degree from those other relics in an older world . . . which hold for us everywhere memories of human toil and action."

49 **Kanab Cañon.** Artist: T. Moran; engraver: Andrew Varick Stout Anthony; wood engraving; 9-1/4 × 6-1/4 in,; *PA* II. Kanab Canyon is in southwest Utah, just north of Arizona and the Grand Canyon. Although Moran and a

Picturesque America writer were with Colonel John Wesley Powell during his exploration of this spot, Moran designed his illustration from a photograph by expedition photographer John K. Hillers. He made a monumental painting from it in 1891, which he retouched in 1892 and sent to Powell; it later hung in the National Museum. The central red limestone tower is about 800 feet high and the rock walls in the distance over 4,000.

50 **The Upper Yellowstone Falls.** Artist: T. Moran; engraver: S. V. Hunt; steel engraving; 8-1/2 × 5-3/4 in.; *PA* I. On the Yellowstone River north of Yellowstone Lake in northwestern Wyoming. O. B. Bunce, *Picturesque America*'s editor under the supervision of William Cullen Bryant, wrote that the Yellowstone area exhibits "the grand and magnificent in its snow-capped mountains and dark canons, the picturesque in its splendid water-falls and strangely-formed rocks, the beautiful in the sylvan shores of its noble lakes, and the phenomenal in its geysers, hot springs, and mountains of sulphur."

51 **The Giant Geyser.** Artist: H. Fenn; engraver: William James Linton; wood engraving; 9-1/16 × 6-1/4 in.; *PA* I. In Yellowstone National Park. Two English-born Americans, illustrator Fenn and engraver Linton, collaborated to produce this charming view, strongly reminiscent in mood of early naive illustrations of the natural wonders of America. The foreground figure is an eighteenth and early nineteenth-century type resembling those used by Thomas Bewick.

52 **Cliffs of Green River.** Artist: T. Moran; engraver: W. Roberts; wood engraving; 6-1/4 × 9-1/4 in.; *PA* II. In southern Wyoming.

53 **Mountain of the Holy Cross.** Artist: T. Moran; engraver: J. Augustus Bogert; wood engraving; 8-15/16 × 6-1/8 in.; *PA* II. This mountain (14,005 ft.) is in central Colorado about 100 miles west of Denver.

54 **The Rocky Mountains.** Artist: Thomas Worthington Whittredge; engraver: R. Hinshelwood; steel engraving; 5-1/4 × 8-7/8 in.; *PA* II. This is one of a class of pictures of the majestic Rockies rising above the plains that was popular in engraved form at least since 1822-23, when Edwin James published *Account of an Expedition ... to the Rocky Mountains,* containing such a view of the mountains by an artist named Seymour. Later examples include another by Whittredge, "Home of the West Wind," illustrating Longfellow's *Song of Hiawatha* in the 1879-80 Houghton, Osgood and Co. edition, and several in *Picturesque Canada* (1882-84) by the American illustrator Fred B. Schell and by the Marquis of Lorne, Governor-General of Canada and son-in-law of Queen Elizabeth.

55 **The Moss-Gatherers.** Artist: Alfred R. Waud; engraver: unknown; wood engraving; 6-1/4 × 9-1/4 in.; *PA* I. T. B. Thorpe, author of the chapter "The Lower Mississippi,"

reveals the gloomy associations that Spanish moss added to this essential picturesque scene of laborers in a wilderness solitude: "This Spanish moss has been, with some truth, likened to the shattered sails of a ship torn into shreds by the storm, but still hanging to the rigging. To Chateaubriand, it suggested ghosts ..." Waud was one of the finest illustrators of his day. His versatility extended to landscape, genre and city scenes, fiction illustrations and more, and makes his illustration work comparable in range and quality to that of Homer and Darley.

56 **A Garden in Florida.** Artist: H. Fenn; engraver: Joseph S. Harley; wood engraving; 8-15/16 × 6-5/16 in.; *PA* I. Careful cultivation turned this cactus—of a species which is generally small and nondescript—into the exuberant plant that Fenn mades the centerpiece of this striking fantasy. The lush and exotic forms are pure Florida naturalism, but the combination of singular objects—bird, dog, banana bunch, fruits lying on the path—have the allegorical resonance of items in Renaissance paintings.

57 **Scene in St. Augustine—The Date Palm.** Artist: H. Fenn; engraver: J. S. Harley, wood engraving; 8-15/16 × 6-1/4 in.; *PA* I. "Rich in line" was W. J. Linton's approving comment on this cut by Harley. Linton ranked Harley—who never signed his first name or initial—and F. W. Quartley as the most consistently skillful and artistic engravers to work in *Picturesque America.*

58 **On the Coast of Florida.** Artist: H. Fenn; engraver: R. Hinshelwood; steel engraving; 5-3/8 × 9 in.; *PA* I. At the mouth of the St. John's River.

59 **A Florida Swamp.** Artist: H. Fenn; engraver: F. W. Quartley; wood engraving; 8-3/16 × 5-1/8 in.; *PA* I. Along the Ocklawaha River, northern Florida. Like Fenn's other Florida scenes, this one shows his skill and feeling with subjects entirely different for his usual northern and European landscapes and architecture. The picture is idealized in that Fenn has conveyed the sense of teeming life by including more animals than would probably be seen at once: alligators, snakes, turtles, lizards, several varieties of birds. This hyper-realistic crowding, together with firmly naturalistic drawing and engraving, gives the picture its surreal flavor.

60 **A Farm on the French Broad.** Artist: H. Fenn; engraver: J. A. Bogert; wood engraving; 8-15/16 × 6-1/4 in.; *PA* I. The scene is between Asheville in western North Carolina and the river's warm springs near the Tennessee border. F. G. deFontaine, author of the chapter "The French Broad," writes, "The fame of the beauty and the sublimity of the scenery is extensive and the realization does not belie the report. Tall, grim, old rocks lift their bold heads far, far toward the heavens, in all the sublimity of solemn grandeur; while the vision of the distant lowlands, that may be enjoyed from this summit or that, is a soft, sweet delicacy which breathes almost of the celestial..." Fenn, however, here captures the precariousness of human life

in these surroundings, which by their very magnificence create isolation and labor.

61 **Richmond From the James.** Artist: H. Fenn; engraver: R. Hinshelwood; steel engraving; 5-3/8 × 8-15/16 in.; *PA* I.

62 **Goshen Pass.** Artist: William L. Sheppard; engraver: Henry Linton; wood engraving; 7-3/16 × 6-1/8 in.; *PA* I. In Virginia west of Lexington, near the West Virginia border, Goshen Pass lies along Jackson's River, a tributary of the James. This is one of the best engravings in *Picturesque America* by the English native, Henry Linton, whom W. J. Linton characterized as one of the least satisfactory engravers to work on the project. Many of his engravings for the book are indeed sketchy compared to the general level, but this one represents very careful work.

63 **Lookout Mountain—View From the "Point."** Artist: H. Fenn; engraver: Richard L. Langridge; wood engraving; 9 × 6-3/16 in.; *PA* I. Lookout Mountain covers the area where the northwest corner of Georgia and the northeast corner of Alabama converge with the southern border of Tennessee. This view looks north to the valley of the Tennessee River and the plain on which Chattanooga is located. Fenn depicts himself sketching under a tree whose branches and flat planes of foliage repeat the rising levels of rock in the promontory.

64 **Cumberland Gap, From the East.** Artist: H. Fenn; engraver: W. H. Morse; wood engraving; 8-13/16 × 6-1/4 in.; *PA* I. Now the center of a national historic park, the famous gap lies just inside Tennessee at the point where Kentucky, Virginia and Tennessee come together. The only good opening through the Cumberland Mountains for eighty miles, it was the route that Daniel Boone and other early settlers took from Virginia to the west. Fenn's old mill stands for the isolated human settlements in the region that the *Picturesque America* text speaks of, and for the historic associations of the winding mountain road, which include the Civil War and the raids of the ancient Cherokees.

65 **Harper's Ferry by Moonlight.** Artist: Granville Perkins; engraver: R. Hinshelwood; steel engraving; 5-3/8 × 8-15/16 in.,; *PA* I.

66 **Great Falls of the Potomac.** Artist: William Ludlow Sheppard; engraver: A. F. Harral; wood engraving; 6-3/16 × 9-1/16 in.; *PA* II. North of Washington near Georgetown, where the river separates Virginia and Maryland. Harral, an English native, is one of the mid-to-late-nineteenth century "reproductive" wood engravers who strongly favored the original white-line style of Thomas Bewick; another is the American A. V. S. Anthony.

67 **The Cliffs of Seneca.** Artist: W. L. Sheppard; engraver: A. F. Harral; wood engraving; 6-1/8 × 9-1/8 in.; *PA* I. Near the mouth of the Seneca River in eastern West Virginia, north of Petersburg. All the illustrations for the chapter "In West Virginia" were drawn by the painter Sheppard after sketches by David H. Strother.

68 **The Levee at St. Louis.** Artist: A. R. Waud; engraver: W. Roberts; wood engraving; 6-1/8 × 9-1/16 in.; *PA* II.

69 **Milwaukee River, at Milwaukee.** Artist: A. R. Waud; engraver: J. Filmer; wood engraving; 6-1/8 × 8-7/8 in.; *PA* II.

70 **Silver Cascade, Michigan.** Artist: William Hart; engraver: F. W. Quartley; wood engraving; 8-15/16 × 6-1/4 in.; *PA* I. Near Munising on the north shore of the Michigan Upper Peninsula; now in the Pictured Rocks National Lakeshore.

71 **Arched Rock by Moonlight.** Artist: J. Douglas Woodward; engraver: A. Measom; wood engraving; 8-3/16 × 5-15/16 in.; *PA* I. On Mackinac Island between the Michigan mainland and Upper Peninsula. Measom—whom W. J. Linton classed with Henry Linton as one of the less accomplished of *Picturesque America*'s engravers—here provides an effective interpretation of Woodward's old-fashioned image of romantic melancholy, with the lonely traveler contemplating the full moon in a dreamlike wilderness of strange natural forms.

72 **City of Cincinnati.** Artist: A. Coolidge Warren; engraver: W. Wellstood; steel engraving; 5-3/8 × 8-3/4 in.; *PA* II. At first an engraver, Warren was a pupil of Joseph Andrews, whose work appears in Wilkes' *Narrative*.

73 **Lake Erie, From Bluff, Mouth of Rocky River.** Artist: J. D. Woodward; engraver: J. S. Harley; wood engraving; 8-7/8 × 6-1/8 in.; *PA* I. Constance F. Woolson, author of the chapter "The South Shore of Lake Erie," writes, "West of Cleveland, the coast grows more picturesque; the shore is high and precipitous, and the streams come rushing down in falls and rapids. Seven miles from the city is Rocky River, which flows through a deep gorge between perpendicular cliffs, that jut boldly into the lake and command a wide prospect."

74 **Mauch Chunk, From Foot of Mount Pisgah.** Artist: H. Fenn; engraver: R. L. Langridge; wood engraving; 8-7/8 × 6-7/16 in.; *PA* I. This coal mining village, today called Jim Thorpe, Pennsylvania, after its most famous son, is on the Lehigh River north of Allentown. The original name is a corruption of Indian words meaning "Bear Mountain."

75 **Sinking Run, Above Tyrone.** Artist: G. Perkins; engraver: F. W. Quartley; wood engraving; 9 × 6 in.; *PA* II. On the Juniata River, central Pennsylvania. R. E. Garczynski wrote in *Picturesque America*, "The scenery around is decidedly Alpine in character; and some of the roads made for the lumber business traverse regions of strange beauty."

76 **Niagara.** Artist: H. Fenn; engraver: S. V. Hunt; steel engraving; 5-1/4 × 9-3/16 in.; *PA* I.

77 **Tree Crushed by Frozen Spray.** Artist: H. Fenn; engraver: C. Maurand; wood engraving; 5-1/2 × 6-3/16 in.; *PA* I. Maurand was one of two French-born engravers who did outstanding work in *The Aldine, the Art Journal of America* after 1872. The other, Jonnard, specialized in figures whereas Maurand preferred landscapes. W. J. Linton praises the vigor of his work. The extreme simplicity of the engraving style here effectively highlights the three main elements of the picture: the mighty falls in the background, the figure group of fascinated man and dog, and most important, the ice-laden tree tortured into a strange arch.

78 **East Side, Upper Falls of the Genesee.** Artist: J. D. Woodward; engraver: W. H. Morse; wood engraving; 8-3/8 × 6-3/16 in.; *PA* II. At Portageville, Wyoming County, western New York.

79 **Rainbow Falls.** Artist: H. Fenn; engraver: J. H. Richardson; wood engraving; 8-1/2 × 5-1/4 in.; *PA* I. At Watkins Glen on the south end of Seneca Lake, New York.

80 **General View of Trenton Falls, From East Bank.** Artist: H. Fenn; engraver: R. L. Langridge; wood engraving; 9-1/8 × 6-1/4 in.; *PA* I. Fourteen miles from Utica, New York, on the Kanaba River. As often in Fenn's pictures, the artist himself—with his long hair, long mustache, and wide-brimmed hat pinned up at one side—can be seen sketching in the foreground. In true picturesque fashion, the tiny figures, precarious stairs and dwarfed house at left convey man's smallness in the face of nature's might and vast extent. This is an example of outstandingly clear and forceful engraving in service of a successful composition.

81 **Clearing a Jam, Great Falls of the Ausable.** Artist: H. Fenn; engraver: W. J. Linton; wood engraving; 9-3/16 × 6-1/4 in.; *PA* II. In northeastern New York, the Ausable River descends from the Adirondacks into Lake Champlain.

82 **Lake George.** Artist: John William Casilear; engraver: R. Hinshelwood; steel engraving; 8-15/16 × 5-5/16 in,; *PA* II. Casilear, trained as a steel engraver by Asher Brown Durand, was famous for engravings such as one he made of "A Sybil," a popular painting by Daniel Huntington, the first president of the National Academy, who was himself an engraver and illustrator as well as a painter. Casilear's gentle, lyrical style as a landscapist classes him with the Luminist painters. Here, his choice of location and treatment have created a radiant, peaceful Lake George entirely unlike the dark maze of islands and jagged trees presented by Bartlett.

83 **The Catskills: Sunrise From South Mountain.** Artist: H. Fenn; engraver: S. V. Hunt; steel engraving; 8-5/8 × 5-3/4 in.; *PA* II.

84 **Adirondack Woods.** Artist: James M. Hart; engraver: R. Hinshelwood; steel engraving; 5-11/16 × 8-7/8 in.; *PA* II.

85 **West Point and the Highlands.** Artist: H. Fenn; engraver: S. V. Hunt; steel engraving; 5-1/8 × 7-3/16 in.; *PA* II. Site of the famous military academy, West Point is on the Hudson in Orange County, southeastern New York.

86 **The Hudson at "Cozzens's."** Artist: H. Fenn; engraver: J. Filmer; wood engraving; 8-7/8 × 6-1/8 in.; *PA* II. Near West Point.

87 **Grist Wind-Mills at East Hampton.** Artist: H. Fenn; engraver: J. Karst; wood engraving; 8-7/8 × 6-3/8 in.; *PA* I. East Hampton is the easternmost town on Long Island, New York. O. B. Bunce, author of the chapter "Eastern Long Island," commented that "no town in America retains so nearly the primitive habits, tastes and ideas of our forefathers as East Hampton."

88 **Scene on the East River.** Artist: H. Fenn; engraver: unknown; wood engraving; 6-3/16 × 9-3/16 in.; *PA* II. The construction cranes atop the rising warehouse or storage elevator in the background add an industrial note to this moody and, for 1870, somewhat anachronistic waterfront scene dominated by picturesque sailing vessels. The engraver has skillfully used white line technique to create dark foreground areas—the ship at left and the water at lower right—that frame the overcast, misty harbor.

89 **The Passaic, Below Little Falls.** Artist: Jules Tavernier; engraver: J. S. Harley; wood engraving; 6-1/8 × 8-15/16 in.; *PA* II. Five miles southwest of Patterson, New Jersey. Harley's engraving style, as much as Tavernier's sensitive drawing, have created a full-scale landscape reminiscent of Thomas Bewick's bucolic vignettes.

90 **Old Furnace, at Kent Plains.** Artist: J. D. Woodward; engraver: J. G. Smithwick; wood engraving; 7-3/4 × 6-3/16 in.; *PA* II. Near Milford, Massachusetts. An early example of the industrial ruins in which America now abounds. It is portrayed here so as to convey a reminiscence of the heroic pioneer days of iron-making.

91 **Connecticut Valley From Mount Tom.** Artist: J. D. Woodward; engraver: S. V. Hunt; steel engraving; 5-3/8 × 8-7/8 in.; *PA* II. Mount Tom (1,200 ft.) is at the border of Hampden and Hampshire Counties in western Massachusetts.

92 **East Rock, New Haven.** Artist: Casimir Clayton Griswold; engraver: S. V. Hunt; steel engraving; 5-1/2 × 8-3/8 in.; *PA* II. East Rock is in the suburbs of New Haven, Connecticut; it overlooks the Quinnipac Valley.

93 **The Housatonic.** Artist: Albert F. Bellows; engraver: S. V. Hunt; steel engraving; 5-7/16 × 9 in.; *PA* II. The Housatonic rises in the Berkshire Hills of western Massachusetts and flows through western Connecticut into Long Island Sound; this view is in Massachusetts. Bellows was one of the most popular of late nineteenth-century American landscapists.

94 **Powder-Mills.** Artist: G. Perkins; engraver: Nathaniel Orr; wood engraving; 5-1/8 × 8-7/8 in.; *PA* I. The Brandywine is in southeastern Pennsylvania and Delaware; this scene is in Delaware. O. B. Bunce writes, "Other streams are perhaps as beautiful as the Brandywine, but no other unites the beauty of wooded heights and tumbling waterfalls with structures of art that give rare charm and even quaintness to the picture. What is there in an old mill by a brook that fascinates so quickly the eye of an artist and the heart of a poet?"

95 **Old Fort Dumpling.** Artist: C. Griswold; engraver: J. S. Harley; wood engraving; 8-13/16 × 6-3/8 in.; *PA* I. An English colonial installation built some time before 1778, Fort Dumpling is on Conanicut Island in the harbor of Newport, Rhode Island. T. M. Clarke, author of the chapter "Newport," writes, "it is more venerable than the Republic; and we trust that it will be left undisturbed for ages, as it is one of the few memorials in existence of our early history, and may do something to take away the reproach brought against us by our brethren over the sea that we have *no ruins* in the United States."

96 **Indian Rock, Narragansett.** Artist: William S. Hazeltine; engraver: S. V. Hunt; steel engraving; 5 × 8-15/16 in.; *PA* I. At the western end of Narragansett Bay, Rhode Island.

97 **Mills on Blackstone River.** Artist: William H. Gibson; engraver: A. F. Harral; wood engraving; 6-3/16 × 9-1/8 in.; *PA* I. The scene is at Providence, Rhode Island.

98 **Looking Toward Smuggler's Notch, From the Nose.** Artist: H. Fenn; engraver: W. J. Linton; wood engraving; 9-1/8 × 6-1/4 in.; *PA* II. The nose belongs to Mount Mansfield, Vermont, in the Green Mountain range. The mountain is on Lake Champlain, and Smuggler's Notch was a spot used for smuggling over the Canadian border. This dramatic view is from a perspective that provides both precipitous height, to stimulate the sense of danger, and a deeply receding vista of mountains and valleys to suggest vastness. It shows off master-engraver W. J. Linton's clear drawing, suppression of extraneous detail and creation of strong contrasts. He emphasizes the picture's basic composition and brings out the differences among various distances, substances and textures in a way that is perfectly suited to the goals of picturesque art.

99 **Untitled illustrations for Longfellow's "Prelude."** Artist: J. D. Smillie; engraver: W. J. Linton; wood engraving: 7-1/2 × 5-11/16 in.; Henry Wadsworth Logfellow, *Poetical Works*, Houghton & Osgood edition of 1879-80, Vol. I, 1879. Illustrating the lines, "But the dark foliage interweaves / In one unbroken roof of leaves."

100 **Falls of Minnehaha.** Artist: W. H. Gibson; engraver: W. H. Morse; wood engraving; 8-1/16 × 5-11/16 in.; Longfellow, *Poetical Works,* Vol. I, 1879. Illustrating *The Song of Hiawatha.* The falls are in Minnesota on the Minnehaha River, an outlet of Lake Minnetonka into the Minnesota River.

101 **Lake Memphremagog, From Owl's Head.** Artist: Frederic B. Schell; engraver: J. W. Lauderbach; wood engraving; 8-7/8 × 6-1/8 in.; *Picturesque Canada*, Vol. II, 1882. This lake, thirty miles long and two miles wide, is in Vermont and Quebec. Bartlett depicts it, and *Picturesque America* has a chapter on its picturesque features, with illustrations by J. Douglas Woodward, but this view by Schell is one of the best, and is very similar in vantage point to Woodward's "Lake Memphremagog, North from Owl's Head."

102 **Sunrise on Lake Superior.** Artist: R. S. Gifford; engraver: J. Hellawell; wood engraving; 6-5/16 × 9 in.; *Picturesque Canada*, Vol. I, 1882. The three selections from *Picturesque Canada* presented here are by two American New School engravers, and clearly display the strictly representational ideals of this engraving movement, which extended even to portraying the visual impression of the painter's brush strokes and impasto. Other prominent New School engravers who worked on *Picturesque Canada* include two of the group's leaders, who took part in the written controversy with W. J. Linton: F. Juengling and R. Schelling.

103 **Lake of the Woods.** Artist: F. B. Schell, engraver: J. W. Lauderbach; wood engraving; 6-1/2 × 9-7/16 in.; *Picturesque Canada,* Vol I, 1882. Lake of the Woods lies in Minnesota, western Ontario and eastern Manitoba.

104 **The Death of Old Ephraim.** Artist: A. B. Frost; engraver: S. P. Davis; wood engraving; 7-3/8 × 4-1/4 in,; *The Century Illustrated Monthly Magazine,* Vol. XXX, June 1885. This and the following engraving illustrated an article by Theodore Rossevelt, "Still-Hunting the Grizzly," about adventure in the Big Horn Mountains of southern Montana and north-central Wyoming. Frost, beloved for his outdoor scenes, was one of a group of fine illustrators that arose after 1880 and spanned the period in which hand engraving was replaced by photographic techniques as a means of reproducing illustration. These artists included Howard Pyle, William T. Smedley, Fred Schell and Frederick Remington.

105 **In the Big Horn Mountains.** Artist: R. S. Gifford; engraver: Richard A. Muller; wood engraving; 6-1/2 × 4-5/8 in., *The Century,* Vol. XXX, June 1885. Muller was one of the leading lights of the New School of engravers, which in the late 1880s was favored by the editors of *The Century,* the successor of *Scribner's.* It was Scribner's which in 1879 published a limited edition book which gave an impetus to the New School by prominently featuring the work of Muller and Timothy Cole beside that of superb traditional engravers such as A. V. S. Anthony and W. J. Linton; this was *A Portfolio of Proof Impressions Selected from Scribner's Monthly and St. Nicholas.* At this time the New School style was also entrenched at *Harper's* under art director Charles T. Parsons, an important figure in American art through his encouragement of such figures as Howard Pyle.

106 **Clearing Up Under-Currents.** Artist: J. Henry Sandham; engraver: T. Shussler; wood engraving; 5-1/2 × 4-3/8 in.; *The Century*, Vol. XXV, January 1883. Sandham (1842-1910) was a Montreal-born painter who established himself in New York about 1881 and became one of the finest and most prolific designers for wood engraving in the last decade of the art's prominence. This dramatic view is from an article on "Hydraulic Mining in California."

107 **Ayans Pulling the Raft.** Artist: J. H. Sandham; engraver: T. Shussler; wood engraving; 6-3/8 × 4-1/2 in.; *The Century*, Vol. XXX, October 1885. The scene is from "Exploring the Middle and Lower Yukon," the second part of an article on "The Great River of Alaska."

108 **Wood-Engraving Direct From Nature.** Artist and engraver: Elbridge Kingsley; wood engraving; 8 × 5-1/8 in.; *The Century*, Vol. XXV, November 1882. In an article on this engraving, Kingsley wrote, "Camping alone in a New England wood, from the window of a car fitted up with every convenience for painting in oils, engraving on wood, and photographing whatever appealed to the fancy, I overlooked the scene before me and wrought it on my block." He recommended that the wood engraver return to the example of Thomas Bewick, in whom "the artist and engraver were combined. He selected the scenes he loved best, and wrought them out on the block in a manner individual to himself."

109 **Life and Death.** Artist and engraver: E. Kingsley; wood engraving; 6-15/16 × 4-13/16 in.; *The Century*, Vol. XXVIII, June 1884. Another of Kingsley's original engravings, this one harkens back in mood and subject to the grand picturesque visions of Thomas Cole and Frederick Church.

Grateful acknowledgment is made to the Fisher Rare Book Library, University of Toronto, for use of Schoolcraft and *Picturesque Canada*, the Robarts Library, University of Toronto, for use of *The Century*, and the Metropolitan Toronto Library Board for reproductions from Wilkes, Benjamin's *Art in America*, *The Poetical Works of Henry Wadsworth Longfellow*, and the *American Art Review*.

A "Crevasse" on the Mississippi, by A. R. Waud,
Picturesque America, 1872

Bibliography

Beam, Philip C., *Winslow Homer's Magazine Engravings*, New York, 1979.

Benjamin, S. G. W., *Art in America*, New York, 1872.

Bliss, Douglas P., *A History of Wood-Engraving*, New York, 1928.

Bryant, William Cullen (ed.), *Picturesque America; or, The Land We Live In. A Delineation by Pen and Pencil of the Mountains, Rivers, Lakes, Forests, Waterfalls, Shores, Canons, Valleys, Cities, and Other Picturesque Features of Our Country*, 2 vols., New York, 1872.

Carver, Jonathan, *Travels through the interior parts of North America*, London, 1778.

Cumming, W. P., et al. (eds.), *The Discovery of North America*, London, 1971.

——, *The Exploration of North America*, London, 1974.

de Bry, Theodor, *America*, 10 vols.. Frankfurt, 1590-1618.

Glaser, Lynn, *Engraved America*, Philadelphia, 1970.

Grant, George Munro (ed.), *Picturesque Canada: The Country as it Was and Is*, Toronto, 1882.

Hamilton, Sinclair, *Early American Book Illustrators and Wood Engravers*, Princeton, 1958.

Hind, Arthur M., *A History of Engraving and Etching*, London, 1923; rpt. New York, 1963.

Hornung, Clarence P., *The Way It Was in the U.S.A.: A Pictorial Panorama of America 1850-1890*, New York, 1978.

Hornung, C. P., and Johnson, Fridolf, *200 Years of American Graphic Art*, New York, 1976.

Hulton, P., and Quinn, D. B., *The American Drawings of John White*, London, 1964.

Kane, Paul, *The Wanderings of an Artist*, London, 1859.

Lindley, Kenneth, *The Woodblock Engraver*, Devon, England, 1970.

Linton, William J., *A History of Wood-Engraving in America*, Boston, 1880 (in issues of the *American Art Review*; book publication, Boston, 1882).

Longfellow, Henry Wadsworth, *The Poetical Works of Henry Wadsworth Longfellow*, 2 vols., Boston, 1879-80.

McCoubrey, John W. (ed.), *American Art 1700-1960: Sources and Documents*, Englewood Cliffs, 1965.

Moritz, Albert F., *Canada Illustrated: The Art of Nineteenth-Century Engraving*, Toronto, 1982.

Mott, Frank Luther, *A History of American Magazines*, 4 vols., Cambridge, Mass., 1938-57.

Ross, Alexander M., *William Henry Bartlett: Artist, Author & Traveller*, Toronto, 1973.

Rumpel, Heinrich, *Wood Engraving, Craft and Art*, Paris, 1972; tr. New York, 1974.

Schoolcraft, Henry Rowe, *Information Respecting the History, Condition and Prospects of the Indian Tribes of the United States*, 6 vols., Philadelphia, 1851-57.

Sheldon, George, *American Painters*, New York, 1881.

Stauffer, David McNeely, *American Engravers Upon Copper and Steel*, 2 vols., New York, 1907.

Weld, Isaac, *Travels through the states of North America...*, London, 1799.

Wilkes, Charles, *Narrative of the United States Exploring Expedition During the Years 1838, 1839, 1840, 1841, 1842*, 5 vols., Philadelphia, 1856.

Wilkins, Thurman, *Thomas Moran: Artist of the Mountains*, Norman, Okla., 1966.

Willis, Nathaniel Parker, *American Scenery*, London, 1840.

——, *Canadian Scenery Illustrated*, London, 1842.

Zigrosser, Carl, *Six Centuries of Fine Print*, New York, 1937.